D1351753

DAVID NOTON
THE VISION

To Wendy, of course, for all the times we've spent together from Patagonia to Padstow, waiting for the light.

DAVID NOTON
THE VISION

THE ART OF PHOTOGRAPHY FROM IDEA TO EXPOSURE

D&C
David and Charles

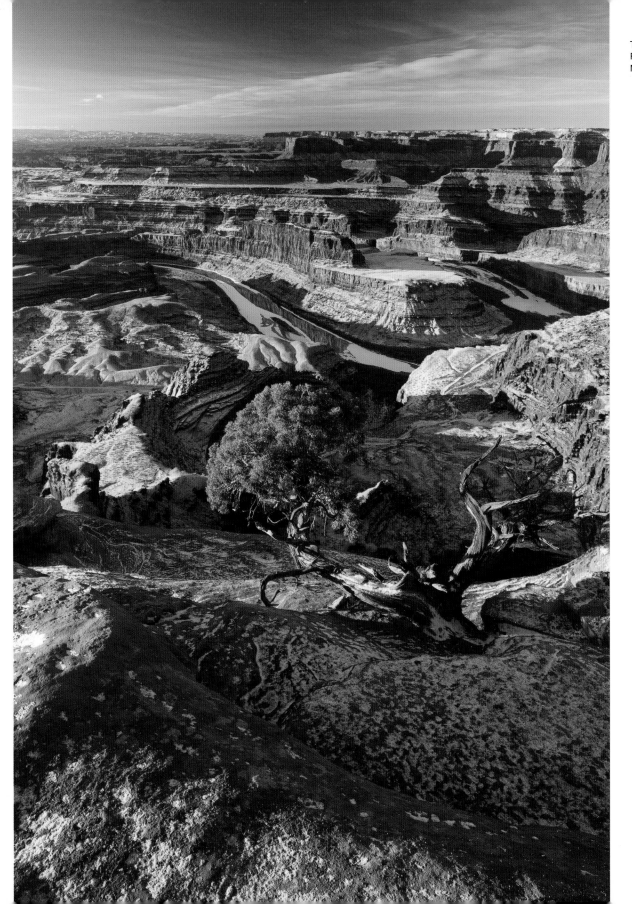

The Colorado Valley from Dead Horse
Point at dawn, Utah, USA. Canon 5D
Mk III, 24mm TS-E lens, 1/13 sec at f11

Contents

Introduction

It's 8pm and Ngapali is shutting down for the night. I can hear the surf pounding on the beach, other than that all is quiet as we prepare for tomorrow's dawn patrol. Another early evening is inevitable; we're unlikely to make it past 9pm, but that's OK. No one, least of all us, comes to Burma for the nightlife, and tomorrow morning's adventures in the twilight zone will make up for it – they always do. After the best part of a month on the road here in Burma I'm suffused with the satisfaction of knowing I've stacks of full memory cards from day after day of relentlessly inspiring photographic opportunities. I've shot markets, mountains, temples, lakes, weathered farmers, earnest artisans, beaming stallholders and maybe a few too many monks, but I must keep pushing: these times spent leading the simple life on the road when all that matters is the next shoot are so precious. We're on the last leg of this trip, but just a few more sessions can surely be squeezed in.

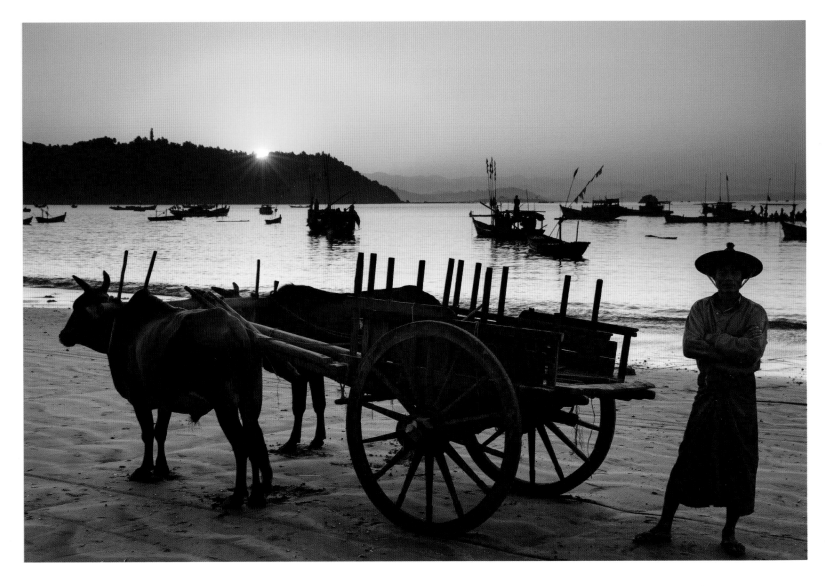

Last light on the hoodoos, Bryce Canyon, Utah, USA. Canon 5D Mk III, 100–400mm lens at 150mm, 1/800 sec at f8, ISO 800, polarizing filter. This game of photography involves so much more than knowing how to use a camera. Having a Photographer's Eye able to recognize the visual potential in any situation is a must, but on top of that we need the vision to be able to pre-visualize, predict and plan to be in the right place at the right time to make the most of fleeting moments of clarity such as this.

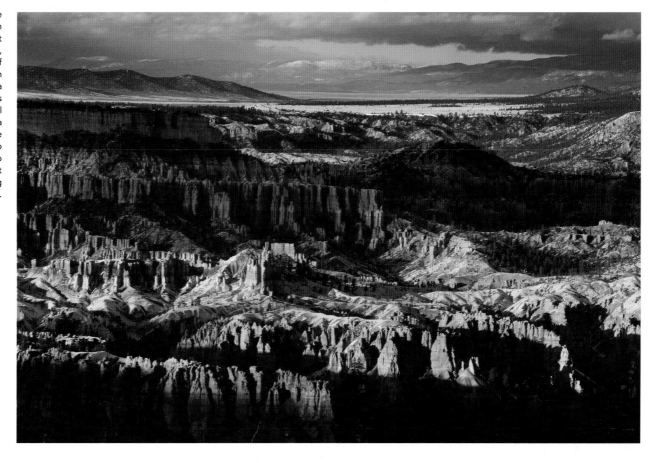

An ox-driven cart awaiting the fishing boats landing their catch at Gyeiktaw at dawn, Ngapali, Rakhine, Myanmar (Burma). Canon 5D Mk III, 24–70mm lens at 50mm, 1/30 sec at f10, ISO 400, 0.9 ND grad filter. I could never have planned on making this exact image; the ox cart and driver standing immobile on the beach as the sun rose was a stroke of luck and a chance I was glad to seize. But luck is merely where chance and preparation combine, and heading out on this shoot in the darkness before dawn, I was as prepared as I could be with ideas, a plan and a vision following the previous day's recce.

I'm going through my gear and mental checklist; it's a routine that has dominated my life for more years than I care to acknowledge. On the spare bed both camera bags gape open as I decide what to take; I can never carry it all. More important is my vision of what the morn may hold and how I'm going to tackle it. What's my idea? Where are we going? What's the plan? What lighting do I envisage? How will I compose my intended pictures? What colour will be available and how can I use it? How is the weather likely to influence the plan? When will be my Decisive Moment? As usual the success of tomorrow's shoot will depend much more upon those decisions than what's packed in that weighty camera bag. Many of those decisions have already been made, but some will be shaped by tomorrow's chain of events. I may get lucky as unforeseen opportunities play out around me, or it could all just turn out to be a non-event. Yet having the vision in the first place has ensured the shoot is more likely to be productive than not. Photography is all about making the decisions that are likeliest to plonk me down behind the lens in the right place at the right time. The better my vision, the more informed those decisions will be, and the images will be the proof in the pudding. Actually puddings are in short supply here; fried banana is about the only dessert on offer and serious chocolate deprivation is kicking in, but I digress. I have the vision; I'm as ready as I can be.

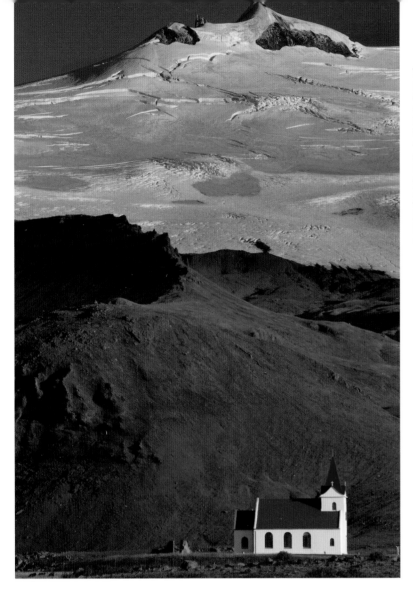

The church at Ingjaldsholl near Hellisandur, with the Snaefellsjokull towering above, Snaefellsness Peninsula, western Iceland. Canon 1Ds Mk III, 100–400mm lens at 375mm, 1/40 sec at f16, polarizing filter. I had the idea of trying to emphasize the setting of the lonely church dwarfed by the surrounding elemental landscape by using a long lens perspective before I even left for Iceland.

My Idea is to shoot a fishing village at work on the beach as the night's catch of crustaceans is unloaded at dawn. We're headed for a bay just a few miles away that we checked out earlier today. The Plan is to be dropped off an hour before sunrise so we're in position as the first light seeps through the sky. I have in mind to shoot the bay and boats first using the twilight, then as the sun checks in I may be able to use the silhouetted activity in the water and on the beach before shifting around to take advantage of the low, warm early sunlight on the fishing folk doing what

they do. Usually with a set piece landscape shoot I know exactly where I'm going to stand and how I'm going to compose, but tomorrow's challenge is bound to be chaotic and impromptu – so be it. All sorts of opportunities may present themselves and I'll need to be fast, flexible, intuitive and responsive to make the most of them; but I'm unlikely to be short of local colour. The weather here now rarely seems to change; I could do with a few more tantalizing clouds in the sky, but I do have the luxury of planning this shoot with virtual certainty that golden early light will bathe the bay.

It's a loose plan formulated to take into account the unpredictable imponderables of a bustling beach, but there will be at least two Decisive Moments: when the dawn twilight is at its richest, and when the sun makes its first appearance. Other Decisive Moments will depend on the vagaries of the locals; this being Asia anything could happen, and I hope it does. The plan is unlikely to survive its first encounter with reality, but it's a starting point. The success of the shoot will depend upon my vision, how I translate it into reality and my technical expertise. The latter is a skill that can easily be learnt; the former – formulating the vision – is the difficult part, and what this book is all about.

Later the next day I'm reviewing the shoot on my laptop. How did it go? I'm still buzzing; yet another captivating experience from this Burmese adventure unfolded. Of course this close to the event I'm unable to be totally objective about the results; the RAWs look promising but I'm not yet ready to make harsh editing decisions. The shoot loosely followed the script I'd envisaged. We arrived in the pitch black as boats returned from a night of tempting prawns to the surface in the Bay of Bengal. I started as planned, shooting the unloading of a boat on the beach as the twilight brightened the eastern sky, with the fisherman's lights on at first, then as day broke without them. As that Decisive Moment passed I moved up the beach to take advantage of an ox-driven cart waiting for a load; silhouetted against the dawn sky with the boats in the bay beyond it made for a strong, evocative and typically Burmese scene. I waited maybe 20 minutes for the light with the cart in front of my tripod and a gathering crowd behind.

My second pre-visualized Decisive Moment came as the sun just peeked over the trees and I hit the shutter, watched now by a sizable throng that gathered around to gaze at the glowing monitor. With that shot nailed, I immediately moved around to use the soft, low sidelighting of the first direct sunlight on the driver, cart and oxen, palm trees and beach. Wendy then retrieved the tripod and I carried on shooting hand held in amongst the ladies laying out sprats to dry. The light was gorgeous and there were so many ways to look; too many really.

So, how did I perform? Not bad: I think in the latter part of the shoot I could have been more focused and disciplined. With so much going on I was like a child in a sweet shop; trying to taste it all at the same time. I should know by now to settle down and make the most of one opportunity at a time, not moving on until I've made the very best picture I can. Still, I've always said that I never stop learning in this game and that's another case in point. All in all, it came together pretty well, but I know no pixels would have been exposed without the vision in the first place. So what is this 'vision' I keep harping on about?

We all know about the most important equipment needed for our craft: a Photographer's Eye. The ability to see strong pictures in a multitude of situations is a fundamental skill to be nurtured, but actually we need to do better than that; on top of recognizing the photographic potential in front of us there and then, we need to be able to pre-visualize, predict and plan to be there, camera in hand, in the first place. It is rare to randomly stumble over the photographic opportunities we crave; somehow we need to improve our chances of being there, ready and

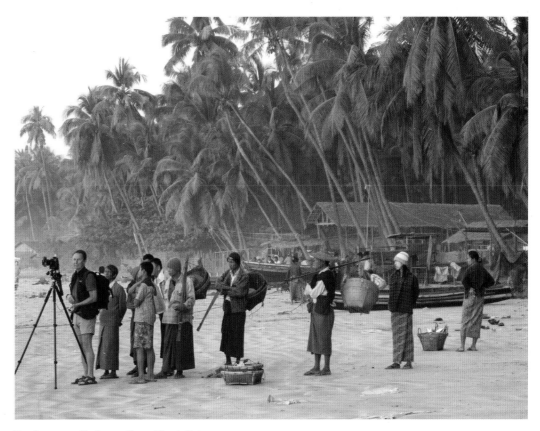

Drawing a crowd in Burma. Photo: Wendy Noton.

waiting when the light is right. Where? What? How? That's what the vision is all about. In my book, in this book in fact, the vision is the process that gives birth to a picture from the conception of an idea through to the point the shutter opens.

My first book *Waiting for the Light* was all about the travelling photographer's life, illuminated by the stories behind the making of pictures in a multitude of the world's most challenging and inspiring environments. My second book *Full Frame* explored how the vision can be nurtured with new challenges around the globe along with before, during and after analysis from behind the lens. Now *The Vision* will continue to clock up the miles as I scrutinize in a detailed and logical progression how a successful photograph comes into being,

from idea to exposure, and from Burma to Utah.

I have had many lucky breaks, opportunities and encounters on my travels that have resulted in some of my favourite images, but not one of those opportunities would have come about if I hadn't had the vision in the first place. Luck is after all only where chance and preparation combine. The better my vision, the luckier I get. Conversely when life's complications and distractions cloud my vision, the pictures suffer. There have been all too many times when the productivity of whole trips to the far side of the world has suffered from a lack of clarity. I continue to live and learn. Spawning the vision is the hardest bit; the actual photography seems easy by comparison, and it all starts with the idea.

Chapter 1

The Idea

I shuffled by the tripod as I pondered if I was making the right call. I knew there were thicker profusions just up the lane; surely the more poppies the better? Maybe I should just fill the frame with scarlet blobs. But no, Monet's influence held sway. With ethereal mist laid over the green heart of Italy dressed in its verdant best, I really did have the perfect morning to be out ready and waiting behind the lens. Soon the sun would appear above the mountains to the east; my Decisive Moment was nigh. The temptation to relocate was strong, but this was no time to be faffing about; I needed to have faith in my idea.

As the sun prepared to make an appearance, the thick fog that had enveloped all receded momentarily. The hills above appeared, as the trees in the field below stood out like sentinels in the mist. In the foreground my chosen poppies were random splashes of scarlet against the lush green of the barley. The light was cool and subtle, the composition was simple and graphic, and I was ready and willing. The shutter clicked as the mist wafted then dissipated in the heat of the sun. The moment passed in seconds.

Scouting the location the day before, a seed of inspiration that had been lodged in my subconscious for months germinated into an idea. A visit to the Musée d'Orsay in Paris earlier in the year had prompted fresh consideration of Monet's famous 1873 masterpiece *The Poppy Field, near Argenteuil*. The way the artist used the swath of red splashes in the foreground, the compositional harmony of the piece, and the relationship between the three dominant yet subtle primary colours hit home. I didn't hatch a plan then and there to replicate Monet's vision, but I was sure that sooner or later I could inject a trace of his influence into a shoot – somewhere, somehow. A hefty helping of inspiration was duly banked. It is valuable stuff; I hoard it when I can.

Poppies in a field at dawn, near Norcia, Umbria, Italy. Canon 1Ds Mk III, 17mm TS-E lens, 1/30 sec at f11. This picture was influenced by Monet's famous 1873 masterpiece *The Poppy Field, near Argenteuil*.

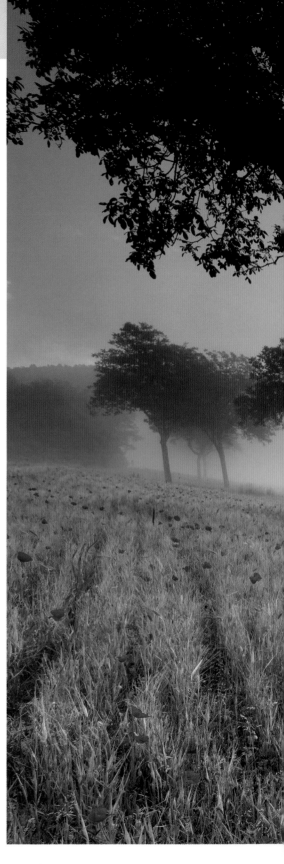

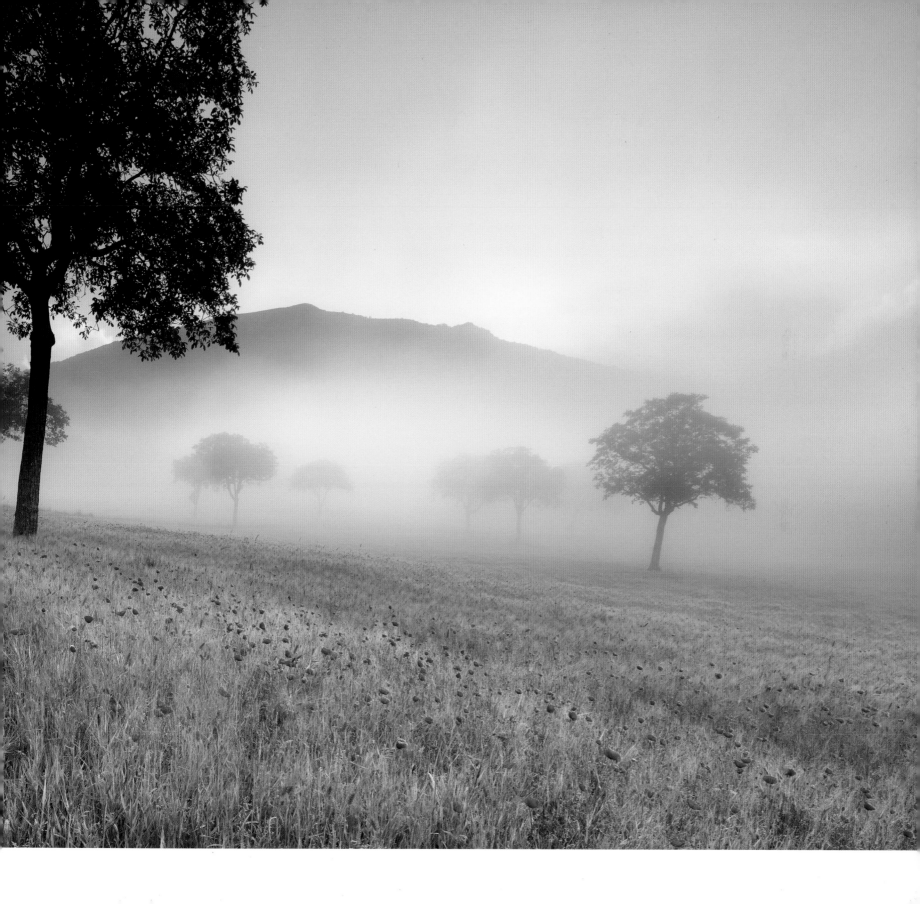

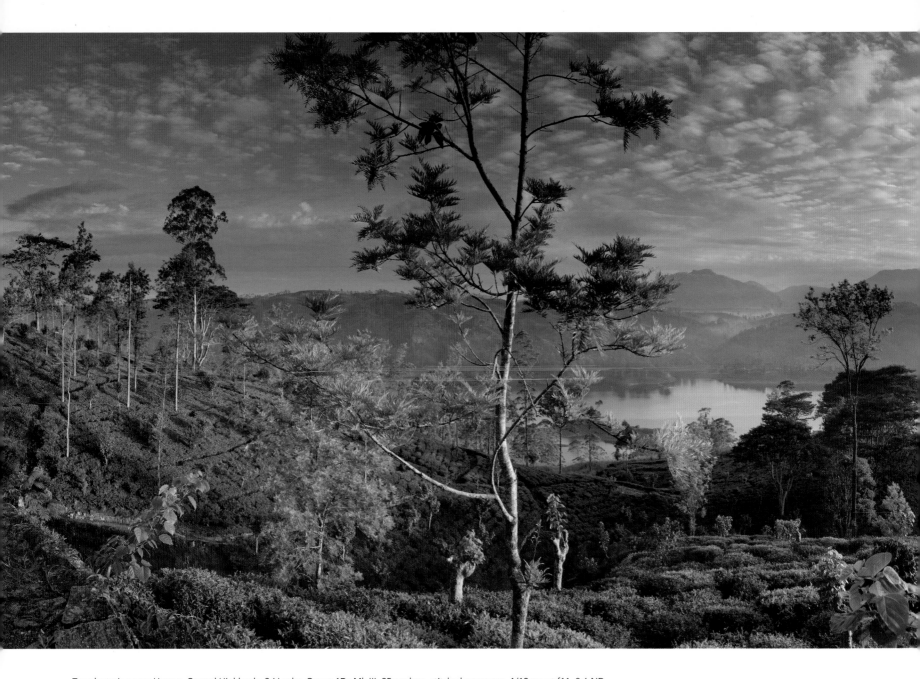

Tea plantation near Hatton, Central Highlands, Sri Lanka. Canon 1Ds Mk III, 35mm lens, stitched panorama, 1/13 sec at f11, 0.6 ND grad filter. The idea to head to Sri Lanka as all colour leeched out of the late November landscape in northern Europe came in a moment of rash inspiration. Normally trips are slotted into the diary months or even years ahead, but this one was the product of last-minute desperation to expose in a lush tropical environment as the prospect of a winter of discontent loomed at home. I never take for granted the luxury of being able to make such impromptu calls. It is rare to have such freedom from commitments, but sometimes ideas come in such startling clarity that resistance is futile and I question why I never thought of them before. I grasped greedily the stimulus of the idea and heeded the best travel advice I've ever received: don't think about it too much, just go. I had unfinished business in Sri Lanka; our visit a decade previously had only touched on the visual potential. Once that decision to go had been made, the ideas of what I could shoot came naturally. One absolute priority was the impossibly green verdant landscapes of the hill country clad in the velvety green of the tea plantations. The idea spawned the plan, and before I knew it I was there in the warm morning sun, struggling to centre the tripod spirit level bubble as I prepared for this panorama.

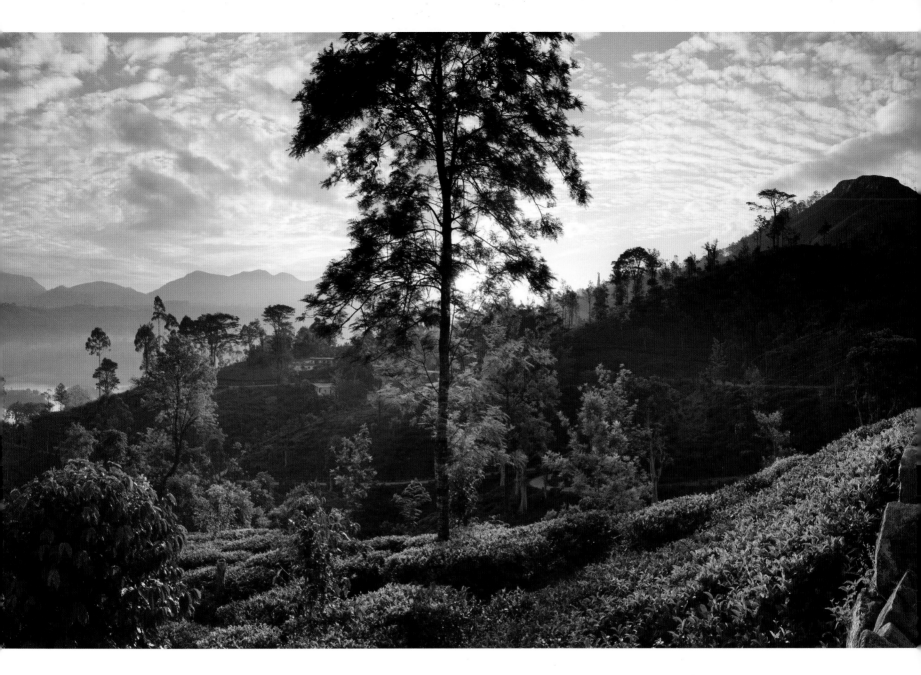

Let's face it; shooting poppies in the landscapes of Italy is not exactly the most novel idea in the world. In fact, it's difficult to avoid these flowers, as they seem to paint every Italian verge in early summer. I've stopped even trying to resist their pull; clearly I have a 'poppy problem'. Yet there on a verge near Norcia, with passing stoic farmers slowing to stare suspiciously, Monet's inspiration provided me with fresh stimulus.

I wasn't planning a literal replica with Wendy and friends dressed up as Victorian ladies wandering the scene with parasols, but in Paris I'd been struck by how Monet used a swath of red blobs splashed diagonally across the foreground as a bold compositional tool. The impact of the scarlet blobs standing out against the green was more powerful than if portrayed as a dense solid block of colour, providing an object lesson in how often in art Less is More. And so the idea coalesced. The composition was determined, the colour content pondered, and the lighting pre-visualized. When the previous day's rain was followed by a clear night, I knew in my bones that the next morning would be the time for the creative egg that had been incubating from my moment of revelation in the Musée d'Orsay to finally hatch.

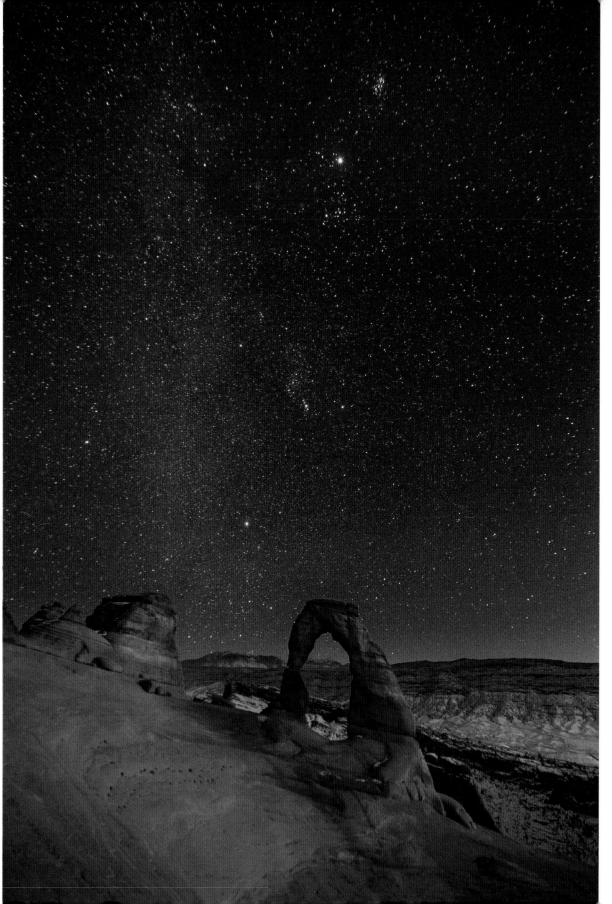

Night sky over Delicate Arch, Arches National Park, Utah, USA. Canon 1Dx, 14mm lens, 20 sec at f4, ISO 12800. I wasn't planning to revisit this location that I'd photographed 20 years before, but the prospect of shooting there under the clear star-laden night sky brought me a breath of fresh inspiration. I arrived late afternoon to find a row of tripods awaiting the last light, but after the sun dipped to the west their ranks thinned, leaving just me and an Italian photographer as twilight fell. We chatted about the cuisine of Emilia-Romagna as the darkness fell before he eventually started his descent, leaving me alone in the pitch black, savouring the mood, the setting and the solitude. Making these nightscapes is an experience that connects me with the very roots of my soul.

Writing this now has provided me with the first excuse to actually look at the Argenteuil painting alongside my finished image. Monet's influence is even more evident than I imagined, which just shows the power of inspiration. The evening before the shoot, with a strong location bagged, favourable conditions forecast, a definite idea in mind and a plan in place, I was as relaxed as it's possible to be. Life had purpose: all I had to do was Be There. Of course the weather or just one random cloud in the wrong part of the sky could still scupper my plan – it happens frustratingly often – but I'd done the hardest bit. Whether the shoot was destined to come together or not was now in the Lap of the Gods.

Decades ago when the photography bug first bit I thought I could sate my new hunger to expose by just taking my camera for a walk. It took some time and miles of aimless wandering to realize that it's rare to stumble randomly across photographic opportunities; strong images usually have to be made to happen. Lady Luck always looks on more favourably when I offer her a helping hand aboard. Capturing even the most opportune events has usually involved some preparation, and that whole process starts with the idea. Without an idea my photography is lost at sea, rudderless and in distress. Launching an idea is the first and often the hardest leg of the voyage.

There are three broad types of stimuli for ideas that I routinely require to get the creative ball rolling: ideas for projects, trips or assignments, ideas for whole shoots, and ideas for individual images. For each of them I need a clear sense of purpose; the better the ideas, the better the pictures. The process by which those ideas develop can be a chance moment of blinding illumination, but more often than not the mind takes a little nudging. Ideas flow when fuelled by inspiration, the lifeblood of our creativity. How and where we glean that inspiration is therefore our first step to consider.

Ideas for projects or trips usually come about as the result of previous knowledge of a destination. Next month I'm off to Utah. Why? The reason is as simple as the fact that I've not been there for 20 years and I'm excited about the prospect of another jaunt to shoot the immense red rock desert landscapes of the south western USA. Since I last visited the whole digital revolution has passed; I'm buzzing with ideas for new things I can do there using the techniques I've evolved since 1993. That's all well and good, but the landscapes of this region are some of the most heavily photographed in the

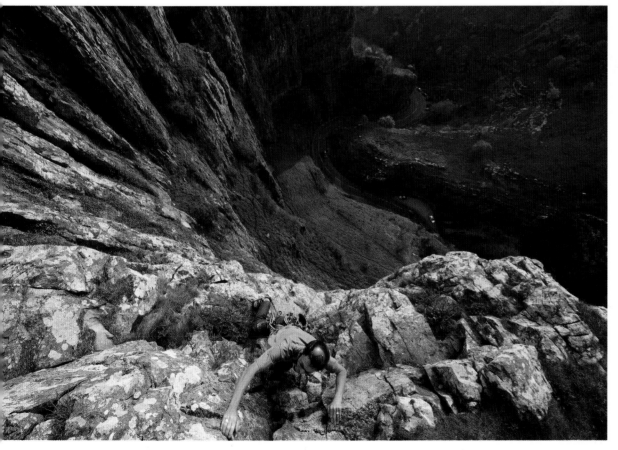

Martin Crocker, the climber on Warlord Wall, Cheddar Gorge, Somerset, England. Canon 5D Mk II, 14mm lens, 1/40 sec at f10. The job of being a professional photographer is all about turning a client's ideas into reality. In this case I was commissioned to shoot Cheddar Gorge with the specific brief of including a shot of a climber doing what a climber does on the precipitous rock faces. How to tackle that imaginatively was my challenge, so I conceived the plan of suspending the camera above the gorge looking vertically down, with Martin climbing up towards us. Manoeuvring into such a vantage point was going to be impossible without the ability to hover in mid-air, and my angels' wings lost their tarnish long ago. With the camera fitted with an extreme wide-angle lens and connected by cable to a monitor on the cliff top, we swung it out over the edge on a boom and watched with Live View as Martin climbed towards us, shooting with a remote release when the time was right. When he reached the lip I, in time-honoured photographer's fashion, asked him to do it all again, and again, and again until I was happy we'd nailed the shot. I then strolled over to the edge of the gorge and contemplated what I'd so blithely asked him to do; reversing such a sheer route is far harder than climbing it. Turning a brief into photographic reality is very satisfying; sometimes it's liberating to be presented with a brief I would never have dreamt up myself. Photography with a purpose always nets stronger images than when shooting with no specific brief in mind.

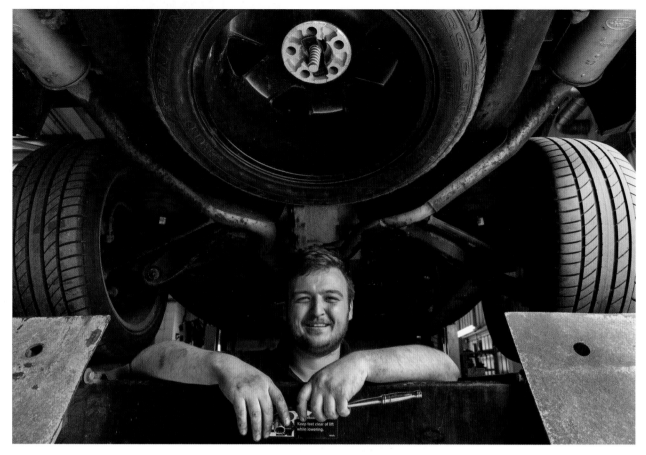

Dan Smith, aka Smudge, the motor mechanic, Yeovil Land Rover, Somerset, England. Canon 5D Mk III, 24–70mm lens at 25mm, 1/100 sec at f8, ISO 1600. One question from the audience at a recent Road Show really made me pause for thought. I photograph interesting faces from Sri Lanka to Bolivia, so why not shoot the people around where we live? I'd fallen into a trap of only photographing crusty peasants in distant rice fields and colourful markets, totally disregarding the characters that populate our lives at home. And so The Locals project was born. I'm now on a mission to shoot people we come across on our own home patch in their places of work, and Smudge was one of my first victims. The idea has given my photography in between trips to the far side of the world a real shot in the arm; it's fun, and a project that will just run and run.

world. Last time I was there I covered the area pretty extensively, so if I'm going to produce anything of value in Utah I'm going to have to be imaginative. Just rehashing my old stuff is not going to achieve anything; I need fresh ideas. Unfortunately random interventions from the heavens can't be relied on; usually I need to kick start inspiration. How to proceed?

I could surf the Internet and scroll through the reams of photographs of Arches, Canyonlands, Bryce and Zion National Parks, logging locations and ideas. It is the most obvious approach, and one most of us follow. Whilst it's a useful way of building a visual profile of a destination, it's nevertheless a procedure fraught with a potentially lethal hazard to our creative integrity. If this were all we ever did, we'd be stuck in an endless cycle of repetitive photographic regurgitation; none of us would ever shoot anything truly new or original. Of course it's easy to kid ourselves that everywhere and everything has already been shot and there's no more room for originality in this crowded world awash with imagery, but that's a fallacy.

I believe every location, no matter how famous or well known, has the potential to allow an imaginative photographer fuelled with the oxygen of inspiration to create an image that is a unique product of his or her vision. If that's the case, then what's the problem with using existing photographs as a starting point? None, but we need to always question at what point inspiration becomes plagiarism.

It's quite possible to look at the many pictures of Delicate Arch and work out exactly where and when to position my tripod to nail the classic image of this iconic feature. Standing at known viewpoints amongst well-worn tripod holes will usually net a picture that works – there is no doubt about that – but of what worth will it be? Mindlessly replicating what has been done before is the road to creative impotence, a technical exercise devoid of the stimulus of originality. The trouble is that coming up with new ideas and scouting fresh locations is difficult and soaks up precious time and energy, so all too many take the easy option by following the well-worn track beaten by legions of previous photographers.

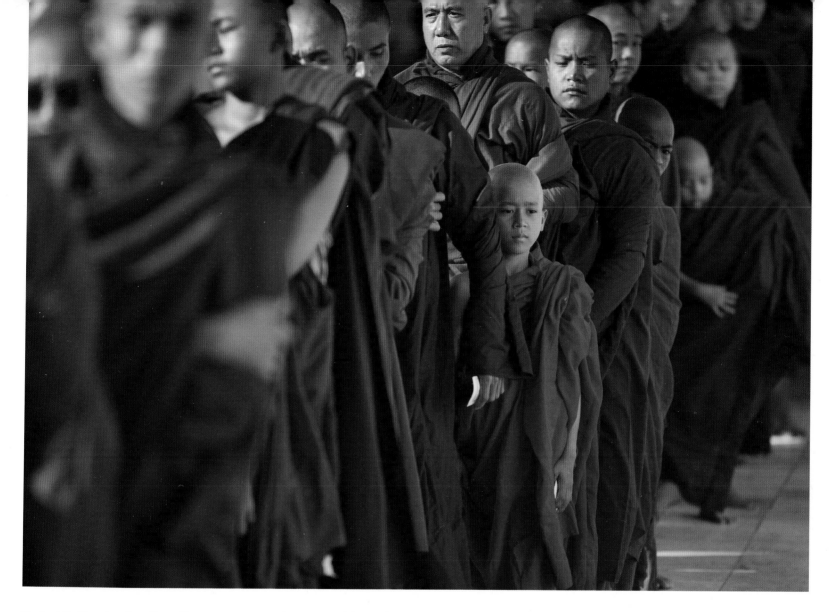

Monks at the Shwezigon Paya, Bagan, Myanmar (Burma). Canon 1Dx, 70–200mm lens at 200mm, 1/1000 sec at f2.8. We were whisked by our guide to the Full Moon Festival at yet another pagoda not really knowing what to expect. More monks obviously, a photographic subject like poppies I've never been able to resist, I've stopped trying. I never realized men can dip in and out of monkhood as they please; when life gets complicated it must be tempting to shave the head and have a break at the monastery to get the head together again. Impromptu shoots such as this can never be pre-visualized the way a landscape can be, but stepping into the fray with ideas of how to approach it always helps. To offset the more set-piece shoots in our itinerary, I was determined to return from Burma with pictures like this. Together the resultant picture essay is stronger collectively than the pictures are individually.

I may visit Delicate Arch, but if I do I'm determined to go armed with an idea of how I can approach the potential of the location in a way that I at least have not seen before. I will need to forget the countless pictures I've already seen and open my creative arteries to the Utah air. Hiking back from the location with an exposed image unique to my vision will be a hundred times more satisfying then just making yet another photocopy.

There's no doubt however that existing photography can be a useful prompt, as long as the temptations of plagiarism are resisted. We all can derive inspiration from each other, there's nothing wrong with that. It is

possibly for that very reason you've bought this book! Generations of artists, musicians and flighty creative types have drawn influence from others in their field. That influence fuels inspiration, which in turn leads to an end product out of all recognition to the original source. That's not copying; we all benefit from that process. Looking at the original image was just the starting point. With that in mind, clearly the more pictures we look at the better. I find, however, that I rarely glean inspiration from other photographers of my own genre; the real gems come from less obvious sources, such as Claude Monet.

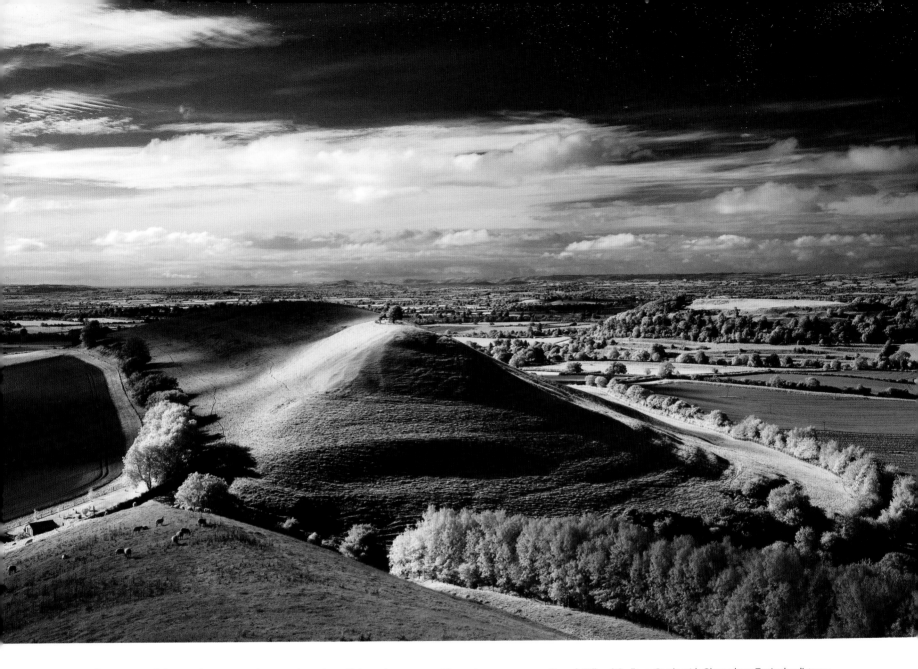

The Masters of the past have so much to teach us about light, colour, composition, perspective; the lot really. A flick through any image sharing website or photography magazine suggests many exponents of our craft are producing a lot of lookalike pictures. It's difficult to avoid the trap of falling into line, which is why relying solely on photography as a source of inspiration is a double-edged sword. I find going back in time to peruse the work of the acknowledged Masters pays real dividends; I should spend more time wandering the salons of the National Gallery. Even if I don't like a work, there are always lessons to be learnt regarding what aspect of the artist's vision has or hasn't worked. More often the influence can be so subliminal as to be invisible to all but me, but that seed of inspiration – which may lie dormant for years – can flower into life at any time. The more seeds planted in our creative beds, the healthier our vision will flourish.

Parrock Hill and Cadbury Castle with Glastonbury Tor in the distance, from Corton Hill, Somerset, England. Canon 1Ds Mk II converted for infrared, 24–70mm lens, 1/250 sec at f11. Coming up with fresh ideas for how I can photograph the landscapes that lie on our own doorstep is difficult. This scene just down the road from us is so familiar: it's one we traipse through routinely on one of our favoured local circular walks. It's funny how all such routes tend to incorporate a pub. Familiarity can breed contempt, but I know there are endless visual options all around us that I'll never exhaust; I just need the vision to see them. The fresh approach of shooting the view with a camera adapted to be receptive to infrared light only provided the stimulus.

Of course I do peruse a lot of photography; I have shelves at home bursting with coffee-table books covering all manner of subjects. I find photographic genres different from my own most inspirational; particularly wildlife, photojournalism and sports. Often I'll subconsciously soak up ideas on composition, colour, impact, location, or more fundamentally how the photographer has worked the subject. The big danger I dwelt upon in my second book *Full Frame* was that if we don't keep challenging our creative selves, we unconsciously start approaching our photography in a pre-determined way. Dipping into the world of other photographer's specializations far removed from our own helps to refresh the vision.

Other visual art forms such as textiles, ceramics, patterns in nature, or indeed anything with strong graphic appeal that uses shape, texture, colour and form can be inspirational. Ideas that can be applied to our vision lie all around us; we just need to be in the appropriately receptive frame of mind to recognize them.

Inspiration often comes out of the blue, without any warning, rhyme or reason. Sometimes a tantalizing clip on TV can prompt an idea resulting in flights being booked the next day; many an adventure has started that way. Wherever and however inspiration comes it should be immediately bottled: the lifeblood of our creativity is precious. Blinding moments of mental clarity and exhilarating inspiration are usually fleeting; I need to log mine. I may think I'll remember, but the demands of day-to-day life soon clog up the mind. A database of half formed thoughts, dollops of inspiration and half-baked ideas to be ransacked when needed is a valuable asset.

It is crucial to have an idea in mind before heading out on location, but more often than not it's the destination itself that provides the inspiration. I'm writing this here in Burma, where the novelty of our first visit to this previously off-limits but enticing country has stimulated a constant flow of inspiration and ideas. Of course, to get this far I needed a clear sense of overall purpose when conceiving the trip six months ago. Typically I'll aim to return from an odyssey such as this one with a set of pictures that collectively represent the destination: landscapes, travel portraits, reportage, details, culture, cuisine, street and market scenes – in a nutshell, a photo essay of Burma. Why? Because it's what I do, and photography with a purpose is actually a lot easier to pursue than photography without.

When planning this trip I deliberately avoided looking at images of Burma, as I didn't want pre-conceived ideas to creep in. I needed to be receptive to the stimulation of a novel destination and our guide's input; I think it's working. Whilst each leg of our adventure has an aim, the specifics of what and where I'll photograph have remained open. Local knowledge has proved invaluable; although I've started each leg blind, after the first day or so the magic of Burma has revealed itself and ideas for subsequent shoots have flowed. Working this way of course takes time, but far better to return with a set of images I'm happy with as a product of my own vision rather than a whistle-stop tour of the tourist hot spots. Sure, we've visited some of Burma's acknowledged highlights, but I'd like to think I've produced a set of unique images. Having the time to soak up the inspiration and duly formulate ideas has been the key; far better to return home with one strong image from each leg than with hundreds of average ones. Of course I hope and strive for more, but I'll always opt for quality over quantity, and the first requirement of that quest is a strong idea to start with.

Exotic travel is a fail-safe tonic for jaded inspiration; nearer to home novel ideas can prove more elusive. I love our home patch on the Dorset/ Somerset border, but whilst familiarity doesn't exactly breed contempt, thinking I've run out of ideas for what I can shoot on our own doorstep is an easy trap to fall into. Over the years we've lived here I have photographed many local scenes, and coming up with new slants is proving increasingly difficult. But I know the problem lies not in my familiarity with our local landscape, but more in my perception. There are endless options within a few miles; I just need the time and mental space to get out and see them afresh without the distractions of life cluttering my view.

Whilst local knowledge is such a valuable asset, it is in many ways easier to come up with ideas on the road where my sole function is photography. That sense of undiluted purpose is difficult to maintain when the flagged messages in my Inbox are demanding replies, the editing mountain needs scaling and the deadlines are looming. After a week in front of the computer I will inevitably be desperate to expose again, but where and what? There's nothing worse than knowing that all the elements are in place for a stunningly evocative dawn shoot, and not having a clue where to head. That's when a backlog of ideas ready in reserve to be drawn upon when the season and weather looks favourable is so precious. But wherever I am in the world, the idea and the location go hand in glove; one leads inevitably to the other.

Journal Entry: Sri Lanka

DAY 1

0600: In my jet-lagged state I'm sorting out my gear as we prepare to head out from Colombo and up into the Hill Country. I've only been in Sri Lanka a few hours but already I've triggered a bank security alert and realized I have no means of charging the batteries for my cameras, laptop or phone.

1700: This is a novelty; I'm being devoured by leeches on the first day. We're recceing a location on a tea plantation at Maskeliya with a stunning view over a lake towards Adam's Peak; the clouds are leaden now, but we shall return.

DAY 2

0700: We're out for our first shoot and I've had my first encounter with the tea plucking ladies. It took me a few minutes of faffing about before I zeroed in on the visual possibilities, but I'm in the groove now. After all the planning and travelling it feels so good to be out doing what I do, and what a stunningly beautiful country.

0900: Breakfast back at the hotel; on the TV in the background Bear Grylls is eating raw grubs and drinking elephant poo fluid. My roti and hoppers are delicious; looks like this could be quite a foodie trip.

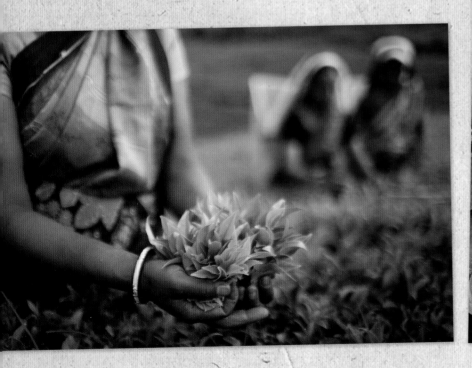

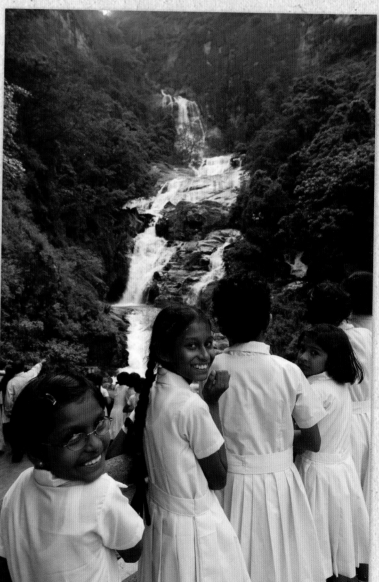

DAY 3

1100: We're moving on to Ella. Ranawaka, our driver, is a rarity; he actually slows down for hazards, such as dogs that miraculously seem to get out of the way at the last moment, and bus drivers who hurtle around blind bends with their feet flat on the throttle, oblivious to the precipitous drop one side and the mother clutching her infant on the other.

DAY 4

0600: The overnight rain has ceased, and as mist drifts up from the valley below and the sun rises over Eden Peak, Buddhist chants resonate through the Ella Gap. This is what it's all about, the adventure of travel enhanced by the joy of photography. I can feel the heartbeat of Asia.

2000: Rice and curry for dinner. Sounds simple, but the table in front of me is crowded with the accompaniments: sambal, dhal, poppadoms, jackfruit, potatoes and the rest. Meals at our local curry house back home will never seem the same. The trip is going well; my only problem is the first stirring of chocolate deprivation.

DAY 5

1600: On an overcast afternoon I'm attempting to make something happen photographically at Ravana Ella Falls, but, ho hum, how many waterfalls can I get excited about in a lifetime? A party of schoolchildren turn up and the uninspiring vigil is turned into a heart-warming photographic opportunity.

DAY 6

0430: I'm creeping out of the guesthouse in the darkness, trying not to wake the others. Trusty Ranawaka is waiting. I've been staring at the ceiling for the last few hours, waiting for the buzz of the circling mosquito to stop and do what it must.

0530: We're trudging up Little Adam's Peak by the light of our head torches, all memories of a sleepless night forgotten.

1600: In amongst the jostling throngs at Bandarawela market I'm the only foreigner in sight, having fun with my 35mm lens wide open at f1.4. Stallholders and shoppers are curious but unfailingly welcoming and open to being photographed. The sights, smells and colours are intoxicating.

DAY 7

0600: I'm waiting for the light by the tripod when I feel the first sharp bite on my ankle – leeches again. Why are the best vantage points always the most uncomfortable? I stick it out as the sun rises over the rows of tea plants below and my boots fill with blood.

0900: A lovely, elegant Sri Lankan lady has done my laundry, poor woman. I'm trying to filter out the nearby Brit couples' conversation in the background as they vie to outdo each other with intrepid travel tales; they move on to discussing Spanish property prices. The view through Ella Gap as I breakfast in the warmth of a tropical morning is to die for. It's tough to leave as this has been a magical stay, but it's time to move on; some tea pickers at Nuwara Eliya await.

1200: As we drive on, my mate Sashi's secretary rings; strings are being pulled and travel arrangements put in place for me. I could get used to this. I must make the most of the opportunity; no pressure then.

1600: Five tea pickers in their most vibrant saris are at my beck and call, waist deep in amongst the lush green tea plants. They just don't stop smiling, the colours in my viewfinder leap out, the light is perfect, and I'm in heaven. This is one of those photographic sessions I know I'll revel in remembering for the rest of my days.

DAY 8

1700: Arrival in Andarpathura. I wander down to the lake; an elephant is grazing as dusk settles. We've dropped down from the cool Hill Country; the landscape and ambience here feels much more tropical.

2300: Death to all mosquitos. My chocolate deprivation is getting serious.

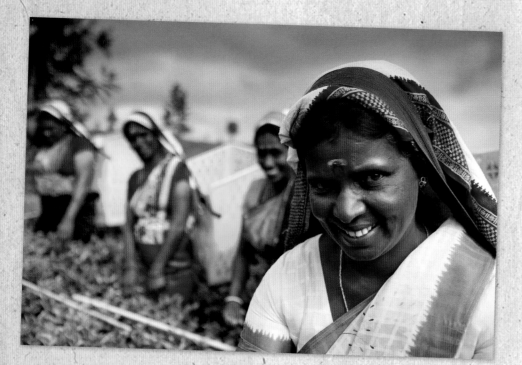

DAY 9

0500: We meet Sashi at the gates of Wilpattu National Park. He has some chocolate brownies with him, just for me; what a mate.

2000: After a long day spent lurching in the back of a vehicle searching for elusive leopards, I'm sat with our tracker Darnushka looking at the night sky. I offer him a dram of my diminishing supply of single malt from Heathrow and he wants to put Coke in it; I don't think we're going to get along too well. Wild boar are foraging and snorting in the darkness nearby. Darnushka asks me for an English song; a rather feeble version of *Over the Hills and Far Away* follows.

DAY 10

1000: A peacock displays and my auto focus locks on; brief contentment suffuses my whole being.

2330: I think there are more mosquitos inside my net than out.

DAY 11

1900: On our way back to the hut after another long fruitless day of searching we come across three leopards ahead on the track in the light of our headlamps. Darnushka is ecstatic, but for me photographically it's hopeless.

DAY 12

1200: Crab curry on the beach at Kalpitiya. I sit in my hut under the palm trees going through the unedited images from the shoot. What a trip it's been.

DAY 13

0600: The last shoot; tomorrow I fly home. Ranawaka is having fun driving the 4x4 along the beach. We surprise a group of fishermen by the light of the moon, and I'm soon shooting their weathered faces. What fun, what friendly people, what fantastic food, what spectacular landscapes, what a wonderful country. I'll be back.

The Location

I'm clambering over rocks compass in hand, crouching and peering, contemplating the position of trees and suitably shapely rocks in relation to the serrated ridges beyond, and musing on the rotation of our planet. The Col de Bavella, framed by the surrounding ridges, drops away dramatically to the valley that extends away to the sea below. Here at this time of year, early June, the sun rises well to the north of east; on a bearing of 058 degrees to be precise. With this lie of land, to capture the epic scene I'll be shooting straight into the rising sun at dawn, a lighting scenario not without its problems. At the other end of the day those peaks of the Aiguilles de Bavella to my left will be casting a shadow right across the landscape below, which is not a viable option.

Without a doubt this is a dawn location and a strong one at that, but the lighting is going to be tricky. Of course I could choose to return in autumn when the scene below would be lit by attractive cross lighting from the south-east early in the day. This is an appealing thought for the future that we'll certainly not rule out – Corsica has already got under our skin – but for now I need to make the most of the here and now. I need to get a shoot plan plugged in for tomorrow morning and this is definitely a dramatic location, one with much visual potential for wide views, panoramas and long lens landscapes. It's a setting certainly worth investing repeat visits in. With the right dawn sky the north-east aspect could work, but now I need to decide on my

definitive composition for tomorrow; casting about trying to decide where to position the tripod in the darkness is not the way to work.

My camera gear is back in the car, but this is where the process of making a picture really kicks in. The final pieces of the location search that started months ago when the first rough plan to visit Corsica was hatched are now slotting into place nicely. The process of how I've come to this Col and pieced together this shot that I've yet to expose are, in a nutshell, what location finding is all about. It is, quite frankly, the hardest bit of the whole process of turning a vision into pixels.

The Col de Bavella at dawn, Corsica, France. Canon 1Ds Mk III, 17mm TS-E lens, 3.2 sec at f11. Finding locations such as this is usually the hardest and most time-consuming part of the whole process of making an image unique to our own vision. I worked this location on three successive mornings to try and make the most of its potential. What really made the picture work was a combination of dogged persistence and Mother Nature's input: the way the clouds in the dawn sky in the right of the frame almost perfectly mirrored the shape of the rocky ridge below resulted in an unrepeatable opportunity. Such moments are the reward for days of planning, searching and location scouting.

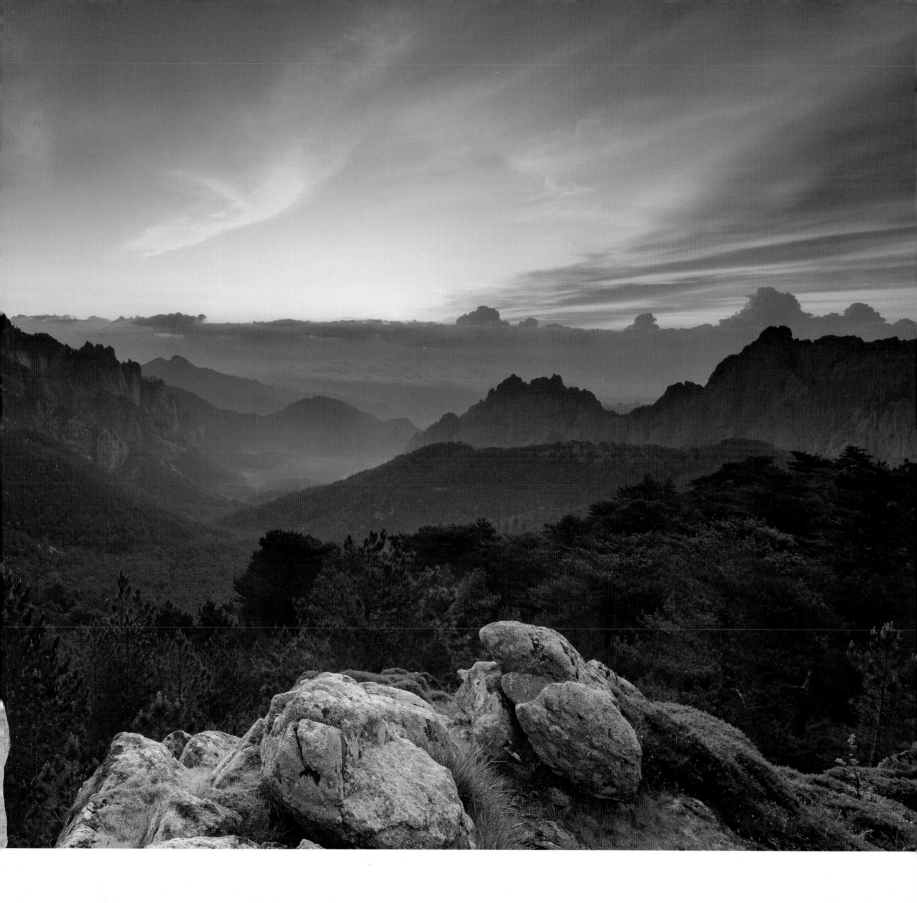

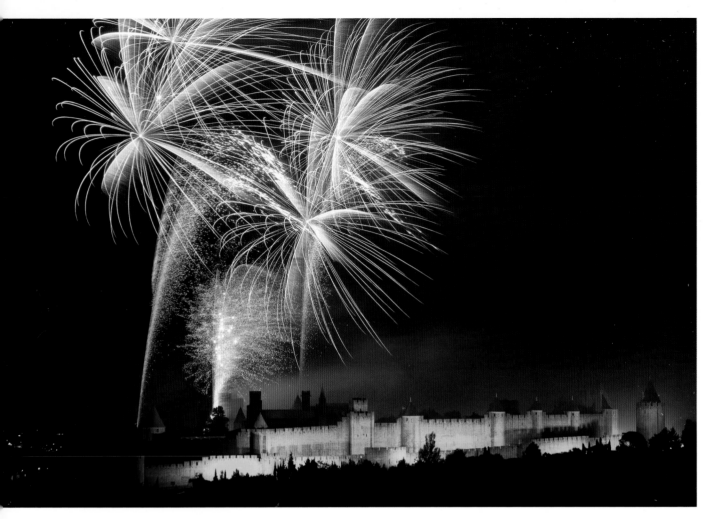

Bastille Day firework display over Carcassonne, Languedoc-Rousillon, France. Canon 5D Mk II, 70–200mm lens at 180mm, 10 sec at f11, ISO 100. The idea was obvious – the Bastille Day firework display over Carcassonne – yet finding a suitable location from which to shoot it was an operation requiring military precision. I knew a likely vantage point, but hadn't reckoned on just how popular the event would be. Arriving in the area during the early afternoon, every available scrap of land around the Cité was occupied by loungers and picnic tables: the French know how to lunch like no others. I reasoned an adjacent hilltop that would allow me to use a longish lens perspective would be the best option, and I also knew from which aspect the Cité looked best, so we methodically started scouting hilltops to the south-west further and further away using maps in tandem with the car's SatNav. After much casting about up dead end country lanes braving rabid farm dogs we found a suitable summit and staked our claim with tripod and blanket; slowly the rest of France joined us. By darkness we were surrounded by supping revellers and a not so furtive copulating couple. Finally, after a five hour wait, it all kicked off; even the amorous couple sat up to take note.

Corsica has a beautiful coastline featuring dramatically sited old walled towns, secluded coves, rocky headlands and imposing citadels. Inland lies a harsh, rugged mountainous interior that invaders, from the Greeks to the French, struggled to conquer. This was all that I knew about the island before first setting eyes on its serrated peaks slowly rising above the flat, calm Mediterranean Sea. As we sailed past bleak Montecristo I considered our plan for making the most of the two weeks we would spend on the island. As with any shoot in previously undiscovered territory, the business of finding the most promising locations would determine just how photographically successful our venture would be. Despite its relatively manageable size, I knew there was no way we could hope to tackle all Corsica had to offer in the limited time available, but if I could return with a strong set of images that gave a representative flavour of the place, I'd be happy.

Logically that meant breaking down the trip into three 3 to 5 day blocks, each with its own photographic priority. This is a way of working that has become second nature to me: slowly and steadily narrowing down the multitude of alternatives until

I'm kneeling amongst the pinecones scrutinizing a promising view. My research indicated that starting at the southern tip of the island with the incomparably situated Bonifaccio as my first photographic priority would be a good move; from there we could move north to tackle the mountains, before finishing on the coast at Calvi. That plan had evolved well before embarking on the ferry at Livorno; it seemed logical and workable based on the time available, given Mother Nature's benevolence, but I'd need to get out and about to bag some choice locations as soon as possible.

For each leg of the journey we'd need a base from which we could range across the surrounding countryside to carry out the spadework of location finding. My work months before burrowed in guidebooks, zooming in and out on Google Earth and trolling the Internet had suggested that for the mountain leg, a base near Zonza could work: from there we could access the southern mountain range around the Col de Bavella where Corsica's jagged peaks are known to be at their most dramatic. Studying the topographic map in more detail confirmed the potential. And so after

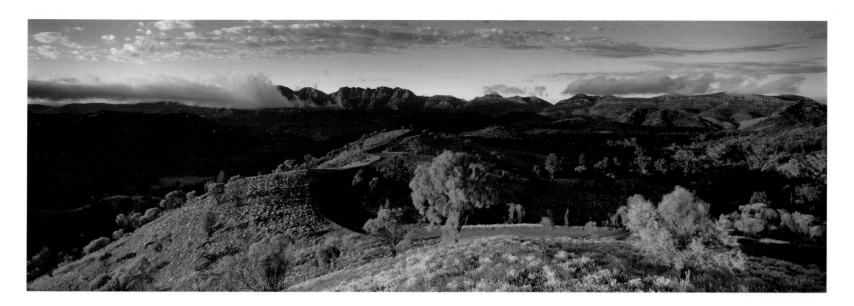

the first four-day leg, which successfully culminated in shooting Bonifaccio bathed in the soft morning light beneath a perfect rainbow, we drove up into the mountains to set up camp and start the whole cycle of location finding again.

Ultimately I could research as much as I like, but the business of scouting locations always eventually boils down to getting the boots muddy; now was the time to start eyeballing vistas and coming up with a shoot plan. It was our first time on Corsica so we had no prior experience to draw on, but the way the trip was coming together conformed to a pattern that's been repeated around the world many times over the years. It's a system of mapping out a trip that has been proven to work, and is one based around the simple fact that location finding is the hardest and usually the most time-consuming task. Pitching the tent under the jagged peaks of Bavella was the next vital step in turning the simple idea, spawned a year previously while chatting to a head waiter from Calvi in a hotel in Penrith, into reality.

I'm often asked how I know where to go. The simple fact is at first I don't have a clue. Faced with a decision to travel but a blank canvas of a plan, it is a bit daunting knowing where to start. The bigger the country the more daunting it becomes, but the business of location finding that starts by browsing the Internet a continent away and ends perched on a rock beholding a stunning vista below boils down to systematically narrowing down the bewildering array of choices available.

Consider a commitment to visit Canada, or Australia. With countries so vast the options are multitudinous, so obviously the first step is to acknowledge the simple fact that we can't do it all.

A dirt road above Bunyeroo Gorge, Flinders Ranges National Park, South Australia. I'm always incredulous of visitors from Japan or North America who try to 'do' Europe in two weeks, but then when planning a trip to Australasia it's easy for us Europeans to fall into the same trap of biting off more than we can chew. Maps of continents can be seductive, and air travel makes it possible to contemplate cherry picking the obvious attractions on a tour of departure lounges. It never works, not for me at least. Knowing where to start when piecing together a shoot Down Under is tough – Australia is just so vast – so it's a case of realizing that it is best to pick just a few objectives and to concentrate on them. What is the quintessential appeal of Oz? In my book it's the Outback. Which bit of Outback should we head for? We'd visited the Northern Territories and Red Centre so, after a pleasant evening of research, I narrowed down the choices to settle on South Australia's Flinders Ranges.

That sounds so blatantly obvious it seems hardly worth mentioning, but in fact it's at this stage of the initial planning that a fundamental mistake can so easily be made: that of biting off more than we can chew. Looking at a map, glass in hand in front of the warm fire at home, it's easy to fall into the trap of planning a whistle-stop tour of a huge swath of territory on a continental scale to take in all the acknowledged jewels in the crown. Yet such a plan usually results in tedious days on interminable drives, moving on every day, never really getting beneath the surface of a destination. Time spent on the move is a waste; the more time I can spend with my boots on, trampling about, using my eyes and finding promising locations before ending up behind the lens exposing pixels, the better. Travel less, see more; be realistic.

A trip divided into manageable blocks allows a reasonable ratio between time spent deploying the vision and time spent on the road. For us, the three day rule rarely lets us down: we'll never move on before having spent at least that amount of time investigating an area that our research indicates is photographically promising. Often we'll spend up to a week or more in one place; it always pays off and makes for a much more enjoyable travel experience. Of course time is the currency we are all short of, but it all comes back to priorities. I would far rather return with a handful of strong images from a select few destinations than clutching memory cards full of thousands of boring records of locations in less than perfect lighting. Quality over quantity, every time.

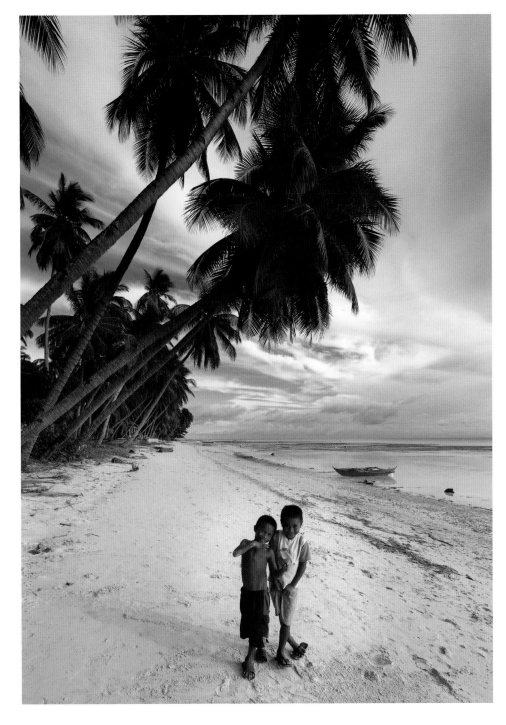

The work of location finding that can be done from the far side of the world consists of creating a framework for a shoot with clear objectives. Narrowing down options to concentrate on a few priorities with likely bases to work from is as far as it goes. Ideas for individual shots are as yet broad brushstrokes; they will only coalesce when I view the lie of the land. I take it as read that the plan existing before departure is unlikely to survive its first contact with reality. Flexibility is the key, which is why we rarely commit to pre-booked rigid travel plans. The research up to this point has enabled me to identify the areas that seem to hold the most potential to fulfil my objectives. At this point it's time to pack the bags and go.

Finally we arrive, often bleary eyed, puffy faced and bewildered from the long journey. A trap to avoid at this vulnerable stage is the unreliability of first impressions. Arriving in the harsh light of the day or under leaden grey skies, few destinations, no matter how enticing, are likely to appear at their best to a weary traveller's eyes. Beholding a destination for the first time I've felt disappointed many times, and have been tempted to push on in the hope of stumbling across somewhere more immediately enticing over the next hill – but this never works. Experience has taught me time and again the wisdom of trusting my research and granting a destination time to reveal its appeal. Five days later, when we're reluctantly moving on with the glow of satisfaction from having ticked off another objective, I wonder how my first impressions could have been so wrong.

Two boys on San Juan Beach, Siquijor, the Visayas, Philippines. Canon 1Ds Mk III, 17mm TS-E lens, 1/60 sec at f11. Location finding isn't all about shooting landscapes; it's just as important for shooting people. On Siquijor we'd based ourselves on this beach for the best part of a week. Setting up the tripod and waiting for something to happen in front of the lens is a tried and tested formula for opportune portraits in Asia. Sure enough, with my backdrop composed some local lads started larking in front of the camera and this image was the result. A tripod mounted camera with a wide-angle tilt-and-shift lens is not a normal recipe for portraiture, but time spent in one location allows the luxury of experimentation.

A woman rowing a boat on the Mekong River, near Can Tho, Vietnam. First impressions of Can Tho were not inspiring: a dreary town on the banks of the Mekong with few redeeming attractions. But we were committed to sampling the Vietnamese river life and that's what we did for several days, cruising up and down the waterways of the delta, visiting floating markets and living largely afloat. Shooting from bobbing boats is never easy, but this image of a rowing lady says it all for me. I deliberately used a slow exposure to portray movement; nothing is sharp, but who says it has to be?

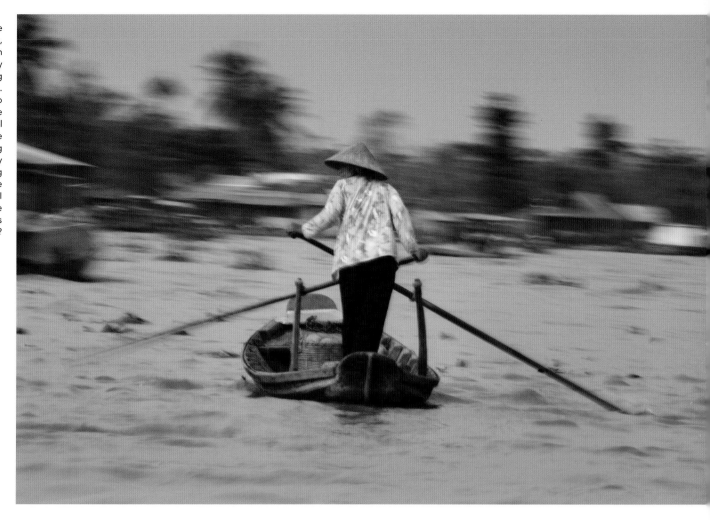

When the research has been done, the trip divided into prioritized blocks, the journey in completed and a base established, the time for eyeballing potential locations inevitably comes. There is simply no alternative to scouting out a location visually: pacing around, planning vantage points, contemplating where the light is going to come from at different times of the day and year. Once again it pays to have a plan; wandering around aimlessly wastes time, so the more the options can be narrowed down the better. Maps, Google Earth, the photos of others, guidebooks and local knowledge are all useful sources of information that will help to point us in the right direction, but these are no substitute for our own honed photographic vision. Actually having a strong well-defined idea in the first place helps enormously, as it's easier to rule out possibilities beforehand if I know exactly what I'm looking for.

Arriving at Zonza, my self-imposed brief was quite specific: a dramatic mountain landscape dropping away to the sea would say it all about the rugged Corsican interior. My research and the map seemed to confirm that the Col de Bavella was as good a place to start as any, so that's where we headed first. Having a decent map is a huge asset. In many parts of the world they are just not available, but here in France the detailed 1/25000 IGN maps are on sale in every *tabac* and *supermarche*: luxury. I've always loved pouring over maps; they can reveal so much. Of course it's virtually impossible to piece together a shoot from just maps, but using them to get a feel for the lie of the land is invaluable. In third world destinations without them I'm forced to rely on my own eyes and local knowledge, which just prolongs the process of location searching. With the map of the area around Zonza spread out on the tailgate of the Land Rover I could see the Col was a mountain pass at the intersection of a road and the famous GR 20 in between two parallel high rocky ridges. Various hiking routes radiated out from the Col; it was an obvious starting point. We'd don our boots and tramp the trails, eyeballing the landscape. Location searching is no more complex than that.

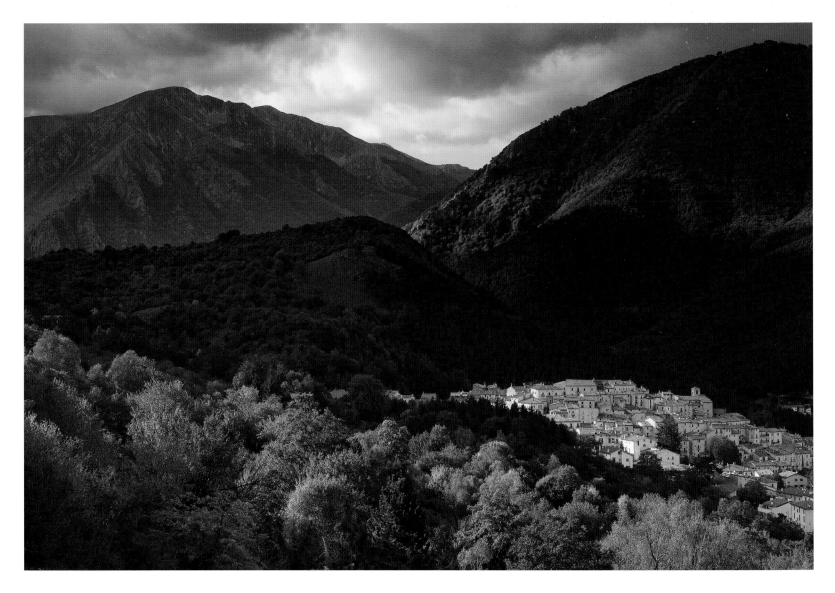

And so we found our chosen location. The process that started with considering an island some 100 miles from north to south ended by scrutinizing individual rocks and wisps of grass. As we drove up the mountain, heavy dark clouds were massed over the peaks but the potential was obvious. As soon as we arrived at the Col, I knew it was as strong a location as I could ask for. The general setting was stunningly dramatic; all I had to do was plan exactly where and when I needed to be based on my intended compositions and the angle of the light.

We ended up shooting at the Col de Bavella on three successive dawns. That location search was a textbook example of the art that went relatively smoothly, but finding a strong location on the first afternoon of searching is unfortunately a rare occurrence. Some locations are stumbled upon immediately, but often it's a task that can be frustrating and time-consuming. If after a few days I've still not found

Autumnal colours and the village of Civitella Alfedena below the mountains of Abruzzo National Park, Abruzzo, Italy. Canon 1Ds Mk II, 24–70mm lens at 70mm, 1/160 sec at f6.3. Abruzzo is one of Italy's less visited regions, and yet it comprises enticing mountain landscapes that nestle rustic villages, and the largest plates of antipasti known to man. To get to know the region we simply put our boots on and started hiking the lofty trails in Parco Nazionale d'Abruzzo. After one such day with aching knees and feet we rounded the hill to find this view. It takes time to discover such locations, which makes it all the more rewarding when it does all come together. But it sure beats days spent sat in front of the computer.

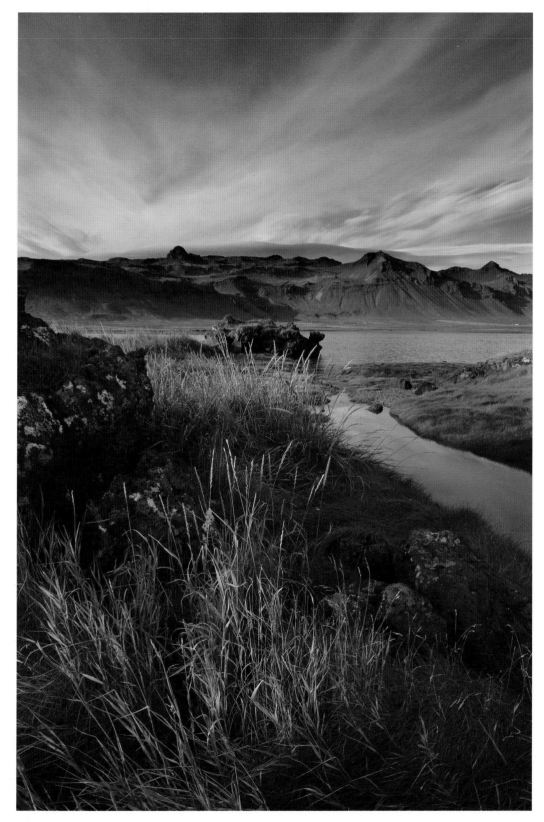

Coast at Budir, a small hamlet in the lava fields, Snaefellsness Peninsula, western Iceland. Canon 1Ds Mk III, 24mm TS-E lens, 1/20 sec at f16. On a job to illustrate a story on the Snaefellsness Peninsula for a magazine, the dynamics of the trip spent travelling with a writer were out of my hands; I had to make the most of what I encountered then and there. Moving on every day was not how I liked to work. Every evening when we arrived at our room for the night I'd have to quickly get out and find a location for the last light and following morning. Location searching is a task that can rarely be rushed. Sometimes having an outside pressure to shake me out of my comfort zone is a good thing, but I came away from the week in western Iceland feeling lucky to have had the assignment yet frustrated that I'd only touched on the promise of the evocative Nordic landscape. A return under our own steam is inevitable.

what I'm looking for the pressure really starts to mount, but it's a process that can't be rushed. Speeding around scouting by car doesn't really work; it's all too easy to glide past, oblivious to views lying just off the road.

The aim of location finding is to establish a shoot plan accounting for every available dawn and dusk session. Ideally on the first day I will find locations that I can shoot that evening and the following morning. If the location is sufficiently strong and varied it may warrant investing a few sessions at different times of the day; a strong location is such a valuable asset it always pays to really work it to extract the full potential. If there is one picture I particularly crave, I will return again and again until I'm satisfied that it is nailed. After a couple of days in situ I would hope to have finalized a full shoot plan, but until that's in place the days will comprise dawn and dusk shoots interspersed with long days of location finding. It's a relentless schedule that can become tiresome; a holiday it is not.

Of course what's crucial is recognizing the visual potential of a setting, but that's not always straightforward. Any landscape under low, flat, grey lighting looks drab; seeing how it could look lit by the first rays of the day or under a twilight sky is part of the skill, and where the feel for light which we will examine in Chapter 4 comes in.

Every time we head out on a shoot we have to have a plan. We can opt to head for the famous viewpoint to set up the tripod in line with the other photographers, or strive to produce something unique to our own vision. If it's the latter, we're going to need to get the boots on and get out searching. Location finding is a vital skill, but a task that can be as simple as choosing a lake and walking around it, analyzing what we see and deciding where to stand and when. The direction of the light, the likelihood of mist or reflections, and the intended composition will all play a part in the decision making process. At its best this is a quiet, contemplative and rewarding excuse for a walk. It is never time wasted. Just recently during a hike on the Welsh border we stumbled across two promising locations looking down on the Dee Valley. I'm already planning to return in the autumn; that Sunday walk with friends netted two precious locations. Valuable assets such as these, products of our vision duly logged for future shoots, are the difference between perceptive original images and stereotypical photocopies.

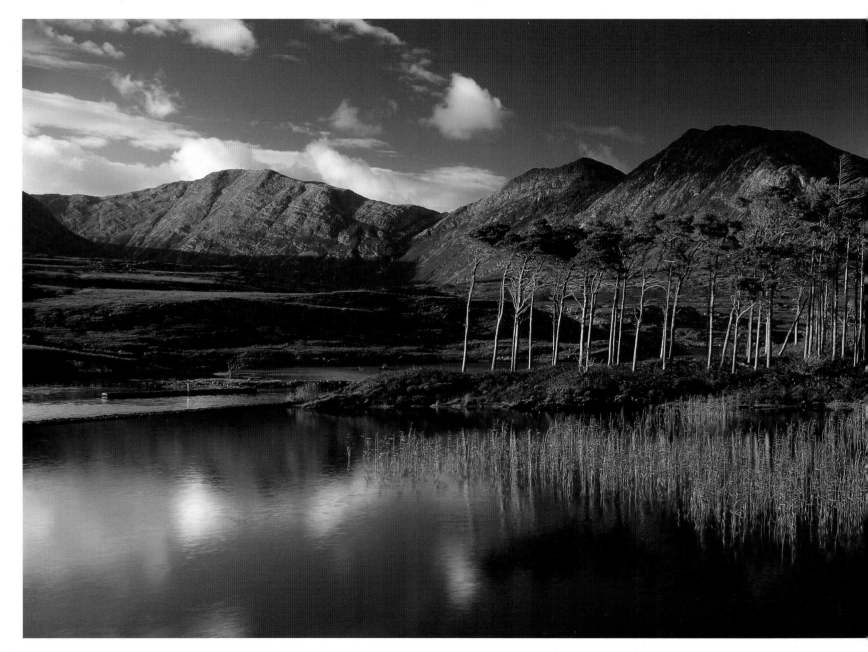

Pine Island, Connemara, County Galway, Ireland. When I have found a strong location I'm like a dog with a bone: I won't move on until I've fed on the visual potential. In Ireland the fickle weather often means days of waiting, if not weeks, but for me it seems the only way to work. After all, given that location finding is the hardest part, why move on to have to start the whole process again with nothing to show for it?

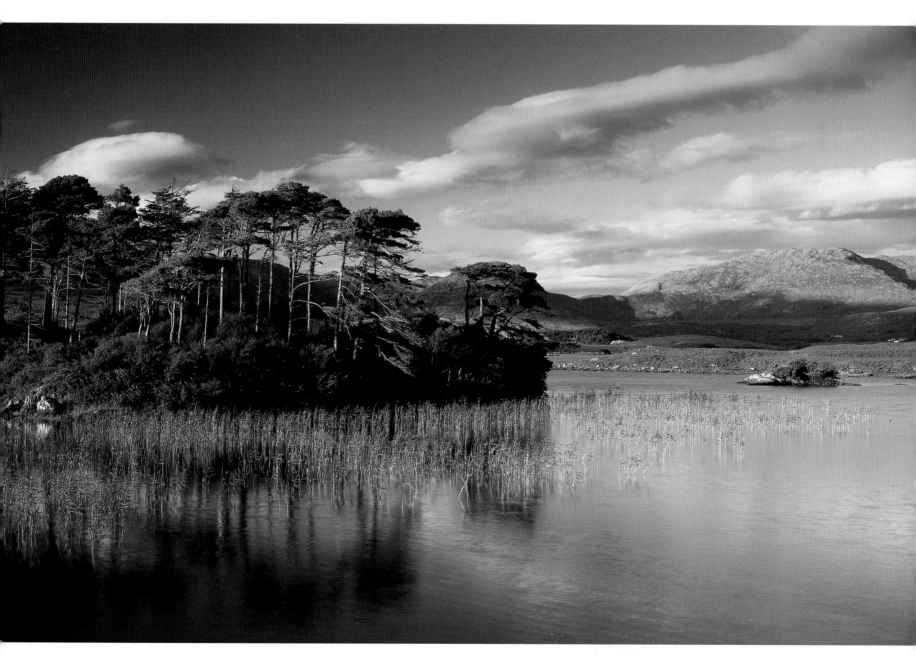

PHOTO ESSAY: TOUR DE FRANCE

The attraction of loading up and heading south never wains; there's a beautiful simplicity to such trips. There are times when I feel distinctly guilty for wandering through France so often – it just seems too easy – but looking at these images now, I just want to go again.

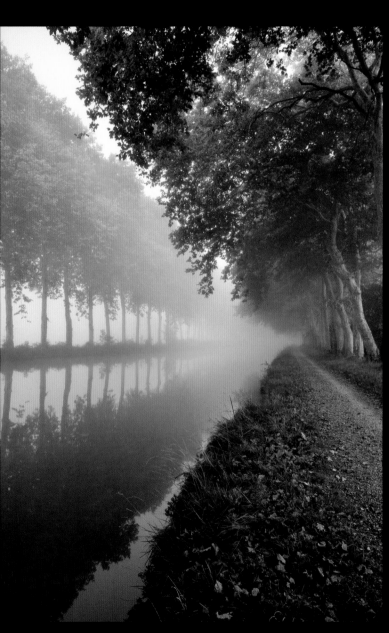

Collonges-la-Rouge in the mist, Corrèze, Limousin. Canon 1Ds Mk III, 70–200mm lens at 200mm, 1/15 sec at f16.

The Canal du Midi near Castelnaudary, Aude, Languedoc-Rousillon. Canon 1Ds Mk III, 24–70mm lens at 24mm, 1/5 sec at f11.

A doorway in Ségur-le-Château, Corrèze, Limousin, Canon 5D Mk II, 24–32mm lens at 70mm, 1/200 sec at f8.

The village of Olargues with the twelfth century
bridge over the River Jaur, Haut-Languedoc,
Languedoc-Roussillon. Canon 1Ds Mk II, 24–70mm
lens at 28mm, 1/5 sec at f8.

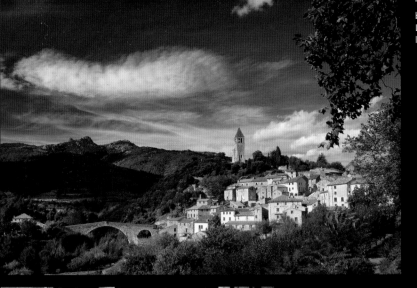

Poterie Not Frères in Mas-Saintes-Puelles, Aude, Languedoc-Rousillon.
Canon 1Ds Mk III, 24–70mm lens at 24mm, 1/80 sec at f5, ISO 1600.

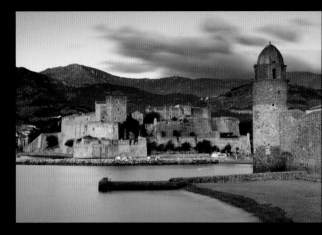

Collioure at dawn, Pyrénées-Orientales, Languedoc-Rousillon. Canon
1Ds Mk III, 24–70mm lens at 63mm, 8 sec at f16, 0.6 ND grad and
0.9 ND filters.

The village of Vissec in the Gorge de la Vis, Gard,
Languedoc-Roussillon. Canon 1Ds Mk II, 70–200mm
lens at 180mm, 1/15 sec at f11.

A window in Saint-Félix-Lauragais, Haute-Garonne,
Midi-Pyrénées. Canon 1Ds Mk III, 70–200mm lens at
105mm, 1/100 sec at f7.1.

Montagne Sainte
Victoire at dawn,
Var, Provence.
Canon 5D Mk III,
70–200mm lens
at 75mm, 0.3 sec
at f11.

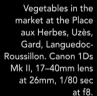

Vegetables in the
market at the Place
aux Herbes, Uzès,
Gard, Languedoc-
Roussillon. Canon 1Ds
Mk II, 17–40mm lens
at 26mm, 1/80 sec
at f8.

A field of
sunflowers blowing
in the wind near
Castelnaudary,
Aude, Languedoc-
Roussillon. Canon
5D Mk II, 24–70mm
lens at 27mm, 2.5
sec at f16.

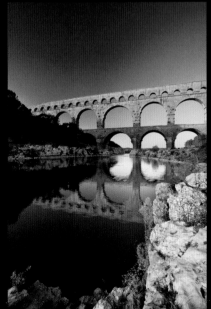

Pont du Gard, Gard,
Languedoc-Roussillon.
Canon 1Ds Mk II,
17–40mm lens at 22mm,
0.5 sec at f16.

A vineyard near
Puyloubier with
the Massif de la
Sainte-Baume
at dusk, Var,
Provence.
Canon 5D Mk III,
24–70mm lens
at 51mm, 0.6 sec

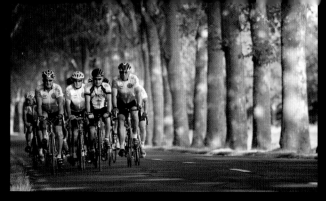

Cyclists riding along an avenue of trees near Revel, Haute-Garonne, Midi-Pyrénées. Canon 1Ds Mk III, 100–400mm lens at 400mm, 1/400 sec at f5.6, ISO 400.

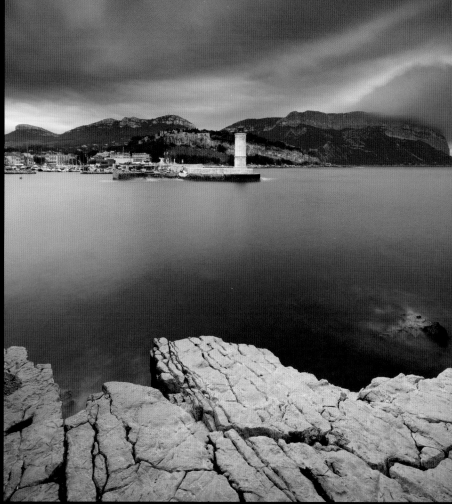

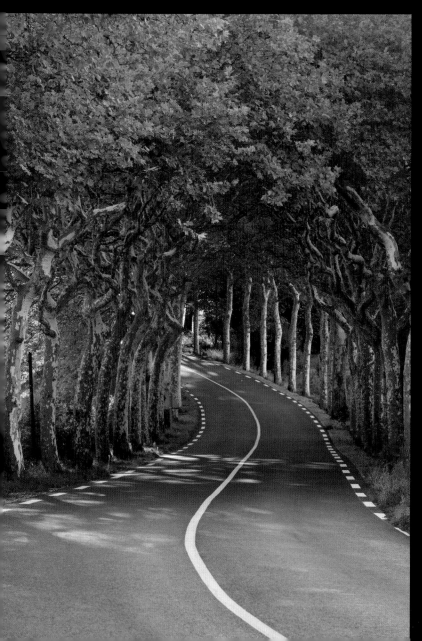

Cassis at dusk, Bouches-du-Rhône, Côte d'Azur, Provence. Canon 5D Mk III, 24mm TS-E lens, two frames merged to make a square image, 4 mins at f16, Big Stopper filter.

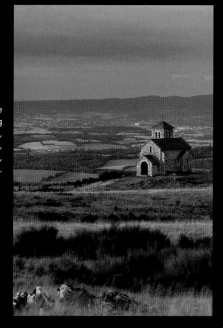

Chapelle de Saint-Ferrèol in the Montagne Noire with the rolling Lauragais countryside beyond, Tarn, Midi-Pyrénées. Canon 1Ds Mk III, 70–200mm lens at 160mm, 3.2 sec at f22.

Avenue of plain trees on a road near Sorèze, Tarn, Languedoc-Roussillon. Canon 5D Mk III, 70–200mm lens at 200mm, 0.3 sec at f16.

The Composition

The Idea was appealing in its simplicity: to shoot England's most southerly rocky headland, Lizard Point. I'd scouted the Location thoroughly the day before; now was the time to really start piecing together the fine detail of the image by finalizing the Composition. The opportunity of turning a good idea into reality at a stunning location bathed in crisp, late autumn light now hinges on how I will arrange all the elements within my frame.

The art of composition can and does make or break a picture; it's a fundamental skill, and the most difficult of all photographic disciplines to learn. I believe it's a skill that is inherently intuitive: when I'm framing up an arrangement most of the key decisions are made subconsciously, and I just do what looks right in the eyepiece. But that doesn't mean we've either got it or we haven't; a thoughtful, analytical approach to composition always pays off. I've noticed recently I'm thinking much more about what I used to do instinctively, and that process of deconstructing the art of composition is paying real dividends. In essence, what I'm now doing before I start kneeling in the mud squinting through the eyepiece is running through a mental compositional checklist. It seems to work.

Most point and shoot snappers, squinting at a camera screen held one-handed at arm's length, expose dreadful compositions in completely the wrong light with acres of dead space and a distant point of interest slap bang in the middle of the frame. Consider for example Aunty Mary with a skip as a backdrop, an empty car park as foreground, positioned beneath a burnt out sky with an aerial protruding from her head. When seeing something deemed worth shooting, most follow the initial impulse to simply raise the camera, point and shoot before moving on, but for us it's just the start of a lengthy process that could see us engrossed for hours, much to the exasperation of our world-weary companions. A novice faced with a juicy photo opportunity will usually expose a few frames before strolling on; a seasoned pro will remain at the location for the rest of the day and maybe the next, flogging it to death. Why? Not because he or she is incapable of nailing the shot quickly, but because most shoots involve really working the location and steadily honing in on the best composition and that, as the late afternoon light paints the Lizard, is exactly what I'm doing.

Lizard Point, the most southerly point in Britain, Cornwall, England. Canon 1Ds Mk III, 24mm TS-E lens, 0.8 sec at f16, 0.6 ND grad and 0.9 ND filters. This composition was pieced together intricately considering how all the elements of foreground, middle ground and background related to each other, and using the dominant lines to take the viewer's eyes on a zigzagging journey through the frame.

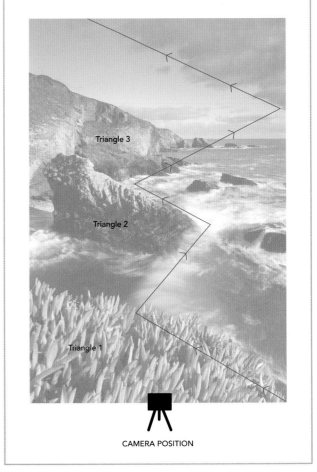

Composition is all about using shapes and lines to move the viewer's eye around the frame.

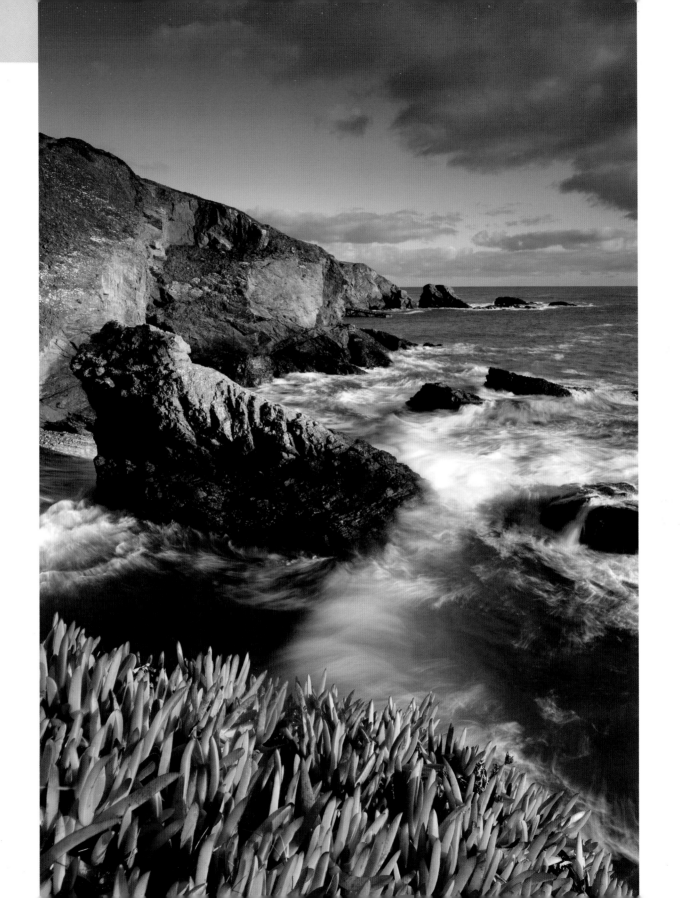

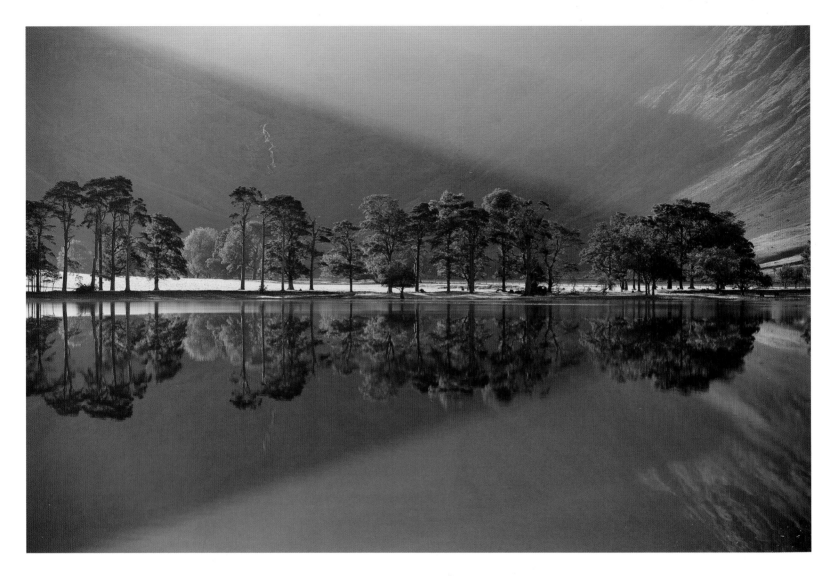

What drew me initially to this spot was the green 'jobbies' tinged with red on the headland that provide tantalizing foreground interest, the rugged rocks being battered by the churning sea in the middle distance, with Lizard Point beyond. The knowledge that this is no ordinary headland – the likes of which are ten a penny around the beautifully rugged Cornish coast – just adds to the appeal of the location. Indeed it was from here on 29 July 1588 that the Spanish Armada was first spotted. The news of the threat of imminent invasion failed to interrupt Drake's game of bowls on Plymouth Hoe, but did cause

the lighting of warning beacons on hilltops around the country and the mobilization of England's fledgling navy. The subsequent decimation of the Armada changed the Renaissance world's balance of power; cemented Elizabeth I's reign and kick-started a process that would see, three centuries later, the Royal Navy dominating the Seven Seas. The British Empire was spawned here on the Lizard, with the result that this evening we will without a doubt be able to score a curry in Helston. There you are: Drake brought chicken tikka masala to England – it's something he's rarely credited with.

Reflections on the shore at dawn, Buttermere, Lake District, Cumbria, England. Canon 1Ds Mk II, 70–200mm lens at 105mm, 1/100 sec at f4. Symmetry and harmony seem to go hand in hand with reflections. Sometimes when I'm out in places such as this I feel I'm shooting the light as much as the location; it becomes the subject. Although the mirror-like reflections of the trees are what the picture is all about, the diagonal shaft of light adds the real compositional impact. Harmony is not always desirable – deliberately unsettling the viewer can be effective – but when all is said and done I for one can't resist such scenes of natural tranquillity. Experiencing such moments of harmony at one with my surroundings is what landscape photography has always been about. It is scenes like this that make heading out with tripod on the shoulder before the crack of dawn a pleasure.

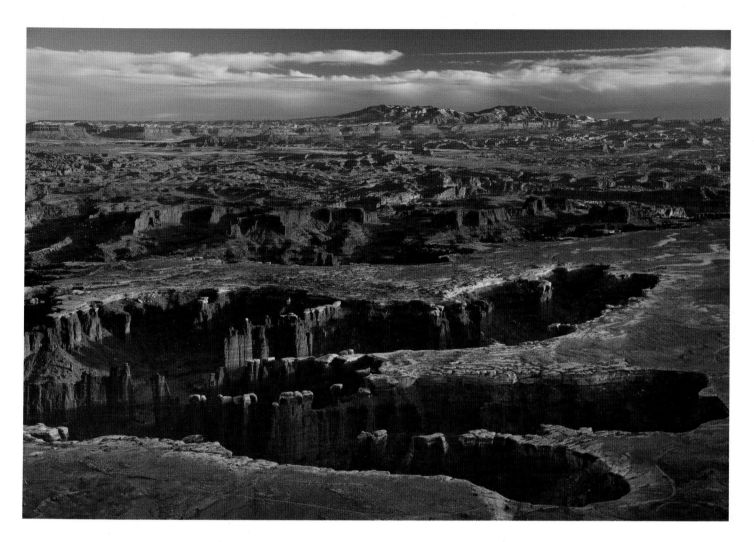

Canyonlands from the Island in the Sky, Canyonlands National Park, Utah, USA. Canon 5D Mk III, 24–70mm lens at 50mm, 1/15 sec at f8, polarizing filter. With landscapes as epic as these in Utah, it's tempting to try to fit it all in, but a wide-angle perspective often just results in an image populated with dead space and a whole lot of unimpressive distant objects. The balanced perspective of a standard lens takes some beating. I tend to make decisions about perspective and composition before I've opened the camera bag.

Now, as the light is steadily improving, I move on from pondering the course of history and start working through my compositional checklist, well before the camera is even out of the bag. My first consideration is perspective: what relationship do I want between near and distant features? Going wide to fit it all in will emphasize the foreground at the expense of the background; going narrow with a long lens will preclude the coloured 'jobbies' clinging to the cliff top that I'm trying not to tread on. In this case I really want to use them as a bold feature up close to the front element in the bottom of the frame, so a 24mm wide-angle tilt-and-shift lens for optimum depth of field is the way to go.

With the perspective considered and lens choice duly made, I finally get the camera set up on the tripod and start squinting through the eyepiece. The next item to consider is the frame. The art of composition is dominated by the consideration of the impact of dominant shapes and lines within the image area, and the most fundamentally significant shape to consider is the frame itself. The margins of the frame don't just constrain the composition, they define it; and the lines of the edges need to integrate with the elements within to make the strongest possible composition. Although I'm constrained to a degree by the dimensions of the camera's format I do have options: I could if desired make a panorama using image stitching, or crop to make a squarer image, but in this case I'm sticking with my favoured 2x3 aspect ratio, today tilted vertically. Already I'm looking at the scene with the strong shapes and diagonals of the rocks and headland, picturing how they will relate to the dynamics of the frame.

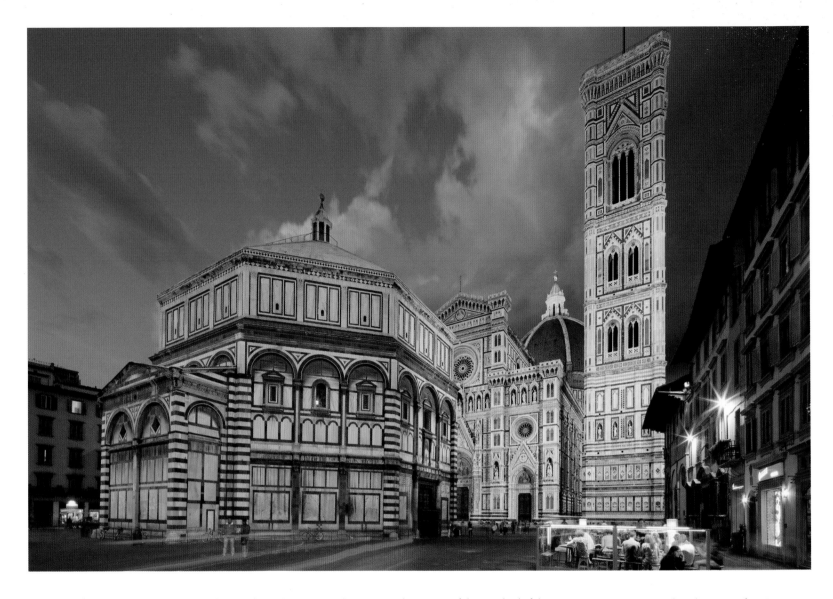

Next it's time to apply the most failsafe rule of thumb there is in the art of photography, and life in general for that matter: keep it simple. Countless potentially strong compositions are ruined by the oversight of leaving some random detail incurring within the frame, distracting the viewer's attention. Photography is the art of knowing what to leave out. I sweep my eye from corner to corner of the frame; is there anything in that doesn't deserve to be there? Composition is all about making simple, bold, uncluttered arrangements of shapes within the frame. Sounds easy, doesn't it?

At the moment I have most of the top third of the frame occupied by an expanse of boring blue sky. Dead area is to be avoided, although sometimes emptiness can be used to convey a sense of space. I could opt for a panoramic view to show the expanse of open sea to the south, but I've decided to follow my gut instincts and go for a tight arrangement of interlocking diagonals. At the moment that empty space at the top is bringing nothing to the party, but over my shoulder, off to the south-west from where the wind and weather emanate, some 'fluffies' are forming; I can but live in hope.

The Duomo, Campanile and Baptistery from Piazza del Duomo, Florence, Tuscany, Italy. Canon 5D Mk III, 17mm TS-E lens, 10 sec at f16. With a precise architectural image such as this, the way in which the strong lines of the composition relate to the frame is crucial. One reason I like the 2x3 aspect ratio of a full frame DSLR is that the shape harmonizes so well with the rule of thirds: each subdivided section has the same aspect ratio of the whole. The use of a shift lens enabled me to keep all the verticals perpendicular, the strongest of which I placed along the right hand third. The diagonals of the cloud coming in at top left and the car streaks at bottom left provide subliminal lead-in lines. The art of composition is often all about shepherding the viewer's eye around the frame using lines, curves and shapes.

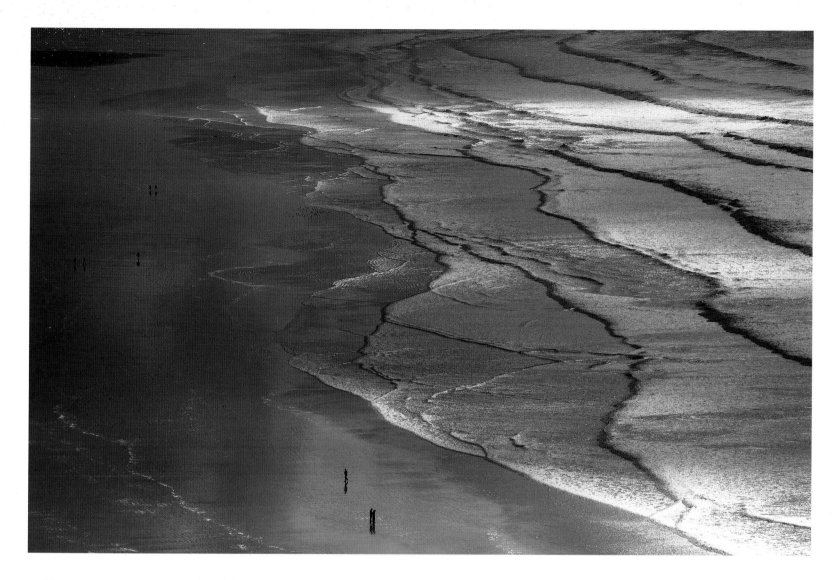

The composition is coming together; all these considerations so far are gradually honing in on a viable arrangement as I constantly ask myself 'how can I make it better?' There is no denying that nine times out of ten it pays to consider the tried and tested compositional edict handed down through the centuries: the Rule of Thirds. We know that our friend shooting his Aunt Mary in the car park could make a better picture by offsetting his relative from the centre to the left hand vertically intersecting third, positioning the horizon along the top horizontal third, with the double yellow lines along the bottom third, and the skip on the bottom right intersection of thirds.

As a compositional default setting, the Rule of Thirds takes some beating. I do occasionally ignore the Rule of Thirds at will, and sometimes I deliberately flout it, but it always pays to at least consider its wisdom – it simply works. Here shooting the Lizard I've no dominant vertical lines to consider, but the horizon of the flat sea is prominent. It just looks best laid along that top horizontal third – it's the natural place for it to be – whilst the lower third of the frame is occupied by my foreground. The Rule of Thirds is not a significant factor in this particular composition, but its influence is there in my thinking; it usually is.

Figures on the beach, Inch Strand, Dingle Peninsula, County Kerry, Ireland. Canon 1Ds Mk II, 70–200mm lens at 200mm, 1/800 sec at f9. There are just two elements to this picture that make it work; the pattern of the waves and the tiny figures on the beach. Of course the appeal of the light glistening off the water and the wet sand adds to the appeal, but the composition relies totally on the simplicity; one distracting detail would rob the image of all impact. Long lenses are a powerful tool for isolating detail from the clutter of the surrounding world. I always sweep my eye from corner to corner of the frame and ask myself if there's anything in the frame that doesn't deserve to be there.

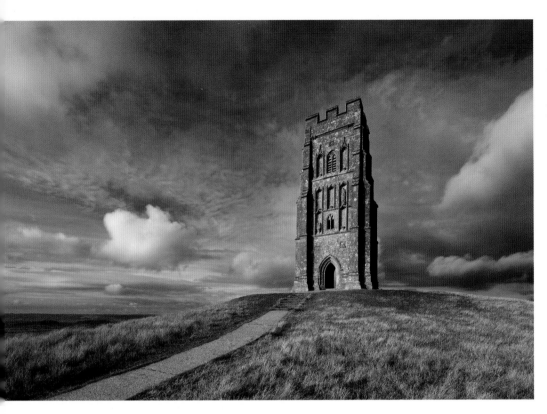

Glastonbury Tor, Somerset, England. Canon 1Ds Mk III, 17mm TS-E, 1/125 sec at f11. I have no doubt in my mind that most compositions benefit from at least some adherence to the Rule of Thirds. This image was destined from conception to be reproduced square as a Royal Mail stamp, but behind the lens I found it virtually impossible to ignore the dynamics of the 2x3 frame and the tempting pull of placing the tower on the right hand third with the landscape occupying the lower third. Because this image needed to work reproduced smaller than even the size of the glowing monitor on my camera back, I had to keep the composition as simple as possible with no clutter anywhere in the frame. The path leading in from the bottom left corner provides a strong diagonal, as do the lines of clouds coming in from the top right and the left, all leading towards the key element: the tower. This being a location relatively close to home, I was able to revisit the location repeatedly until gorgeous evening sidelighting combined with a dramatic sky. Then my only problem was the dog walkers who kept strolling into frame just as the sun briefly came out. Pleads and protestations brought me just a few seconds of opportunity.

Next I need to really analyze the impact that the strong shapes and lines of the coast and rocks are having on the composition. Tiny adjustments of framing have a big impact on how they all do or don't integrate. Three triangles dominate: the foreground, the large rock below, and the headland beyond. Diagonals leading a viewer's eye around the frame are always potent compositional weapons to deploy; even better is when offset diagonals take the viewer on a zigzag journey around the picture. As I kneel watching the waves break below I'm struck by how the line of the waves at one particular moment, just before they crash on the rocks, forms a diagonal offsetting the sloping line of my foreground. This in turn leads to the line of the rock leading diagonally up to the headland, which then zigzags back across the frame towards the most southerly point in England. I require a perfect wave to complete the zigzag; are you on call today, Mother Nature? I'll also need to use a shutter speed just slow enough to convey a touch of wave motion, without reducing the surface of the sea into a milky blur.

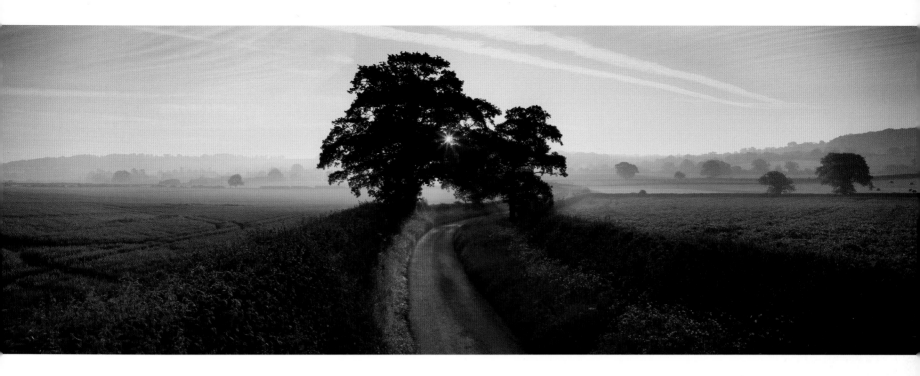

I'm getting the buzz now; the shot's really coming together with a lovely balance and harmony to the composition. I'm still not happy with the empty sky, but that's out of my control; I can only do my bit and hope Mother Nature obliges. Wendy is off focusing on some detail of the verdant plants that cling to the cliffs as I sit, watch and contemplate harmony. How can I possibly define what makes for a harmonious composition? I am struggling. I could proclaim loftily that prominent shapes should be placed in opposing areas of the image to balance their dominance, but I'm wary of such set rules – it's rarely as cut and dried. That isn't applicable here and now: all my dominant shapes are orientated on the left of the frame, but I'm not worried. Intuitively I feel this is a harmonious composition despite the imbalance from left to right. Of course there's nothing to say that all compositions need harmony; sometimes deliberate disharmony can be startlingly effective, but not now for this seascape.

The harmony of the yet to be exposed image is further enhanced by the colour content, which brings me on to the next item on my checklist. I'll be looking much more deeply into the use of colour in Chapter 6, but for now I'm happy to be aware that the two predominant colours in front of me – blue and green – are analogous, which means they reside alongside each other on the colour wheel; analogous colours are generally recognized to invoke harmony. There are tinges of red in the foreground, so when all is said and done I have a bright, colourful image with all three primary colours present and correct, yet all retain a harmonious relationship. Really it couldn't get much better.

Dawn on the longest day, Purse Caundle, Dorset, England. A country lane provides a strong lead in to this image; hopefully viewers imagine themselves strolling into the scene towards the rising sun. I deliberately positioned the road centrally in the frame; why I can't tell you, I just felt it worked. Ultimately composition is all about gut feelings. This picture was meticulously conceived, location searched and planned; the S of the long and winding road, and the position of the trees to mask the rising sun, are critical. A high viewpoint was also necessary to reach above the height of the hedgerows that burst into life in early summer; the roof platform on my Land Rover proved handy again. Looking at this picture now in the depths of winter makes me long for summer in England's green and pleasant land. It was shot at daybreak on the summer solstice at around 5am; I was back home for breakfast, done and dusted before the world stirred from slumber.

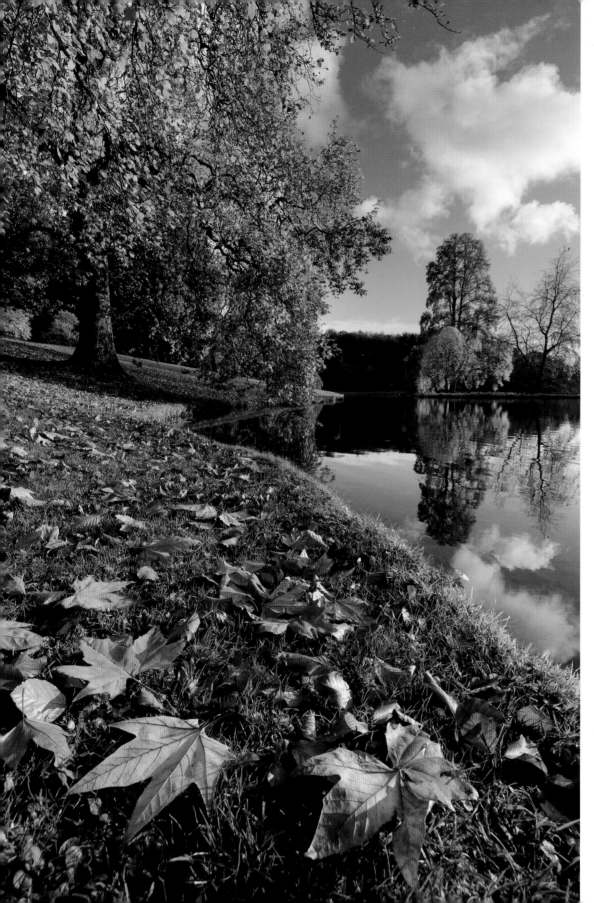

Moving down nearly to the end of my checklist I come to patterns. Most successful compositions are patterns in their own right, but incorporating nature's own artful patterns into the frame is usually a no-brainer. In fact, such patterns often become the sole subject matter occupying the entire frame; many photographers concentrate on little else with good reason. For me here in Cornwall the initial pull of this particular viewpoint was the option of incorporating the repetition of pattern provided by the green 'jobbies' in my foreground. They lift the whole composition. Without them I'd have a pleasant seascape, with them I have depth, impact and graphic interest.

Autumn colours at Stourhead, Wiltshire, England. Canon 5D Mk III, 17mm TS-E lens, 1/40 sec at f14. Whilst minimal depth of field is a nifty technique for isolating subjects, a classic landscape image requires pin sharp detail from foreground to background. Here, if the leaves in the foreground or the trees in the distance were slightly less than sharp, the picture would look awful and be immediately banished to the recycling bin. I went to considerable effort to record ultimate depth of field by using a tilt-and-shift lens; consequently this picture has great depth. The bank of the lake is a strong diagonal, and the low viewpoint accentuates the bold patterns of the leaves in the foreground. We tend to start framing pictures from head height by default, but by getting low, or high, all sorts of tantalizing options for bold compositions open up.

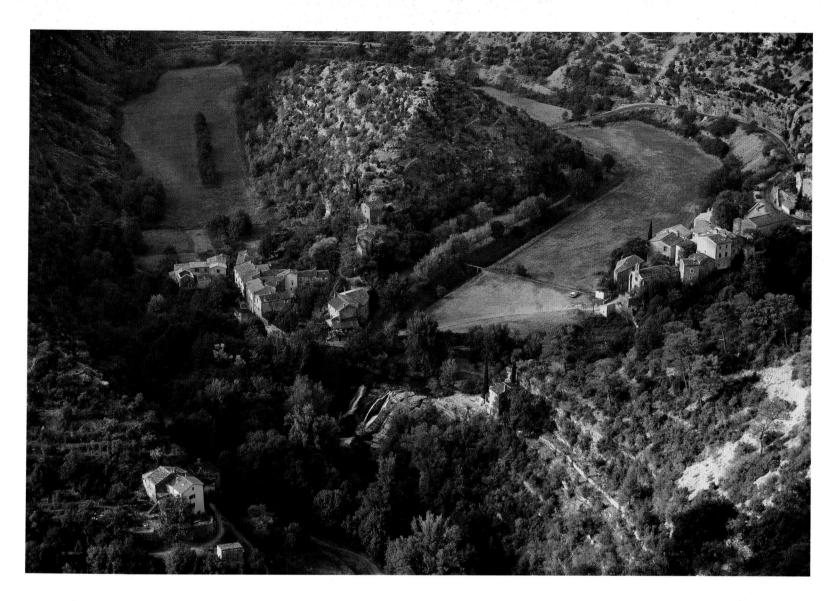

It would be a mistake to conclude that this game of composition was all about cramming in as many of the above concepts as possible; simplicity is always the first and foremost consideration. For example also on my checklist is the use of internal frames. Windows within the frame through which the viewer looks to behold the main subject are often highly effective, but it's a technique clearly not relevant on this cliff. Neither is the use of another effect on my checklist that really sets us apart from our artist forbearers who have influenced so much of

our thinking on composition: differential focus.

I think by now it's becoming apparent that the art of composition can be defined as the ability of the artist to railroad the viewers' attention around the canvas on a circuitous, zigzagging route that eventually ends up at the main object of interest. That journey around the image area is often more important than the final destination, and this is certainly the case with my Lizard composition: Lizard Point itself is clearly the subject, but it has a low-key presence in the frame. However where we do have one

Hamlet of Navacelles in the Cirque de Navacelles, Cevenne, Languedoc-Roussillon, France. Canon 1Ds Mk II, 70–200mm lens at 100mm, 1/60 sec at f8. Shapes and patterns in the landscape are revealed by shooting from a high viewpoint, in this case from the top of the gorge.

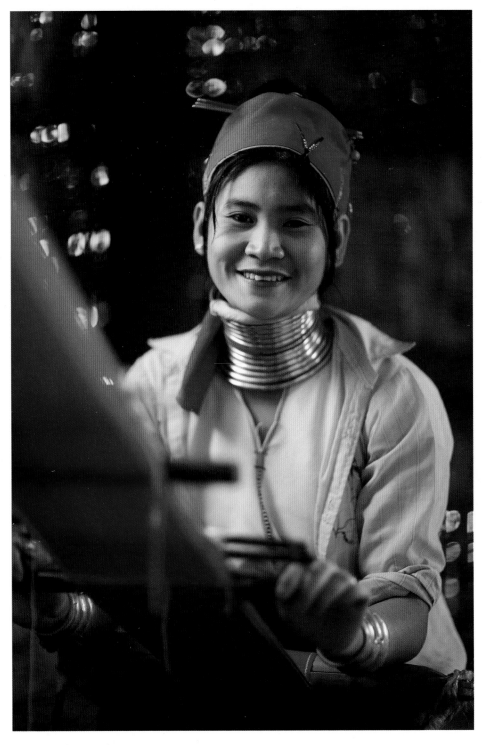

feature that is the crux of the matter, the ability we photographers have to concentrate attention on it with the creative use of selective focus is an effect unique to us, and a highly effective one.

It's not a stratagem relevant today though; I need to devote considerable attention to achieving the exact opposite effect. I need pin sharp rendition of detail from the nearest 'jobby' just centimetres from my lens through to the furthest most clouds that are now thankfully starting to drift into view. The classic landscape use of focus is crucial for this image; near or distant detail that isn't quite as sharp as it should be would look truly dreadful, resulting in the offending image being banished immediately to the recycling bin followed by weeks of bitter remorse. The need for ultimate front to back sharpness for this shot has influenced my lens choice: I'm using a 24mm tilt-and-shift optic with which I can achieve almost infinite depth of field. As soon as I saw these green 'jobbies', I knew this was the way to go.

I'm now ready and waiting for the perfect wave. I'm still considering the composition though; could it be better if I moved up, or down? Ultimately there comes a time when I need to make a decision and stick with it, and that time is now; I'm happy with the composition, further tinkering will achieve little and possibly result in me missing the Decisive Moment. The final element in the composition has been provided by Mother Nature; a bank of cloud has drifted into the top right corner of my frame as if to order. As the moist air approaches the coast after its long transatlantic journey, a distinct line of cloud is forming. That bank of cloud is now providing me with another diagonal in the previously empty top right corner. Now is my moment and here comes a likely wave, the last piece in the jigsaw. Finally, after much meticulous thought and effort to hone and fine-tune the vision, I press the button. It's the easiest part, by far.

A Padaung 'long neck' lady, Inle Lake, Myanmar (Burma). Canon 1Dx, 85mm lens, 1/320 sec at f1.2. Differential focus is a handy compositional tool for separating a subject from the foreground and background. Shooting with a fast glass such as the 85mm lens wide open at f1.2, the depth of field is tiny – focusing on the eyes is critical – but the bokeh background becomes not a distraction but of significant visual appeal.

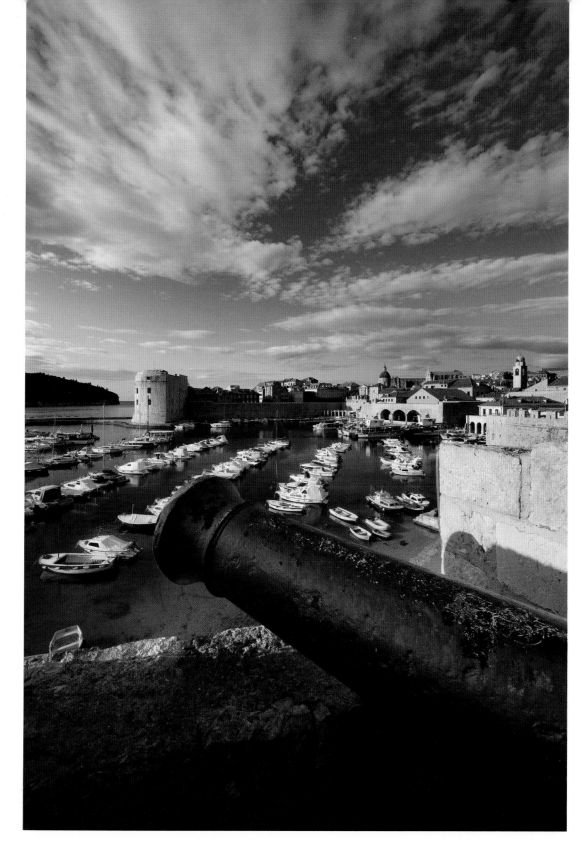

Old Town and harbour, Dubrovnik, Dalmatia, Croatia. Canon 1Ds Mk III, 14mm lens, 1/80 sec at f14. The strong diagonal line of the cannon leading the eye into the frame is obvious; the shape is bold and it also provides context. As a result it creates a much stronger picture than it would have been with only the harbour beyond. The diagonal of the boats below then takes the eye zigzagging through the frame towards the Old Town. Normally I would veer away from having the sky occupy the top half of the frame, but an extreme wide-angle lens and the rigid architectural lines dictated that the sensor plane had to be perpendicular. Luckily the sky was full of fluffy interest.

So what do I do while David is spending hours waiting for the light? This is the question I am asked time and time again on my blog, during workshops and when staging our road shows. In our early days together I just waited and watched with a book, extra layers, a foam mat and a flask of coffee. However, an Open University textile course changed my world by making me look anew at colour, shape and texture; I started to see things that I swear were not there before!

And somewhere along the line I started to experiment with using my camera, a Canon G11, in a way that it was not necessarily designed for. I positioned it in all sorts of angles, using slow exposures to create the appearance of movement and to streak the colours. Indeed this is how I shot the trees in Canada and likewise the sunflowers in Provence; I must say that the latter is one of my favourite images even if, according to the rules of composition, it is totally wrong!

The other sights I always find alluring are scenes within something else; for example, when I perceived a landscape while looking through a block of sheet ice that lay on the edge of a Scottish river. I played with this for an hour while David was shooting the grandeur of the landscape. It was like stepping into a mystical ice landscape and by changing my position and framing, different aspects developed within the scene.

One of the most incredible sights I ever saw was in the Umbrian countryside where David was shooting a field of poppies before dawn. I started following butterflies; the more I kept still and looked – really looked – the more the busy cacophony of the insect world was revealed. On more than one occasion I saw a bee asleep, curled around the corolla of a flower. The next day the farmer had reduced the verdant field to brown dirt. David was disappointed that another landscape opportunity had gone; I was devastated that all the beetles, butterflies and bees that I had seen the day before were now homeless.

Perhaps my message is that even when a shot (in my case a snap) does not come together, there is so much to see and enjoy. The difference between my photography and David's is that his expertise and skill makes for consistency, while mine conjures up a lucky strike when by accident it works. Yet the memory of the moment makes me a happy soul. Enjoy your photography.

It's clear from these pictures that Wendy has a strong eye for shape, colour, texture and detail in the natural world; further evidence if any were needed that this game of photography is all about the vision. The equipment is but a tool, and even with a humble compact camera, great pictures can be made

Flamingos on Lago Colorado, Bolivia. Canon 5D Mk II, 100–400mm lens at 285mm, 1/800 sec

Butterfly in a poppy field near Norcia, Umbria, Italy. Canon Powershot G11, focal length 30.5mm, 1/250 sec at f4.5, ISO 80.

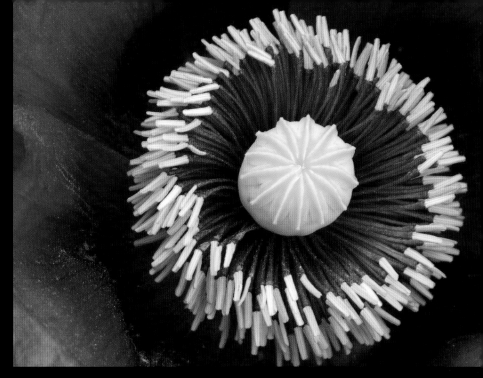

Purple poppy in a garden, Dorset, England. Canon Powershot G11, focal length 30.5mm, 1/160 sec at f4.5, ISO 250.

Lotus flower with bee, Ao Nang, Thailand. Canon Powershot G9, focal length 44.4mm, 1/250 sec at f4.8, ISO 200.

Aspen trees near Lake Patricia, Jasper National Park, Canada. Canon Powershot G9, focal length 29.2mm, 1/15 sec at f8, ISO 80.

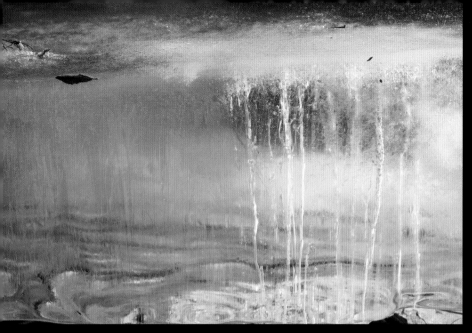

ight reflecting through sheet ice, Isle of Skye, Scotland. Canon Powershot G11,
ocal length 30.5mm, 1/160 sec at f4.5, ISO 80.

Reflection looking up from the bow of SS, Bristol, England. Canon
Powershot G9, focal length 29.2mm, 1/500 sec at f4, ISO 80.

Sunflowers blowing in the wind near Revel, Languedoc, France.
Canon Powershot G9, focal length 39mm, 1/8 sec at f8.

Great egret in flight, Mekong Delta, Vietnam. Canon Powershot G11, focal length 30.5mm, 1/6 sec at f7.1, ISO 80.

Lizard holding a leaf, Ao Nang, Thailand. Canon Powershot G9, focal length 44.4mm, 1/125 sec at f4.8, ISO 200.

Spider with web on Negros, the Visayas, Philippines. Canon Powershot G11, focal length 30.5mm, 1/160 sec at f4.5, ISO 400.

ALL PHOTOGRAPHS: WENDY NOTON

The Light

My old college lecturer from back in the Jurassic Era used to assert that a good photographer could make even a lump of coal look appealing with the skilful use of lighting. I never felt the need to prove his point – I can think of more appealing subjects – but my subsequent wandering decades behind the lens since his sermons have convinced me he was right. Even the Grand Canyon can look uninspiring under the flat grey light of an overcast day, whilst a view of a few flat fields in Essex can be transformed into a breath-taking vision by a trace of mist and the evocative light of dawn. We photographers are obsessed with light; we can and do bore our loved ones rigid by droning on about it ad infinitum. Light is our raw material, the building block that makes or breaks our pictures. Photographing a subject in the wrong light is a pointless waste of time that robs even the most stunning location of all impact. In fact, so important is lighting to the finished image that I often feel I'm photographing the light more than the actual subject.

So clearly we photographers need to see the light; and I mean really see it, feel it, analyze and understand it. The very first thing I do when contemplating a scene is to consider where the light is coming from; it's become an unconscious ingrained habit that never lapses. Yet beyond seeing what's happening now, we also need to predict what could happen at different times of the day and year, and to do that we must strive to understand the nature of light in all its endless forms and subtleties.

Building up an eye and innate feel for natural light is a fundamental photographic skill that doesn't come easily, or quickly. That vision comes only with experience, and is the product of each and every photographic vigil – productive or otherwise. Standing by the tripod watching the light paint a landscape is never a waste of time, even when things don't quite come together photographically. These are the experiences that slowly but steadily build the visual database that underpins our use of light. Anticipating what could happen with the light in a few minutes, an hour, later the same day, the next morning, in a few months or next year is what this game is all about. We've formed an idea, found the location and settled on the composition; now predicting the light that will best illuminate the picture we have in mind is the next step.

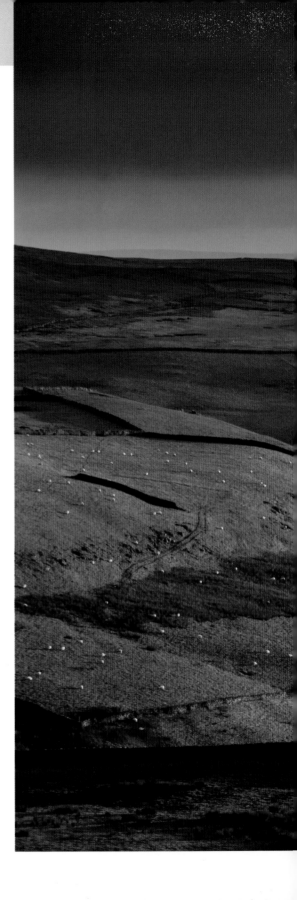

Evening light on stone walls and farms of Wharfedale, near Kettlewell, Yorkshire Dales National Park, England. Canon 1Ds Mk III, 70–200mm lens at 85mm, 0.3 sec at f5.6, ISO 100, polarizing filter. The last direct sunlight of an autumn afternoon glows on the upper slopes of the dale. The sidelighting was soft and golden from the south-west, revealing every detail of the landscape whilst emphasizing the lines of the stone walls. The dappled light and shadow also added drama and mood. It had been raining just minutes before and was raining again minutes later, but between the showers the quality of the light was what we photographers live for. If only we could bottle it.

Ta Prohm Temple, Angkor, Cambodia. After several days spent exploring Angkor it has to be admitted that I was a touch 'templed out'. I was questioning just how many more crumbling temples in the jungle I could do, but Ta Prohm, with the roots of the trees gradually reclaiming the temporary incursion of man, had a special mood that revitalized my creative juices. The last lighting I needed for this subject was strong slanting directional sunlight; the contrast would have been unmanageable and all the detail down in the courtyard lost. The soft, diffuse top light from an overcast day was in this case just the job. I seem to spend my life waiting for shafts of light on the landscape, but here I was waiting for a dull interlude. The merest hint of weak diffuse hazy sunlight is apparent to the centre right of the frame on the tentacles of the encroaching tree; it was just strong enough to lift the scene a touch whilst still enabling me to hang on to the detail in the cooler shadows.

We have the obvious time options – day, twilight or night – and beyond those fundamental choices we have the directional aspect to consider: do we want the main light to come from the front, back, side or above the subject, or from a combination? Then there's the nature and colour quality of the light: high or low, hard or soft, warm or cool? In truth, most lighting situations in the natural world are a subtle fusion of several options from our menu du jour, and the permutations are endlessly variable.

The light the Earth receives from our trusty star is constant; it never changes. Well, an astrophysicist may quibble – eventually the sun will become a big fiery ball consuming us all, which makes me wonder if it's ever worth painting skirting boards – but within our short life span I think we're safe considering sunlight a constant. But as we often sodden, exasperated photographers well know, the sunlight that only occasionally reaches us as

we're stood clutching our cameras on a hilltop is anything but constant, especially in places with such changeable weather as the Yorkshire Dales; it was modified as soon as it reached our atmosphere. What's left of the battered and bruised photons have passed through a considerable slice of our atmosphere by the time it reaches our lenses. Just how big a slice has a marked affect on the colour temperature of the light, whilst the atmospheric conditions otherwise known as the weather that the sunlight shines through and reflects off on its journey also radically change the nature of the rays. We'll consider the complexities of the weather in the Chapter 5.

At noon in the tropics the overhead sunlight that turns lily-white holidaymaker's flesh to pink has had the shortest possible passage through the atmosphere, so is consequently neutral in colour balance; it is what we term daylight, with a colour temperature of 5200K

– give or take a few kelvin. Later, as the sun sets as a golden ball over the Indian Ocean, its light has passed through a much thicker section of the atmosphere. Dust, water droplets and all sorts of unspeakable vapours that we've pumped into the air scatter the shorter wavelengths at the blue end of the visible spectrum leaving the longer rays at the red end to struggle through, which is why that setting sun looks orange. The more particles in the atmosphere the more pronounced the effect, to the point that the sun dipping over congested Bangkok looks blood red, whilst over Shanghai it can rarely be seen at all, as it just settles into the pollution. Beyond our fascination with gazing at the setting sun, the light painting the landscape at that time of day is correspondingly warm and directional – yet soft. How soft depends on the clarity of the atmosphere. Light that is too soft can be too insipid for Big Views but perfect for portraits or details, whilst the last arcing golden light of a crystal clear evening after a rain shower is perfect for revealing all the form, texture and scale of a landscape.

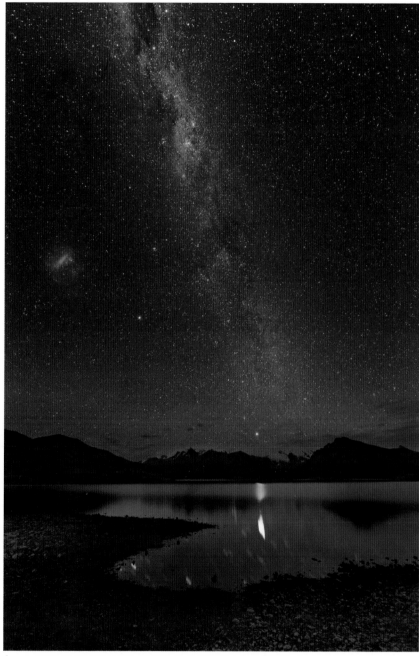

Milky Way and night sky over Lago Roca, Patagonia, Argentina. Canon 1Dx, 14mm lens, 20 sec at f4, ISO 12800. I calculated where and when the Milky Way would be at its best in the sky over Patagonia, then found the location to match. This shoot was a real case of meticulous planning, mostly done from the other side of the world, but when all the research, travel and preparation was done, driving out from Calafate at 1am I had no idea just how bright the Milky Way would actually appear in the southern hemisphere sky. As soon as we arrived and doused the lights I quite literally thanked my lucky stars; the night sky above was awe-inspiring. Out in the wilds of Patagonia the complete absence of light pollution made this shot possible. The ability to make pictures such as this with light we can barely see is liberating, and exciting.

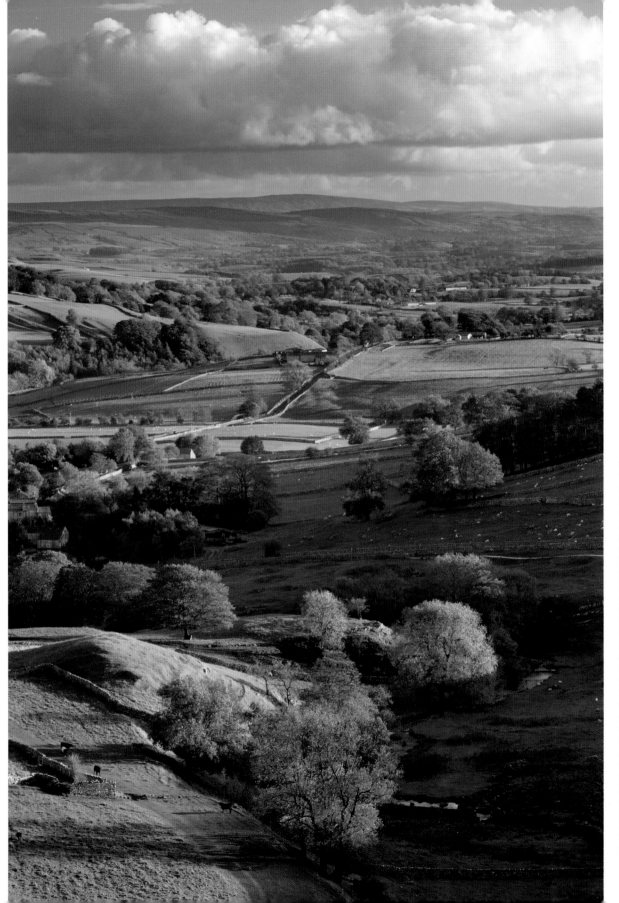

Malham, Yorkshire Dales, England. Canon 1Ds Mk III, 70–200mm lens at 120mm, 1/6 sec at f11, ISO 100, polarizing filter. The late afternoon crystal clear sidelighting revealed all the detail and form of the landscape with enticing alternating light and shadow. This is my default lighting of choice for landscape photography. The trees stand out against the shadows behind, the walls and lanes march boldly across the dales, and the lush green of the patchwork fields is rich and saturated. Artists talk about the light in certain favoured places being special, but that's just artistic exuberance kicking in. The light of Provence, Cornwall, New Mexico or Venice is no different to that in Yorkshire; it's purely a product of what the rays are shining through and reflecting off. There is no difference either between the effects at the beginning or tail end of the day; the same happens in reverse at dawn and dusk. The only discernible difference is caused by atmospheric effects: mist for example is rarely a feature of dusk. Here the visibility all the way to the distant hills was superb due to the recent rainfall. Moaning about the weather is a national pastime in these Isles, but it's evenings like these that make me reappraise our lot. Would I really want to live in the Atacama? I'd miss the slightly damp but sparkling views like this – and the pubs.

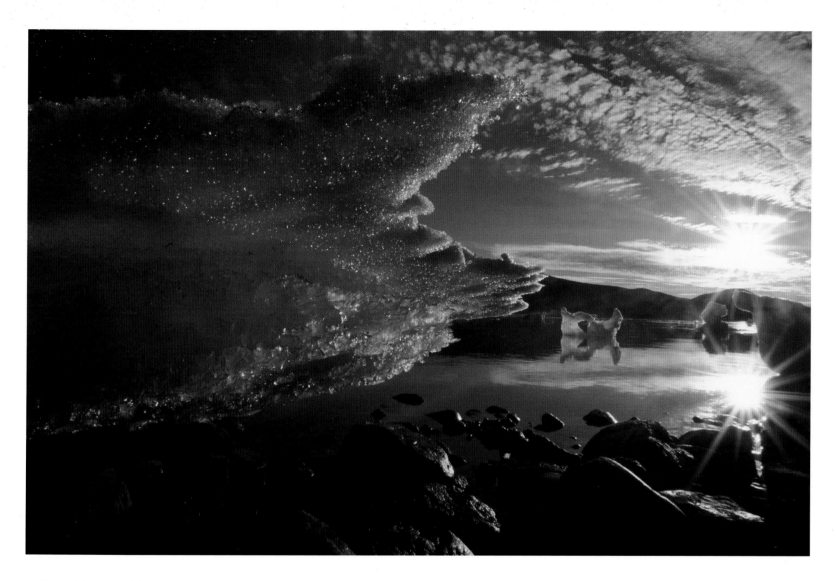

Beyond the time of day and atmospheric conditions, the other major factors that affect the light on the landscape are our position on the planet and the season. At midday in the tropics the light is virtually directly overhead at any time of year, yet at noon in the summer on Ellesmere Island in the far arctic north of Canada the sun is comparatively low in the sky to the south. Twelve hours later, when all is dark down south, the arctic sun is lower but to the north now; it's just bounced right around the horizon all day and night. The 24-hour daylight of an arctic summer is murder for us photographers. Give me the short days of a Scottish Highland autumn at any time!

At the other seasonal extreme, the interminable darkness of an Arctic or Antarctic winter would seem to preclude all photography. In fact, the twilight that hangs in the heavens for most of the day in the winter months in Iceland or South Georgia can offer some very moody opportunities. Throw in the Northern Lights or Aurora Borealis in the long dark hours, and we could be destined for sleep deprivation yet again; we can't win! The passing of the seasons has a greater effect on the length of day and the height of the sun in the sky the further we are from the equator.

With such wide discrepancies dependent on our location we need to know when planning a shoot at what time the sun is due to come and go, and where in the sky it will rise and set. I have to admit that I rely on experience, but it pays to be precise. Apps such as The Photographer's

Ice detail, Alexandra Fjord, Ellesmere Island, Nunavut, Canada. This shot was exposed soon after an irate Arctic tern had drawn blood from my vulnerable scalp around about midnight. The total absence of any haze or pollution in the far arctic north made for light of incomparable clarity. As the sun travelled through 360 degrees right around the horizon each day, I had the option of waiting until the angle was perfect for my intended composition. At this latitude of 84 degrees North the sun never gets very high in the sky. The best light was at 2am; sleep became a precious commodity. The combination of the slanting light reflecting off pristine ice and mirror-like water was endlessly enticing. But when the clouds closed in and the wind off the ice picked up, the Arctic soon became a much more hostile place. We came across a herd of muskox near here, hairy heavy metal beasts that graze on the most exposed slopes right through the long, dark arctic winter. You've got to wonder at their fortitude.

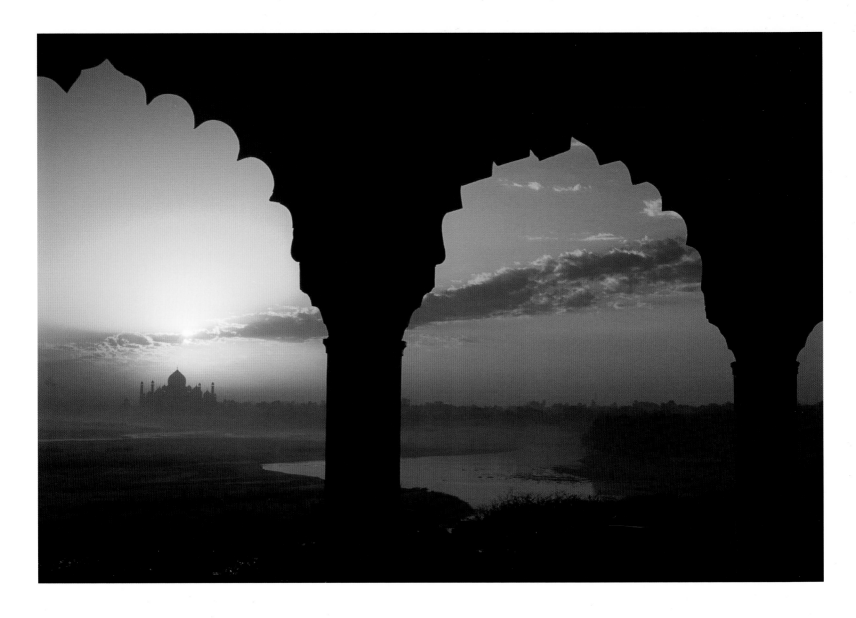

Ephemeris are handy, but I'm cautious of relying on Internet connectivity or cell phone coverage, which is often patchy in the places I extend my tripod legs. Sun compasses are handy, but they are set for specific latitudes and not that handy for the World Traveller. Ultimately there's no substitute for a compass and an innate understanding of the movement of heavenly bodies.

That's all well and good, but still we need to ascertain from which direction we want the light to be coming from to paint the landscape to best effect. Full frontal lighting from directly behind the photographer leaves little to the imagination; all is revealed with maximum stark illumination, usually with the photographer's own shadow thrown in, but the harsh flattening effect and lack of shadow/highlight contrast rarely shows a landscape or indeed any subject off to its best. I'm trying to think of exceptions to that rule but can't; it's an unappealing light that I avoid like the plague.

However the directly opposite option is a different kettle of fish altogether; using backlighting can often be the route to graphic impact. Shooting into the light is beset with problems – flare, exposure and contrast to name a few – but strong shapes backlit and silhouetted against a dramatic sky often have a bold simplicity that

Sunrise over the Taj Mahal from Agra Fort, Uttar Pradesh, India. Shooting directly into the light has rendered the strong graphic form of the Taj and the arches framing it as black silhouettes. In this case the shapes are so bold and evocative of India that they make the picture; any detail in the dark shadows would just look unnatural. As is usual in India, there was a fair bit of haze lying in the Yamuna valley that morning, but that only served to warm the sunrise scene and soften the light. Tripods were banned in Agra Fort so I had to shoot hand held, which caused great unease at the time. For the rest of the trip I was plagued by the notion that these pictures were unsharp. I didn't have to fret too long though: the anti-malarials I was taking had the side effect of stopping me from sleeping; I consequently went slightly loopy, became wretchedly ill and had to head home early – the only time I've thrown in the towel on a trip.

can be very powerful. The big drawback is that any tantalizing detail in the shadowy foreground will be lost. How much detail is sacrificed depends entirely on the contrast range between the rocky vegetation and the bright sky; softer light allows us to retain more foreground detail, whilst stronger, more dramatic light renders silhouettes and foregrounds black. We have stratagems for tackling that immense contrast range – namely graduated filters or exposure merging – but there is a limit to what can be achieved without the loss of all credibility. In my book, any such wizardry needs to be done with subtlety if believability is to be retained.

Of all the options, my favoured default for landscape

work is sidelighting. The low rays of a rising or setting sun slanting across a scene from the photographer's right or left reveal every shape, texture and contour in the landscape. The contrast between the warm highlights and the cool shadows enhances the scene with the complementary colours of orange and blue, shadows provide strong shapes, and every detail from the poppies in the foreground to the distant mountains beyond is apparent. I go to great lengths to find locations where I can use sidelighting, but unfortunately it's not always possible: a view of the Chocolate Mountains in the Philippines looking due east is never going to be lit by light from the side, no matter what time of day or year I

Chocolate Hills, Bohol, the Visayas, Philippines. Canon 5D Mk II, 24–70mm lens at 52mm, 1/40 sec at f5.6, ISO 100, polarizing filter. This bizarre landscape with the regularity of the hills stretching into the distance is a curious sight. My favoured viewpoint from this summit looked due east, but that direction of shooting was never going to work with the light right behind me at dusk, so I compromised and found an alternative looking due south. Fleeing to the tropics whilst England endures the depths of a dark winter is never a tough call, but tropical light has none of the subtleties of northern or southern light. Up North or Down South the Happy Hour stretches into overtime as the sun slants down towards the horizon in a shallow oblique angle, then after sunset, twilight lingers. In the tropics it's all over in a few minutes; all the more reason to be prepared and fixed on what I'm photographing.

choose. Short of swinging the earth on its axis, my only options are to shoot with backlighting at dawn or front lighting at dusk, or to choose another viewpoint. Finding an epic location with such an aspect is frustrating, but no one ever said this game was easy.

Away from the tropics where the sun always rises in the east and sets in the west, we do have the option of choosing to return at a different time of year when the direction of the light at daybreak or dusk is more favourable. Dorset's Jurassic Coast is my home patch, where I have the luxury of being able to choose the exact best time of year to shoot a specific location. The east-west aspect of the coastline makes shooting most locations between the spring and autumn equinoxes unfeasible: the sun is rising and setting over the land to the north, hence casting its own shadow across the cliffs and beaches. In the short days of winter though, when the sun is rising to the south-east and setting in the south-west, tantalizing sidelighting bathes the white cliffs and coves.

White Cliffs of Dover at dawn, St Margaret's Bay, Kent, England. Canon 1Ds Mk III, 17mm TS-E lens, 0.3 sec at f16, ISO 50. There was only one time of year I could have made this picture, as I needed sidelighting shining on the White Cliffs at dawn; within a couple of weeks of the winter solstice was my only option. With the sun rising to the south-east and a direction of view to the north-east, all I needed was a clear morning with just enough cloud in the sky to provide interest. This picture was shot as part of a commission to produce images for stamps of iconic British landmarks. In this case the client formulated the idea; I just had to translate it into reality by scouting the location, planning the composition, and making the shot. Here I got lucky, as the light was perfect on my first attempt; other locations on the same job were far more fickle and inevitably I spent many days waiting for the light in tiny B & B rooms. As usual I shot the image with a Daylight White Balance setting and made no subsequent colour adjustments in post-production. The first light was golden on the cliffs; to my eye that's how it was and should be, but the client demurred; the White Cliffs should look white. I reprocessed the image with the colour balance adjusted to render the cliffs white, and all was well. To me the resultant image looked unnatural, but there you go; the client is always right. This is the unadulterated version.

Remote region of high desert, altiplano and volcanoes near Tapaquilcha, Bolivia. Canon 5D Mk II, 24–70mm lens at 24mm, 1/250 sec at f11, ISO 100. The lunar landscape of this region of Bolivia near the Chilean border is one not many see. We'd been driving all morning increasingly further and further from the madding crowd; it was exciting, adventurous stuff. I lost count of how many flat tyres we endured; Coco our driver seemed to be permanently scrabbling around in the dust under the 4x4. Navigation was by topography and local knowledge alone; there were no roads or maps as such. Amazingly, in the middle of nowhere, we came across a Canadian couple from Vancouver in a camper van. How their 2WD vehicle got there I have no idea; their axle was knackered and they were running short of fuel. We managed to point them in the general direction of the nearest habitation and carried on guiltily, wondering if they'd be all right. At least I now know they made it: an email from them turned up months later. This picture was shot late morning; a time of day I rarely expose in, but the high altitude landscape and skies seemed to turn many of my preconceived notions about light on their head. The hard tropical light seemed to suit the harsh arid landscape.

So far we've concentrated on the light from a sun positioned low in the sky. Most photographers tend to assume the lower the better, but there are a few occasions when top lighting is needed. Generally speaking the hard, vertical light of midday is the least favourable of all to work with. Shadows are hard, contrast is high; the time was when I wouldn't contemplate touching the camera after 10am and before 4pm. But times and ideas change, and I'm deliberately confronting some of my more entrenched assumptions.

Sometimes the skies in the middle of the day have billowing cumulonimbus and streaking cirrus clouds that just beg to dominate the frame and the landscape below. Those skies usually evaporate away by dusk, so I've taken to occasionally exposing much later in the morning and earlier in the afternoon than I used to. The exposure latitude and dynamic range of our latest full frame DSLRs makes this much more feasible; I'm excited by the prospect of carrying on exploring this volte-face. High in the Andes of Bolivia and Peru I found the clarity of light in the thin air and the skies full of drama impossible to resist, even at midday. That's the thing about light; we never stop learning about it.

Oldshoremore Beach, Sutherland, Scotland. Canon 1Ds Mk III, 24mm TS-E lens, 5 sec at f16, ISO 50. What to do on yet another dull, wet, grey winter's day on the far north-west coast of Sutherland. Stare at the walls of the sterile cigarette-smelling hotel room where I am the only guest? Go to the pub? Read a book, write a book, mess about on the Internet, go for a sodden hike, or just descend into a torpor of depression and inactivity? Time was this was a real dilemma: my first book *Waiting for the Light* is peppered with accounts of such testing vigils. But thankfully experience is a wonderful thing; I've learnt to use my time on such days far more wisely. I guess that's a factor of realizing time is not an infinite resource. It is true that dull, grey, overcast weather offers limited prospects for exposing pixels, but that doesn't mean I'm going to stop trying. Oldshoremore Beach, with the clouds low and the rain falling, was unsurprisingly deserted. The diffuse light enabled me to make this minimal colour image featuring the muted tones of the sand beneath the surging waves; it just wouldn't have worked with any other light. Wendy likes this image; I'm not sure. I do know it was worth the soggy few hours crouched behind the tripod. If nothing else was achieved, I logged a few locations for future visits and acquired a taste for this remote corner of Scotland. I shall return.

When the clouds settle and coalesce into an oppressive grey ceiling it usually seems there's little to do photographically but stare whimsically at the sky to the west. Flat, overcast lighting is useless for landscape work; or is it? Ninety-nine per cent of the time I'd agree with that, but it's dangerous to become too hidebound by such assumptions; there are exceptions to every rule. On rare occasions, the low contrast diffuse top lighting of an overcast day can be just the job. That's certainly the case for shooting in the woods; there, the more diffuse the lighting the better. Also when the clouds close in there's always the option of turning the camera on the faces all around us; portraiture thrives in such light.

In the hour before the sun rises and after it sets the light reaching us goes through some wonderful transformations. Whilst direct rays are absent, we are still bathed in twilight from the sun below the horizon. That twilight is reaching us by one of two ways: from sunlight bouncing off the bottom of clouds and down into the landscape; or as residual, ambient light that the atmosphere has scattered. Often the two combine, which is why this time of day is so special and it is worth rising before the crack of dawn or lingering as dinner beckons to witness. The light bouncing down from the clouds is pink and still directional, although very soft. With no cloud in the sky for the twilight to bounce off it's absent, but when all the elements of Mother Nature's perfection slot into place, this twilight can illuminate the landscape in the most achingly evocative glow. It's a very temporary phenomenon, like all her tapestries, but with experience this twilight can be anticipated with just rewards.

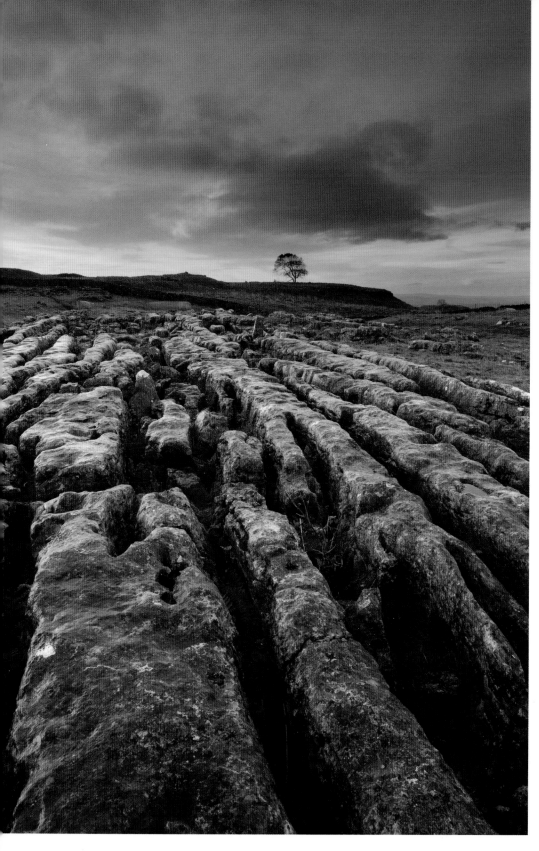

Limestone pavement at dawn, Malham Moor, Yorkshire Dales, England. Canon 1Ds Mk III, 24mm TS-E lens, 5 sec at f13, ISO 100. The sun is still below the horizon, yet the effect the twilight is having on the landscape and sky is obvious: warm highlights are reflecting off the wet rocks in the foreground and streaks of pink flavour the heavens. Distant memories of a Trent College geography field trip to this area remind me that these rocks and cracks I'm slithering on are clints and grikes, classic features of limestone landscapes. The diffuse but increasingly directional twilight reveals the form of the clints, whilst the underside of the clouds to the south are being lit with pink light by the soon to appear sun. The vibrancy of the pink highlights is offset by the deep blue of the shadows and the cool residual ambient light in the rest of the sky. The strange thing is that these twilight effects are much more apparent in the photograph then they were at the time to the naked eye. That's because the combination of the human eye and mind strives to Auto White Balance such scenes whilst the camera, set to Daylight White Balance, does not. These twilight situations don't last long: if I had tried to respond as the scene unfolded I'd never have been able to set up in time; I had to be ready and waiting with my location scouted, composition settled upon, and camera on the tripod ready. As I arrived in the dark and picked my way by the light of my head torch over the lethally slippery clints I was hopeful; the sky to the east was clear, whilst overhead and to the south, interesting clouds drifted for the twilight to work its magic on. One rogue cloud on the eastern horizon would have scuppered the show, as it often does, but this time it all came together as planned.

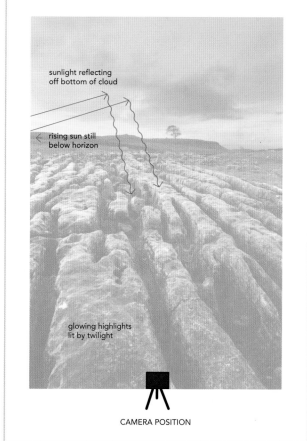

sunlight reflecting off bottom of cloud

rising sun still below horizon

glowing highlights lit by twilight

CAMERA POSITION

The residual ambient half-light that either brightens as dawn approaches or dims as dusk settles has had all of the warmth stripped from it after its laborious journey being bounced and scattered through the atmosphere. Its colour temperature is sky-high, well in excess of 10,000K, which means it's a very blue light, and virtually non-directional. This cool, monochromatic diffuse twilight is a favourite for those hooked on shooting seascapes with slow exposures of swirling water. It's also the perfect light for night shots of notable illuminated landmarks, when the artificial lights of our towns and cities matches perfectly the lingering tones of the twilight sky.

True night photography in the inky blackness when all twilight has yet to appear or has long faded is tricky because, well, it's so dark. Nevertheless the night sky arrayed with all the stars and distant galaxies of the Milky Way is an enticing subject. Many a night as a young Navigating Officer during the 12 to 4 watch on the bridge of a 30,000 tonne container ship mid-Pacific I gazed in wonderment at the heavenly display above, unsullied by any trace of light pollution. More recently huddled by our tent high in the Chilean Andes the night sky has enthralled us, but up until recently I've left the task of photographing it to astronomers.

Incorporating a landscape into an image beneath a star-studded night sky was always an appealing challenge, but the only way we could do that was by using long exposures of an hour or more with the stars streaking through the sky in a vigorous circular motion. This would produce a gimmicky shot with no real connection to how we see the night sky that I've never been drawn to; but now we have the ability to shoot the night sky in all its glory, with all the twinkly stars apparent. Incorporating a landscape into the scene and being in the right place at the right time takes careful planning and persistence; a truly clear night is a necessity with no distracting night pollution. But the capability of modern DSLRs to work with minimal noise problems at sky-high sensor speeds of ISO 6400 or more makes this possible. I'm looking forward to much more starlit experimentation behind the lens in the wee small hours.

Take any photo workshop group out at sunset or sunrise and most members will be transfixed by the sun peeping over the horizon. It takes some mental effort to turn away and observe the far more subtle lighting effects playing on the landscape and sky to the north or south, but that's where the real photographic gold dust lies. Seeing it is one thing, predicting it a whole new challenge. Our ability to pre-visualize these lighting situations is what sets us photographers apart. It's a skill to be honed and cherished; and possibly the most crucial aspect of the vision required to translate our idea into reality.

Strasbourg, Alsace, France. There was a time in the '90s when it felt like I was spending an inordinate slice of my life hanging around on windy embankments waiting for the floodlights to come on – from Prague to Barcelona. Night shots of iconic European views were my bread and butter, but it got to the point where I was getting increasingly weary with the prospect of another river/bridge/castle night shot. Now I can approach the potential of illuminated night shots afresh. Cityscapes that look humdrum and cluttered in the light of day are often transformed by the combination of floodlighting and twilight. The Decisive Moment when the tones in the sky match the man-made illuminations is tantalizingly brief; these kinds of pictures are all about planning and timing.

Dawn at Clogher Head looking towards Sybil Point and the Three Sisters, Dingle Peninsula, County Kerry, Ireland. Canon 1Ds Mk II, 70–200mm lens at 110mm, 30 sec at f29, ISO 50, 0.9 ND filter. To the west of the Dingle Peninsula there's nothing but the wild heaving seas of the north Atlantic for thousands of miles to Newfoundland. That September morning before dawn it felt as if all of the ocean's malevolent force was being unleashed on us. As we parked in the darkness, the Land Rover was rocked by the force of the wind; this was going to be a wild one. Did Wendy really know what she was signing up for when she said 'I do' in 1987? I must ask her sometime.

We trudged out to my chosen viewpoint on Clogher Head, hunched against the gale force wind and driving rain. Quite frankly, at that point I had zero faith that we'd be able to achieve anything photographically worthwhile that morning, and the tantalizing option of returning to our warm B & B for coffee and a leisurely Full Irish Breakfast was compelling. But we stuck it out, and somehow I managed to shelter the camera on the tripod from the worst of the wind's buffeting in the lee of a big rock. To the east over the Kerry Hills, muted twilight was just starting to seep through the sky. Looking to the north towards Sybil Point, the view was intermittently obscured by the low cloud and sea fog, but as the sky became tinged with muted twilight and the waves crashed on the headland the scene unfolded and I attempted a long exposure. Often looking away from the direction of the somnolent sun, the effect of the twilight in the sky and on the seascape is so subtle as to be almost indiscernible; but it's there, and it is a beautiful light source to illuminate such a tormented coast, as this picture testifies. Breakfast was forgotten, momentarily, as we revelled in the mood and atmosphere of another memorable dawn patrol. It is experiences like this that make dawn such a special time, and makes rising in the darkness for another outrageously early start the most natural thing in the world to want to do.

Journal Entry: Sutherland Highlander

DAY 1

I've come on a whim, my first time back to Sutherland for 25 years. The Highlands and Islands in winter have always held a special appeal, but as I near Kinlochbervie I suspect my snow chains, ice spikes and new Cossack-style hat may not be needed; Sutherland is relentlessly catching all the dull, grey clag that the Gulf Stream is capable of transporting across the Atlantic from the warm, moist Caribbean. Maybe I should have headed there instead?

Cape Wrath, the far north western tip of mainland Scotland, has an evocative pull akin to Land's End. The Cape itself is a military firing range and inaccessible, but Sutherland – the region so named by the Vikings as a southern land – is a destination synonymous with lonely northern peaks and rugged shores, just a short 13 hour drive away from home. I passed my old haunt of Pitlochry under blue skies studded with fluffy white clouds, but as the landscape north of Inverness turns increasingly lunar I drive into low cloud and fog. It's bleak, dark and damp. I sense rather than see the looming presence of monolithic beinns hidden in the murk.

On arrival I attempt a quick but futile recce of my immediate surroundings, but soon decide location searching when I can't even see the location is pretty pointless. At the hotel I'm the only guest, and my room stinks of stale fags. I watch the weather forecast with a sinking feeling; more of the same is predicted until the end of time. Still, what did I expect, tropical sun? I gee myself up with a pep talk: this is an adventure just as promising as any on the far side of the world, I've endured many a dismal night over the decades in grim rooms far less appealing than this, and waiting for the light is what I do; just get on with it, Noton.

I'm in bed by 8pm after a meal of something indiscernible and chips; come what may, tomorrow I shall be out for the dawn patrol whilst it's still dark. Where? I saw a lonely abandoned croft by a loch as I drove in; it's as good a starting point as any.

DAY 2

On the menu this morning I have not only low cloud and fog, but also heavy rain and high winds. I haven't exposed anything of worth since Sri Lanka a few weeks ago and the pressure to create is tangible, but I can't make something out of nothing, or can I? I have to try. I manoeuvre the Land Rover to use as a windshield whilst shooting the lonely melancholic croft. What stories could it tell, eviction followed by emigration? The scene in the dull, monochromatic blue light has a certain elemental appeal, but maybe in my desperation to expose I'm just kidding myself that the shot has worked.

After a Full Cardiac Breakfast I'm checking the results on my laptop: good location, awful light. Oh well, at least I have an

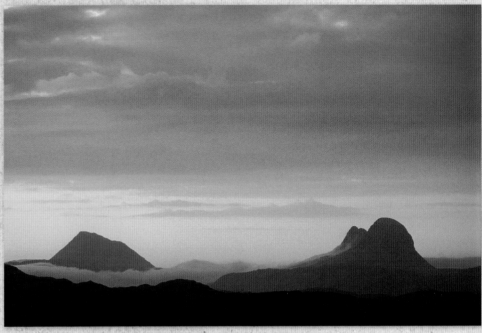

Canisp and Suilven at dawn, the postcard image from my previous visit in 1987.

idea and location logged; time now to scout for others. I hike up the valley behind the hotel; I can tell from the map the brooding peak of Foinaven overlooks it – not that I can actually see it. I try desperate exposures of rocks, bracken and burn, but I know I'm kidding myself that this is productive; every time I get the camera out, sheets of rain drift in.

Out at Olshoremore Bay my spirits lift; even under a dulling blanket of low grey clouds it's a scene of beauty and mood that I have all to myself. A solitary afternoon of wandering and experimentation follows. Is it possible to make something work photographically in such unpromising conditions? Thirty years of experience suggests not; I need at least a glimmer of light, but I'm not about to stop trying and besides, what else would I be doing?

DAY 3

I'm back at the same spot as yesterday morning. The cloud cover is a bit higher today and it's not actually raining; reasons to be cheerful. I mess about in the lee of my vehicle again, experimenting with long exposures as the clouds streak through my frame, hustled eastward by the brisk westerly. Maybe, just maybe, it's working and I've got a picture worth journeying so far north for.

Back at the hotel I have a shock: another guest is in for breakfast, a fireman doing a tour of Sutherland stations. We chat amiably about fire and rescue services to remote communities over a light Highland breakfast of bacon, eggs, beans, sausage, haggis, black pudding, tatty scones, toast, fried bread, tomato and mushrooms, as I feel my arteries steadily clogging up. I know I should resist the call of the daily cooked breakfast but I'm powerless to resist the smell of bacon after a dawn patrol.

Today I'm moving on, as a change of scene is needed. On arrival at Lochinver I discover my postcards of the area from 25 years ago are still on sale in the Post Office. It's a result, but it's a pity I'm not getting royalties.

DAY 4

I'm heading out location searching on another claggy morning. The whole area is dominated by the presence of the dome shaped sentinels of Assynt: Canisp, Suilven, Cul More and Cul Beag. It's a curiously beautiful landscape of coast, lochans and monolithic peaks, quite unlike anywhere else in the Highlands. From the map I can see there's a loch to the north of the most dominant peak of Suilven, the snappily named Loch Druim Suardalain. That will be my starting point. It turns out to be a winner; an idyllic loch studded with islets sprouting shapely pine trees with Canisp and Suilven to the south. Shooting this location now becomes my prime objective.

I'm back for the afternoon/evening light. After initially looking promising, the light just doesn't quite come good. I hang around all afternoon to do a dusk shot, but with blue skies all around and just a trace of cloud over to the west obscuring the sun it's another frustratingly futile vigil. Oh well, nice try. Another dinner of fried pub food follows. I think I'm starting to suffer from scurvy; tomorrow I must track down some fresh fruit.

DAY 5

I'm en route to Inverness Airport to pick up Wendy, driving through epic scenery on empty roads in the late winter sunshine. The Highlands is surely one of the few places in the world where it's still possible to enjoy driving. This two hour journey must be the regular shopping run for the people of Sutherland.

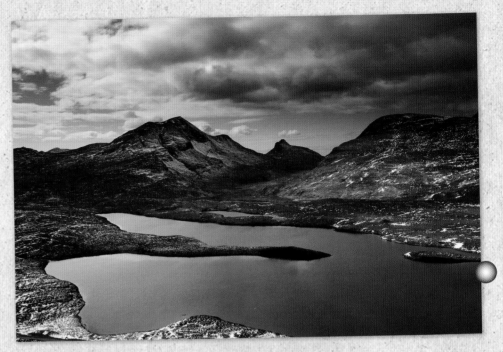
The ancient landscape of Sutherland; one billion years old.

I collect my Mrs and we head on for a few days through Speyside, a region I've never visited despite my enthusiasm for its most famous product. In the whisky shop in Tomintoul the owner slates every single malt I choose, a curious sales technique as he's just talked me out of three purchases. In Grantown on Spey I invest in a pair of Muck Boots, deluxe wellies that I could have used over the last few days slowly sinking into various peat bogs whilst waiting for the light.

That evening in the local pub, the only place to eat for miles around, our worst fears are realized as we struggle to chew a grey substance with all the taste and succulence of boot leather. How can prime Aberdeen Angus beef be so mistreated? It's a crime. I cannot wait for our next self-catering leg of the adventure back in Sutherland. Napoleon observed that an army marches on its stomach; the same is indubitably true of photographers.

DAY 6

We've struck gold; the cottage that will be our base for the next week is in the most idyllic spot imaginable on the shore of our very own sea loch. The only fly in the ointment is that there's a print of a truly gruesome HDR shot of Suilven over the fireplace.

That evening I'm summoning my thoughts whilst gazing out from our cottage over Loch Inver. Wendy is scrolling through the pictures of tadpoles she shot on the hike; she does like her creepy crawlies. I'm debating whether my shot of Suilven reflected in Fionn Loch will work in black and white.

At least I'm trying to, but that tick I picked up whilst brushing through the heather is on my mind as it burrows further into my abdomen. It has resisted all attempts so far to disgorge it; vaseline, whisky and tweezers have been

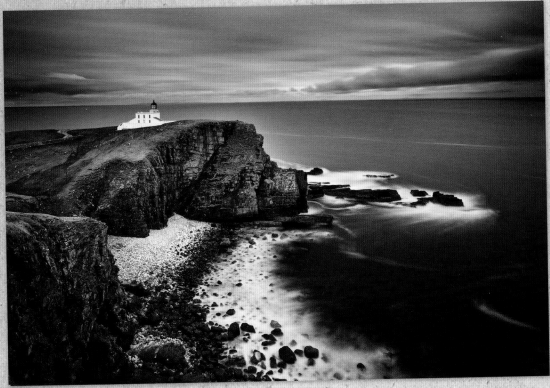

It starts spitting with rain as we arrive; I need to set up and get the shot done before the weather deteriorates. I experiment with compositions briefly but opt to stick with my original idea. One bank of cloud angling in from the west makes the shot as I just about manage to eat a sandwich and keep the raindrops off the tilt-and-shift lens during the six minute exposure. The rain intensifies and our Decisive Moment passes.

On the hike back I'm pleased with the shoot; it's always satisfying to convert an idea into reality and I suspect the image will have a stark black and white graphic impact. It will make a change from the endless pink skies we see in the photo press, not that I've seen any of them up here.

deployed unsuccessfully. I called a halt to proceedings when I saw Wendy heating my seaman's knife over a gas flame. I know she's a nurse but I had to draw the line. Maybe the Scotch needs to be applied internally?

DAY 7

We're out for another attempt at an evening shoot at Loch Druim Suardalain, my fourth time at the location. We get there too early but it's a joy to hang around in such a peaceful spot. The light is now gorgeous, but there's not a cloud in the sky. As we wait, Wendy informs me that Sutherland is one of the oldest geological regions on the planet. The ancient bedrock that forms the unique landscape of Assynt is a billion years old, give or take the odd millennium. As the sun dips I'm trying to work the venerable location, but in the absence of interest above it's just not working.

DAY 8

Above Stoer Lighthouse I'm shooting looking down on the scene with the 24mm TS-E lens and a Big Stopper fitted. As I count down my two minute exposures, Wendy is doing pilates on the cliff top. The light is muted (just for a change!) but the sky is full of northern mood. I was here a few days ago, but then the wind whistling in from the Atlantic made even contemplating setting up a tripod hopeless. Today conditions are relatively benign. It's good to hear the shutter clicking again, a sound that soothes my soul. I think I may go mono with this shoot.

We trudge on to the Old Man through the squelchy bogs. My new Muck Boots are coming into their own. I have a vision: an idea to do a graphic composition with the sea stack central against an elemental background of sea and sky, with nothing else to distract. We're on a mission to make it happen.

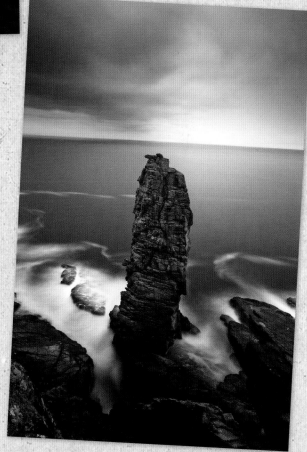

On our way back we're elated to nab some fresh seafood from a van in Lochinver; things are definitely looking up. A bizarre encounter with a Filipino lady doing laundry in a hut on the seashore follows. I chat to Carmen from Luzon about our sojourn in the Philippines a year ago. How did she end up here?

DAY 9

The real world has intruded in the form of a text from the office. We have no mobile phone coverage or Internet at the cottage, so I'm trying to send images back for the newsletter using the computers in Lochinver Leisure Centre. The first won't power up, the second won't recognize my memory stick, and the third won't connect to the Internet; grrrr.

By now the sun is coming out and I'm here pulling my hair out with IT hassles. I swear we've become slaves to these bloody machines. Gone are the days when I didn't think twice about being out of touch for weeks, even months.

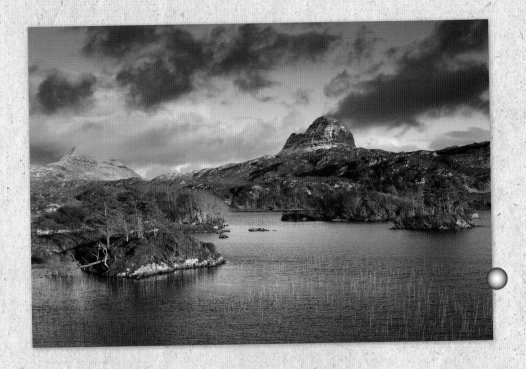

DAY 10

We wake up to realize there's been a fresh snowfall. Back at Loch Druim there's a good sky, with Canisp and Suilven covered in snow. I wait for the sun to shine through on the islands in the lake, shooting slightly contre jour. It's not quite as obvious a morning location as an evening one at this time of year, but with these conditions I think it's definitely worth a try.

The wind gets up, destroying the tantalizing reflections, but I'm saved by the long grass in my watery foreground. The sun resolutely refuses to appear, so I experiment with long exposures that have clouds streaking through the frame. The situation is not perfect, but then again life rarely is. It's still a good session, and it feels good to be exposing again after all the waiting.

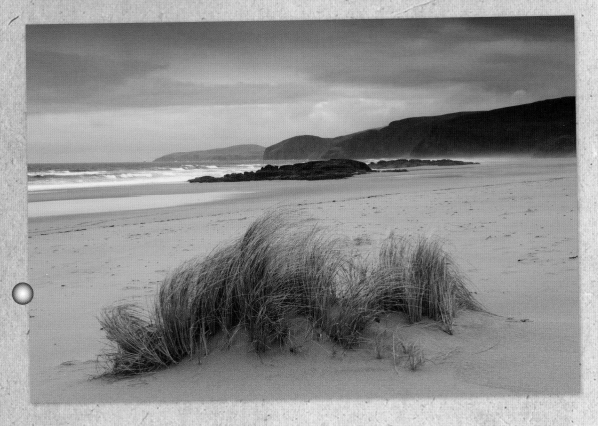

DAY 14

We're hiking under leaden grey skies to Sandwood Bay, a place I've been meaning to visit for decades now. Its proximity to Cape Wrath lends a romantic pull enhanced by its reputation as the most beautiful beach in the country. As we plod along the track across a peat bog surrounded by a featureless landscape we're prepared to be disappointed, but finally we round a spur and see the bay.

A view of receding headlands to the north marching away towards Cape Wrath fronted by an empty pristine sweep of sand backed by big sand dunes and bigger mountains unfolds. To the south a headland with another sea stack stands proud. It's an evocative, impressive, uplifting scene, even on another dull, grey day.

One day we shall return to camp nearby and really work this location. Tomorrow we must head south, but this is a good place to finish. As always in Scotland, the trip has turned out to be an often frustrating battle with the weather, but this place got under our skin long ago. We'll be back.

DAY 11

Late afternoon and we're heading back to Loch Druim yet again. I was pleased to bag the morning shoot here, but I'm determined to also shoot the scene in the evening light. We pick our way across the boggy mush towards our familiar hillock; my new Muck Boots are earning their keep.

A week ago we were barbecuing in the unseasonal warmth, now we've all our layers on to combat the icy northerly wind. Yet we're in heaven; that arctic wind brought the spring snow, and Sutherland looks its very best. The light is crisp, golden, and without a trace of haze. Snow and sleet showers march in steadily from the north; one minute the sky is black and foreboding, the next sparkling with April sunshine. Canisp and Suilven stand proud above the loch, capped with snow and trailing their own clouds.

These are the conditions us photographers dream about, which occur maybe just a few times a year. This is our sixth time working this location, and it was worth the wait.

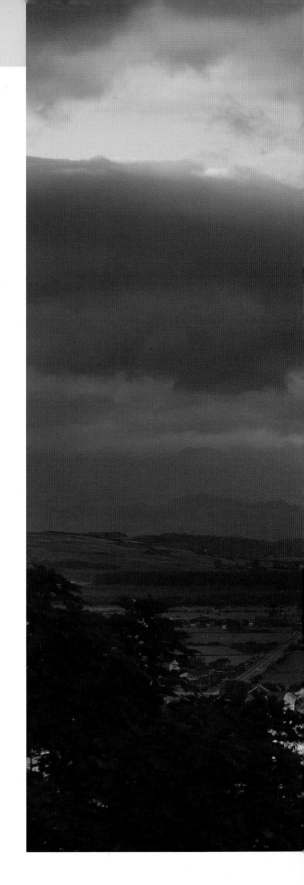

The Weather

After days of bad weather it was difficult to believe the situation would ever change. Holed up in Harlech waiting for the light, three days of soggy Snowdonia weather had passed and another one looked set to peter out without a glimmer of brightness. On a mission to photograph Harlech Castle, the meter was running without as yet one single frame to show for our patience – but it was hardly an unfamiliar experience. I watched the weather forecast in the B & B for the third time that day with exasperation. Another area of low pressure was moving in from the south-west; more rain was predicted.

Maybe we should throw the towel in for now and reckon to return in the summer? Hang on, this is summer! Nope, every shred of experience gleaned over the decades suggested that we just had to wait it out; besides, I knew that as soon as we started heading home the sun would be bound to appear as Mother Nature taunted us with our lack of faith. That has happened all too many times; it's gut wrenchingly soul destroying and ferments months of painful recriminations. Such mental torment didn't bear thinking about; waiting was the only option. Moreover, I reasoned in a fit of optimism, that weather forecast full of doom and gloom could be just the ticket. After all, the last thing I needed was boring blue skies; the changeable conditions brought by the passage of a cold front over the mountains of Snowdonia could bring to the sky the

drama I needed – it only takes one shaft of heavenly light. All of which begs the question: what is good weather for landscape photography?

The next evening a hint of broken cloud brought hope. Thirty minutes later, slanting golden rays pierced the gloom and illuminated Harlech Castle like a spotlight. The clarity of the light after the rain was tangible, and the warmth of the direct rays offset against the backdrop of the mountains under heavy dark skies had all the mood and drama I could possibly hope for. A diagonal gap in the clouds above the castle brought a strong compositional impact to the frame as, after four days of doubt, our patience was rewarded.

Harlech Castle with the mountains of Snowdonia beyond, Gwynedd, Wales. Canon 1Ds Mk III, 70–200mm lens at 70mm, 1/25 sec at f11, polarizing filter. One gap in the clouds and one shaft of heavenly light is all it takes to transform bad weather into an uplifting dramatic vista full of mood. This scene under boring blue skies just would not compare. We waited four days for this light; par for the course really.

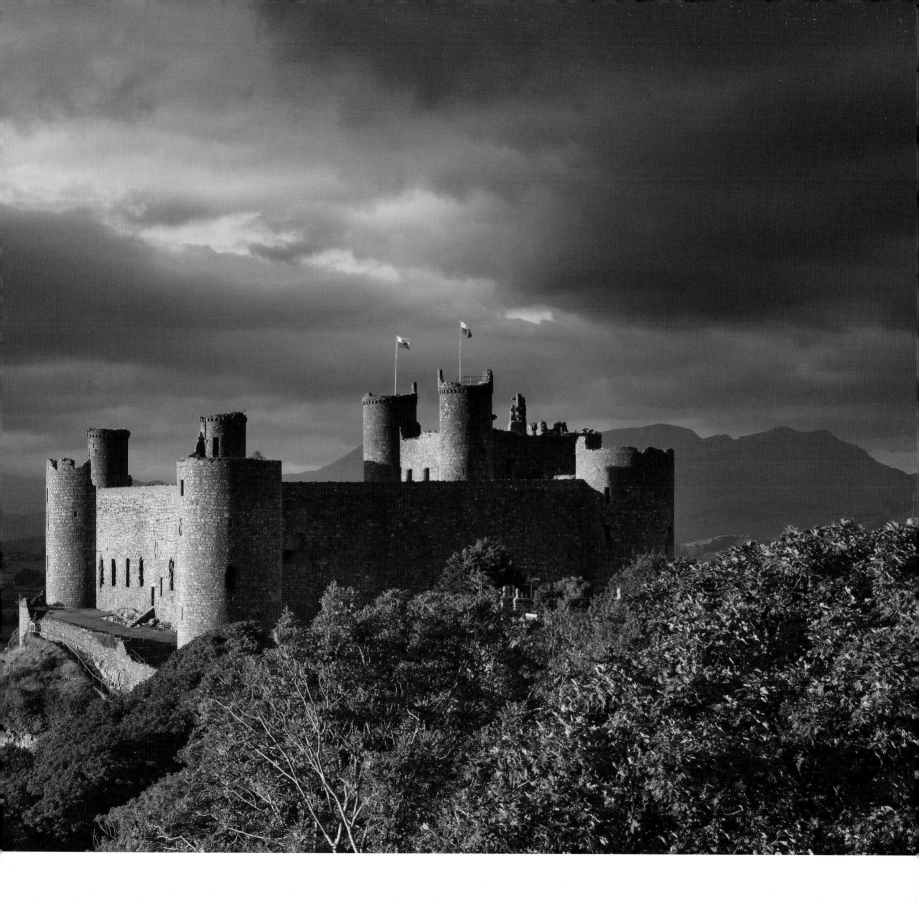

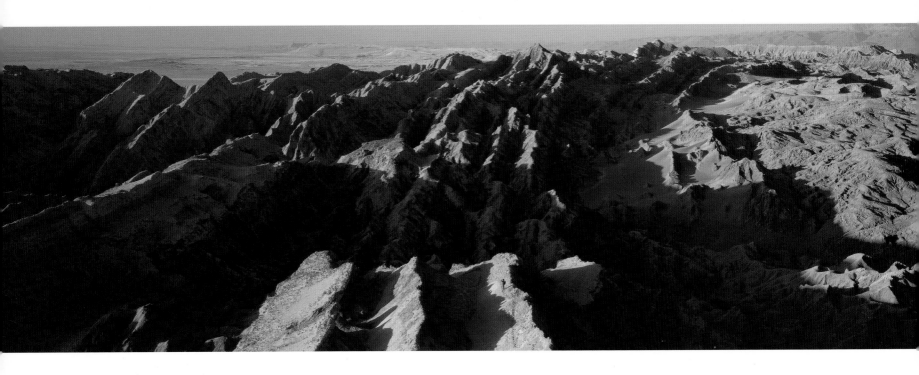

Driving home the next day I contemplated that pessimistic weather forecast; with the benefit of hindsight what could I learn that would help me predict the chance of such magical moments occurring again? Not much, apart from the fact that the BBC weather lady is clearly not a photographer. Actually thinking about it the one overriding message was that changeable weather is usually hopeful, settled conditions less so; although as always when talking about the weather for photography those generalizations need to be qualified with a long list of 'ifs' and 'buts'.

As a native of the green but often damp British Isles, the appeal of working in the driest place on earth was obvious. Each day in the Atacama Desert brought the same conditions: clear skies and dependable sunshine. Let's not beat about the bush – not that there are any in the Atacama – it was a real luxury to be able to scout a location and plan a shoot knowing with certainty that I'd be able to expose the next dawn as scheduled. But we photographers are picky, and after several days of arid landscapes under azure cloudless skies I was longing for a few towering cumulonimbus or rippled cirrus. Landscape photography in a desert where it has never rained means

lots of compositions incorporating the merest sliver of sky. I hate to admit it, but after a week I was longing for the soggy mood of Snowdonia.

Yet camped in one of the wetter places on earth, we were longing for the dry warmth and sunlight of a desert. We photographers are never happy with our lot. Milford Sound on the south western fringe of New Zealand catches the same precipitation that douses the few other land masses interrupting the passage of the Roaring Forties around the southern hemisphere: Tasmania and, yes, Chile again. Approximately seven metres of rain a year is dumped on Fjordland, which made camping there an exercise in positive thinking. I was wondering during another long night spent listening to the torrential rain hammering on the tent why we travel to the far side of the world to seek out such notoriously inclement destinations? But the next morning brought a brief respite, and a landscape weeping in the cool, moody light following the deluge. That's why.

I suspect I'm not alone in my profession in being obsessed with weather forecasts. I watch the TV forecasts a few times a day, while in between I'm checking online for hourly variations even when I've no shoots planned; it's

Wendy treading boldly in the Atacama Desert, Chile. The Atacama is all rock with virtually no sand, and there are places here where it has never rained. Deserts are such elemental landscapes; I loved shooting the arid desert landscapes of jagged rocks and parched valleys, but after a while I longed for a bit of interest in the cloudless blue sky. As here, I resorted most of the time to composing with little or no sky in the frame.

become an ingrained habit. Landscape photographers share a connection with the Gods of Weather just as strong as farmers and sailors. The key question is when we're looking at a forecast, what are we looking for? When the weatherman predicts a fine day we could be frustrated by uniform blue skies and haze, whilst a bad day could deliver the drama we experienced at Harlech or just low grey cloud and drizzle from horizon to horizon. Clearly we need to be able to read between the lines.

I'm writing this back in Wales, in a cottage on the beautiful Pembrokeshire coast. It's early in the morning in late March and the sun is rising to the east, virtually due east to be precise; I know this intuitively because the spring equinox passed just a few days ago. I also know that a high pressure system is sitting over Scandinavia and the North Sea, as it has been for over a week now. Winds circulate around highs in a clockwise direction in the northern hemisphere, so we on the southern fringe of the system in northern Europe are shivering in the cold dry easterly wind from the Russian steppes. The sky is milky with high altitude cirrostratus cloud, typical of the settled conditions that highs bring. Today will be mostly sunny though cold. Whilst that high stays obstinately in position not much is going to change.

All this I know from the forecast and my own observations, but does that mean we're likely to see strong light and a tantalizing sky this evening for a shoot in a rocky cove? My gut feeling is that the light will fizzle out as it dips; there's just too much milky cloud about. My chances of experiencing the dramatic light of Harlech brought by a passing cold front are virtually nil. Does that mean then it's not worth turning out for dusk? Not necessarily, as it's always worth a go. A landscape photographer who only ventures out in perfect conditions would rarely experience the unpredictable subtleties of Mother Nature's designs. Be that as it may, does that mean watching weather forecasts is pointless and we should just go for it hoping for the best? Probably, but a knowledge of weather patterns can help you make informed decisions about where to go and when.

Milford Sound at dawn, Fjordland, South Island, New Zealand. After days of torrential rain this cool muted morning was our reward. Although at times the deluge was enough to test our sanity, the mood of the scene is in keeping with the facts. This is one of the wettest places on earth; Milford Sound under clear blue skies just doesn't look right. Conditions that most would term as bad weather are often a photographer's best friend.

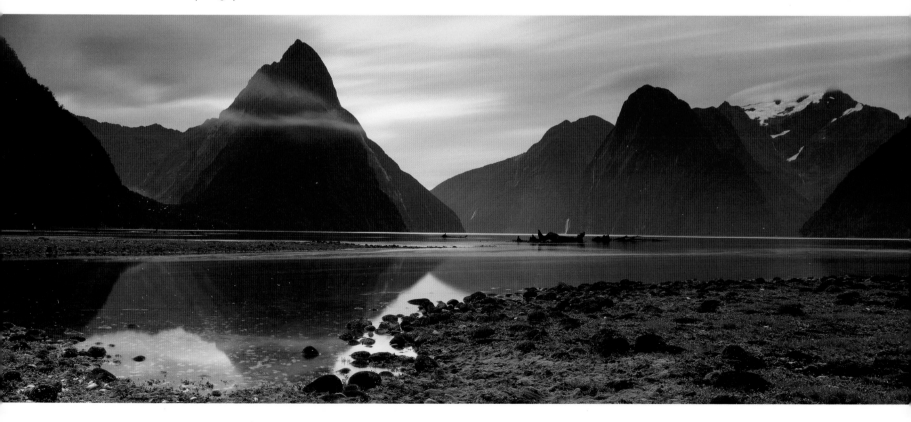

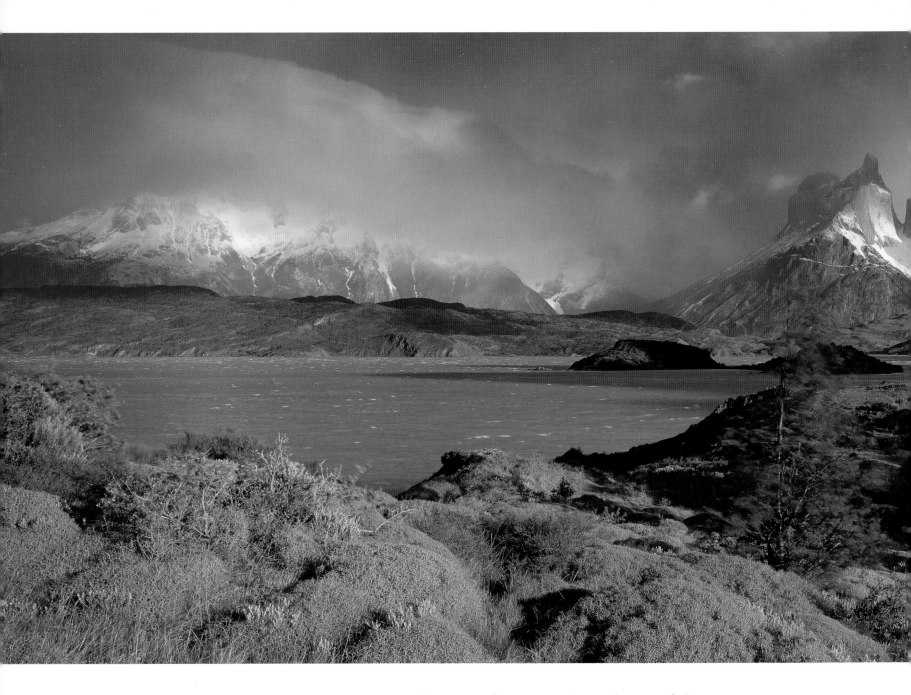

A sweeping generalization: all landscape photographers love mist. We have an enthusiasm for it that the general public doesn't really get, but few would deny traces of mist draped over a landscape at dawn add an ethereal mystery to a scene. For some years now we've been journeying to Umbria in the green heart of Italy every May to run workshops, and the view looking up the Valnerina towards the mountains of Monti Sibillini with the perched village of Preci appearing through the mist is one that never fails to inspire. After many misty dawn patrols I can now feel in my bones when the conditions are right for all the elements to come together. Rain the previous day followed by clearing skies at dusk then a cloudless still night with no wind always does the job. With practise and reasoned observations of local conditions such shoots can be predicted; it's a handy trick.

High winds make life difficult for us. Just keeping the camera steady becomes a challenge; many a lens has been ignominiously

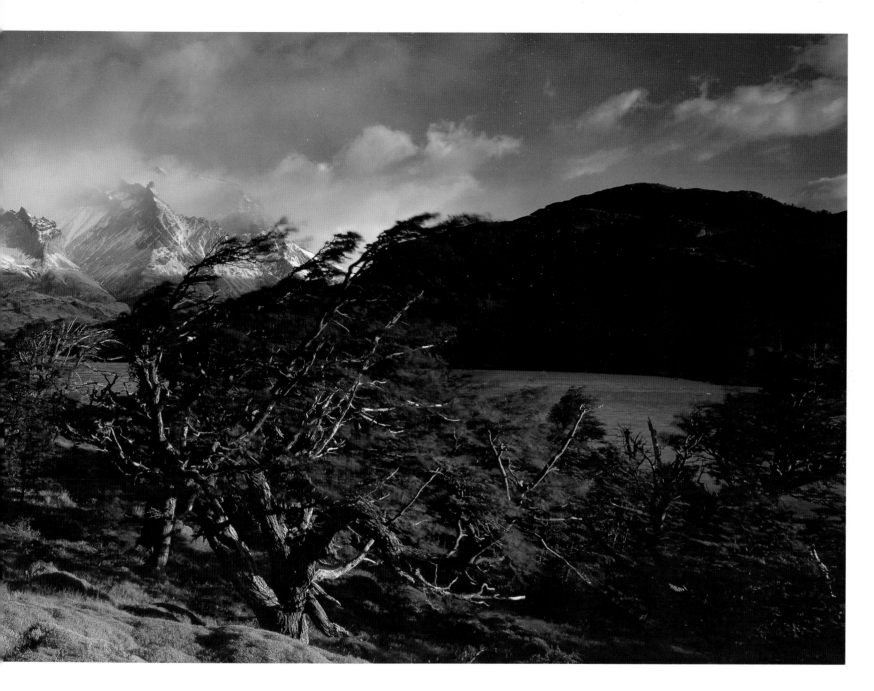

The Cuernos del Paine, Lake Pehoe, Torres del Paine, Patagonia, Chile. The incessant wind that is a feature of Patagonia has shaped these trees into graphic symbols of the gale force winds that sent us progressively around the bend whilst camping here. Expressing the power of Mother Nature is not easy, but sometimes the weather itself becomes the subject of the photograph.

smashed as gusts topple top-heavy tripods. If the winds are too strong, using a tripod is out; hand held shooting with high ISOs and fast shutter speeds becomes the only option. That being said, the wind does open up creative opportunities to express the movement: trees blowing, clouds scudding, grass swaying and waves crashing. For me, the sight of huge waves driven by gale force winds crashing on a rugged shore has far more impact and says far more about the forces of nature than tranquil long

exposure seas of milk. Such conditions with the spray flying are challenging in the extreme; just standing up is difficult, and keeping the salty moisture off the lens is virtually impossible. But there's an old saying that holds some truth: the best pictures are taken in the worst conditions.

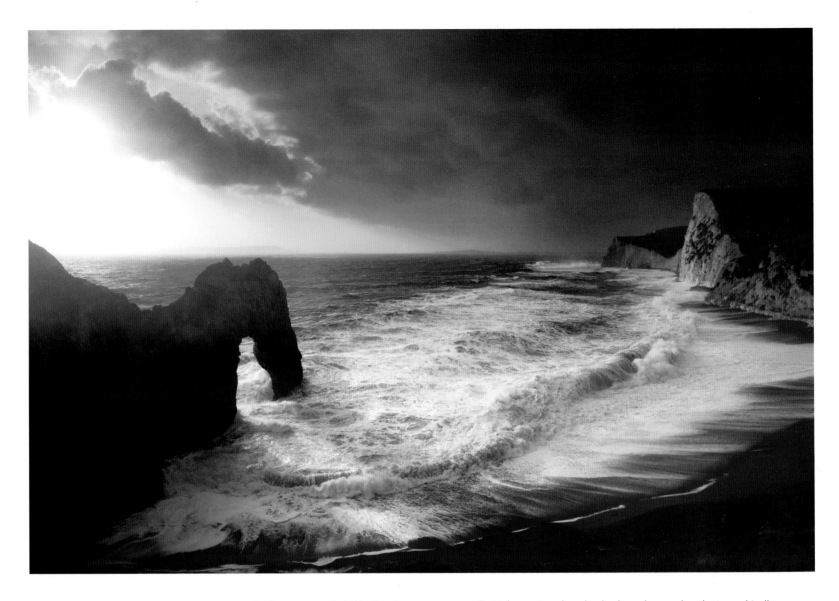

Rough seas at Durdle Door, Jurassic Coast, Dorset, England. Canon 1Ds Mk III, 24–70mm lens at 25mm, 1/800 sec at f5.6, ISO 200. As winter storms battered the south coast, huge waves crashed on the headlands. The southerly wind was so strong that just standing upright was difficult, and using a tripod was out of the question. An unprotected lens was encrusted with salty spray within seconds of being pointed at the scene, while just composing and exposing was a challenge – but what drama.

So it's becoming clear that bad weather can be photographically promising, but the Big Question is: just how bad is good? Steady rain that sets in over huge swaths of territory is usually pretty uninspiring, and the interminable drizzle we know only too well in the British Isles has few redeeming qualities. Those conditions are usually brought about by the passage of a warm front bringing moist air from the tropics to slide over the cooler air beneath, forming an impenetrable layer of low grey, depressing nimbostratus. Such frontal cloud can stretch unbroken for thousands of kilometres and is the kind of weather most photographers use as an excuse to catch up on their editing. Generally speaking, the flat diffuse lighting under such cloud is hopeless for most landscape photography, but great for shooting in forests. Other more localized rain is a different matter altogether.

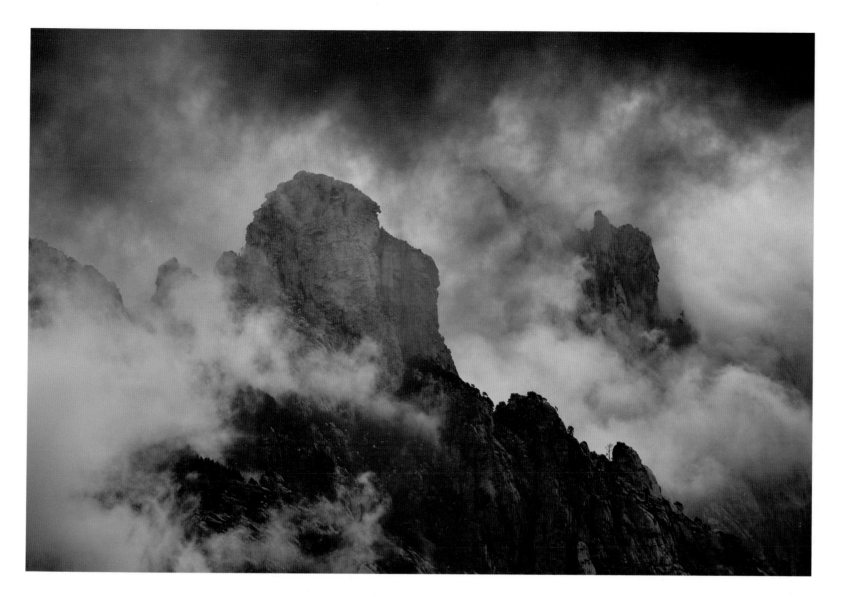

Rain clouds hanging over the Col de Bavella, Corsica, France. Canon 1Ds Mk III, 70–200mm lens at 150mm, 1/250 sec at f5.6, ISO 200. It was chucking it down when I shot this, but the angry mood of the rain clouds swathing the jagged peaks said it all about Corsica. I tested the camera's weather seals well on this shoot, but just a few minutes later we were drying ourselves in the warm June sunshine. Localized rain showers water fertile photographic fields of opportunity.

Of course all this is the talk of a photographer who spends much of his time in a temperate maritime climate. Residents of other climatic zones such as continental, tropical, arid, mediterranean or polar regions will know the peculiarities of their own unique weather patterns. I wish I had space in this book to delve deeper into such variations, but regarding rain one thing is consistent for all photographers around the globe: localized rain is a gift from Mother Nature. Around the margins of scattered showers all sorts of good things are taking place visually: a landscape sparkling in the sun with fresh saturated colour after the dousing, light of a clarity that cuts like a knife, an atmosphere washed clean of haze and pollution, towering clouds, light and shade dappling the countryside, and maybe rainbows.

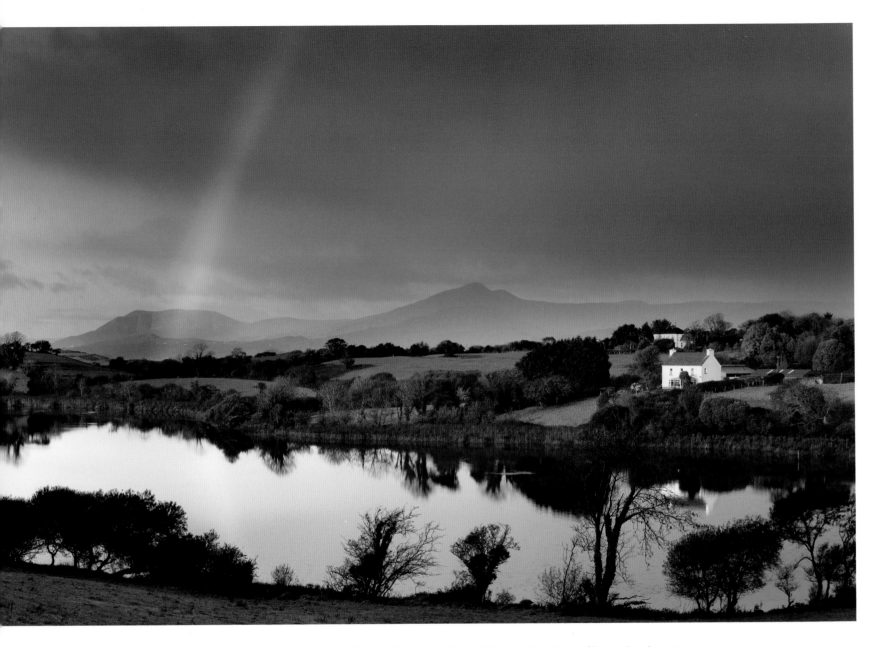

Dawn with a rainbow, near Bantry, County Cork, Ireland. Canon 1Ds Mk III, 24–70mm lens at 70mm, 1/13 sec at f11, polarizing filter. I reckon there are many pots of gold littering the south western fringe of Ireland. As I stood contemplating the passage of rain clouds across Bantry Bay, I could see that rainbows were a distinct possibility. Soft early morning sunlight was painting the green Cork countryside, whilst the mountains of the Beara Peninsula beyond remained in dark shadow. I knew that if I stood with my back to the sun any rainbow would appear arcing from my left at about ten o'clock and to my right at two o'clock. To incorporate a rainbow over the mountains into my composition, all I had to do was move right along the path until the desired peak was at ten o'clock with the sun on my back. I upped and hustled as quickly as I could carrying a tripod and heavily laden camera bag into position, set up and waited for the inevitable combination of sunshine and shower to arrive. It being the west coast of Ireland, the shower was a certainty; the sun took a little more patience. Knowledge of how weather phenomena occur can help us to make special pictures.

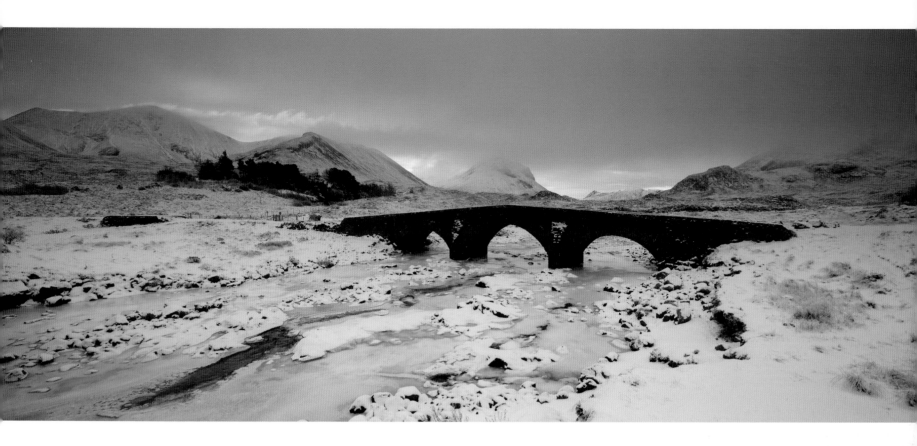

I should stress that I am not qualified in any shape or form to lecture on meteorology. Like most of us I'm an amateur weatherman, but I do know from hard experience what weather produces the conditions we photographers crave, and many of us crave the pristine winter wonderland of a landscape shrouded in fresh snow more than anything. The ideal scenario sees a heavy snowfall followed by the settled, cold conditions of a high pressure system freezing the landscape in time for us photographers to shoot the trees hanging with snow and the landscape etched in white. What is crucial is to make the most photographically of these conditions as soon as they occur; a slight thaw spoils it all and snow that has been hanging around for days looks increasingly manky.

These conditions of perfection are rare, even in countries that endure long severe winters. I have ventured north many times on a whim hoping for such conditions, but whole winters often pass without my being in the right place at the right time. Responding as the snow is falling in a dash up the motorways is usually too late; by the time I arrive the thaw has usually set in and besides, the transport system of the UK grinds to a halt with the merest dusting of white. It seems that to experience consistently the perfect conditions of epic landscape, fresh snow, crisp light and sub-zero temperature, taking up residency in Alberta, Lapland or Siberia is probably the best option.

For the rest of us, winter's nuances needn't be a lost cause – unless you live in Bangkok. Just a trace of white flakes or ice can transform a landscape. Frost forms in similar conditions to mist, but when temperatures fall below freezing at night. Everything looks fabulous coated in frost, even our rubbish bins. The first light of day makes the ice crystals sparkle; the trouble is that it usually melts them, too.

Glen Sligachan and the Cuillins in winter, Isle of Skye, Scotland. Canon 1Ds Mk III, 24mm TS-E lens, a three-frame stitched panorama, 1/8 sec at f11, 0.6 ND grad filter. Christmas Eve on Skye: we'd driven up the day before, as the country's transport system ground to a halt with the onset of winter. Having grown up in Canada the heavy weather us Brits make of a few inches of snow is, quite frankly, pathetic. Paradoxically Skye was one of the warmest places in Britain, and by Christmas Day the thaw was under way. The pressure to get out and make the most of the precious winter conditions was on.

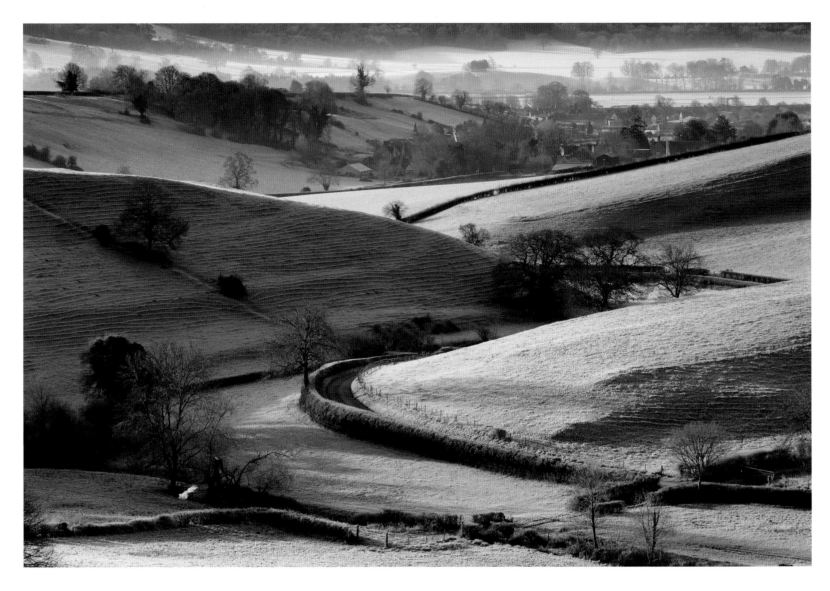

The first few days' residence of a high pressure system bring clear, sparkling winter weather. In summer the same settled, fine weather brings out the barbecue tongs. That initial settled clarity with dawn mist in the valleys and gorgeous light painting the fields soon starts to dissipate as the days pass with the high still in place and haze, the bane of a landscape photographer's life, starts to build. Haze is formed by the build-up of particles held in suspension in the air that settled conditions brings. It robs distant views of impact and turns blue skies to a milky white. Taken to extremes it becomes a suffocating layer of heavy air full of grot. When such conditions build, our only options are to concentrate on subjects close to the lens: people, plants or Wendy's speciality, beetles. Any scene with a sky or a sweeping view is a lost cause. There's nothing for it but to wait for the arrival of wind and rain to flush the high out and clean the atmosphere before the cycle starts again.

Virtually every image in our burgeoning library has an intriguing message about the weather behind the story of its creation. Us Brits can and do talk about the weather for hours. Combine that national characteristic with a

Frosty morning at Oborne, near Sherborne, Dorset, England. Canon 1Ds Mk III, 70–200mm lens at 148mm, 1/40 sec at f11, polarizing filter. Within minutes of the morning sun shining on the frosty fields it had all melted. I suppose the fleeting nature of scenes like this make them all the more tantalizing.

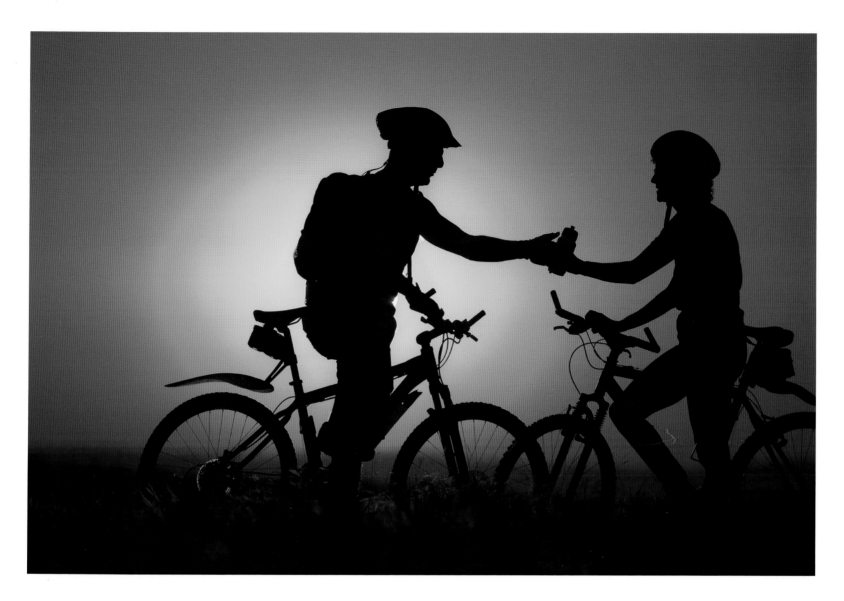

Wendy and our mate Andy on mountain bikes on Hambledon Hill above the Blackmore Vale, Dorset, England. Canon 1Ds Mk II, 100–400mm lens at 400mm, 1/1000 sec at f5.6. The hot, hazy conditions of a high pressure system settled over Britain in the summer offer few photographic alternatives; lighting up the barbie is generally a better option. Haze is as bad as leaden grey skies for shooting landscapes, but using the backlighting of a hazy sunset with the simple graphic shapes of cyclists worked in this case. The haze intensified the orange of the setting sun.

photographer's preoccupation with natural light, and the result is bordering on the obsessive. I am certain in my mind that an understanding of what weather forecasts tell us beyond the basic nice day/rainy day message helps us photographers to plan our movements and improve our chances of being in the right place at the right time.

Weather forecasting now, with the help of satellite imagery, is so much more accurate than when I used to send in observations from the bridge of a cargo ship mid Pacific 35 years ago. Predicting the chances of evening light up to 24 hours ahead has become increasingly dependable. Beyond that sort of time frame things get trickier; planning trips around longer range forecasts is distinctly dodgy. I do know of fellow photographers who think nothing of dashing across continents on the whim of a forecast. For me that seems like madness; by the time I've got there the forecast would inevitably change. No, I'm a firm advocate of committing to a shoot then making the most of whatever Mother Nature deigns to serve up. I am still struck by how many times, thinking the forecast looks hopeless, I have been surprised by a late glimmer of magic. There is always hope.

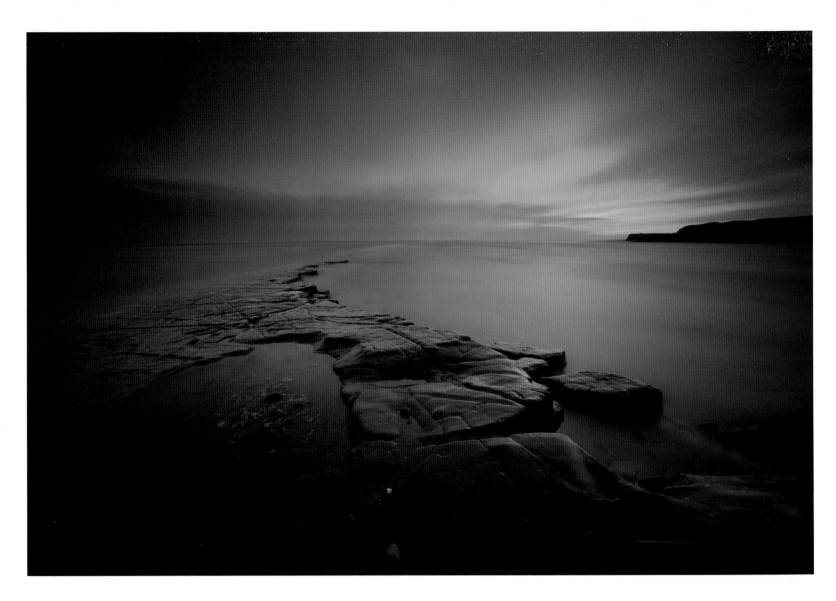

Kimmeridge Bay at dusk, Jurassic Coast, Dorset, England. Canon 1Ds Mk III, 16–35mm lens at 16mm, 4 min at f5.6, 0.6 ND grad and Big Stopper filters. It seemed a futile vigil: the sun hadn't been seen for days and a thick layer of nimbostratus smothered the Jurassic Coast of light. Then after the sun had set, a gap allowed this ethereal twilight to penetrate; an object lesson if any were needed on the power of persistence. No matter how dismal the forecast there's always hope.

No matter how good forecasting has become, I can be sure of one thing: Mother Nature is fickle, she's not going to change. I can also be sure that wherever I go in the world the locals will tell me I should have been there last week. I'm resigned to it, just as I am to the frustrations and days of waiting. For a landscape photographer, to moan about the weather is like a fisherman complaining the sea is wet. Waiting for the light is just what we do – like it or lump it. The weather is our constant companion, friend and foe, and as we spend so much time out in the Great Wide Open scouting locations and pacing by the tripod we might as well know as much

about the forces of nature that shape our weather as possible. Skies, for example, are so crucial to the success of landscapes; identifying the type of clouds floating in the frame is just a bit of additional fun.

Weather awareness and landscape photography go together hand in glove. Increasingly the weather itself is becoming the subject of my photography, particularly as climate change is such a hot topic at the moment. As with our deliberations about light, the more we know about the dynamics of the weather unfolding in front of our lenses, the more complete photographers we will become.

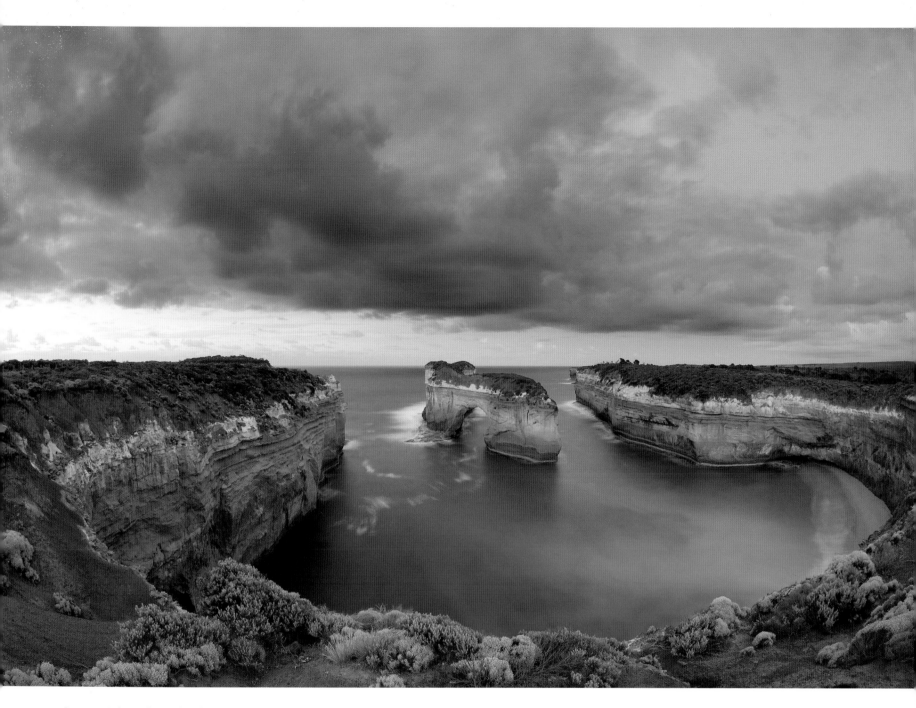

Dawn at window arch in Loch Ard Gorge, Port Campbell National Park, Victoria, Australia. Canon 1Ds Mk II, 15mm lens, 20 sec at f16. Clouds often make a landscape. Sometimes the drama in the sky can dominate the picture, with the landscape below relegated to a subservient role. That's not the case here; the impressive sweep of the bay is counterbalanced by the anger in the sky – rain is imminent. The weather on this wild southern fringe of Australia is fickle and consequently the coast is littered with shipwrecks. It is the first landfall for ships making the long crossing of the southern Indian Ocean from the Cape of Good Hope to Melbourne.

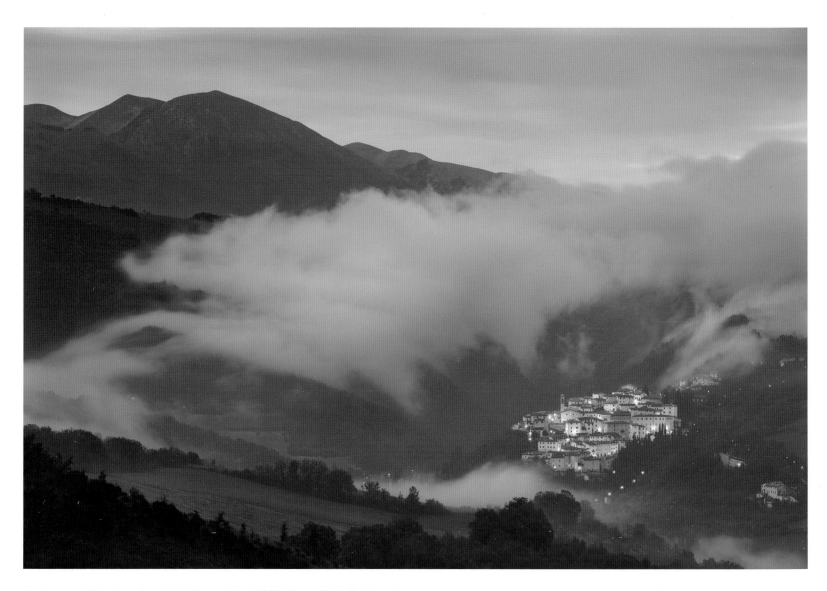

Preci surrounded by mist at dawn in the Valnerina, Monti Sibillini National Park, Umbria, Italy. Canon 1Ds Mk III, 70–200mm lens at 110mm, 4 sec at f8. I have photographed this scene many times with workshop groups in tow, but every time it's different. This morning we were in place well before dawn to take advantage of the street lights in Preci contrasting with the cool blue ambient light. The mist wafted, dissipated, came back again and kept us busy for hours before breakfast, but this early shot that captured it clinging to the valley all around Preci was the one for me.

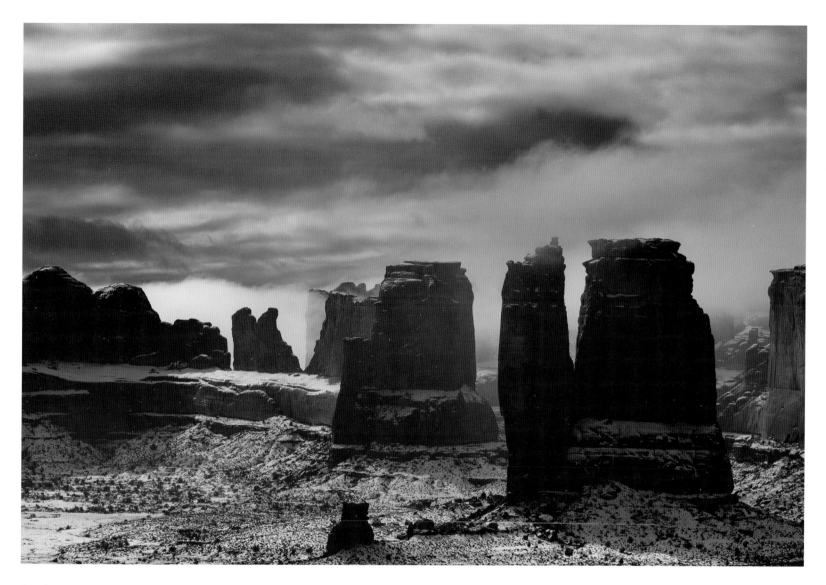

Courthouse Towers in winter, Arches National Park, Utah, USA. Canon 5D Mk III, 70–200mm lens at 200mm, 1/800 sec at f9. When bad weather breaks, the period of transition can often offer the best photographic opportunities. Four days of low cloud, fog and rain had not been the start to my Utah trip I'd envisaged. It's always good to get off to a flying start, but I'd been here almost a week since leaving home, a frame had yet to be exposed, and spirits were low. I'm used to such frustration in the damp climes of the British Isles, but hadn't bargained on them in the arid south western USA. Then, as the fog cleared and the sun made an appearance, my whole world sparkled. An hour later there wasn't a cloud in the sky and the snow was melting.

Chapter 6

The Colour

It doesn't get much better than this: low slanting sidelight painting the landscape with warmth and clarity, a blue sky full of white fluffy cumulus floating above the La Sal Mountains, and the strange pillars and arches of red rock that are unique to this area stretching away into the distance. I'd been on my chosen mound all afternoon, watching as the light just got better and better. Now with dappled light and shade on the scene I wondered if it could improve any more. I'm always mindful that one errant cloud obscuring the sun could signal end of play, so I got on with the job of exposing my overlapping images that would be stitched together to form a panorama.

The combination of the warmth of the low light on the red rock, and the snow lying on the ground reflecting the tones from the sky in the shadows meant there were only two dominant colours at play in the scene beyond my lens: orange and blue. I didn't need telling then and there that these two colours from opposite sides of the colour wheel are complementary and thus offset one another; each appears stronger due to the proximity to its opposite. It was the perfect illustration of why the light of the Golden Hour is so appealing. Yes, the low directional lighting was revealing all the shape, form and texture in the landscape, but the colour relationship between the warm highlights and cool shadows was enhanced by the subject itself: red

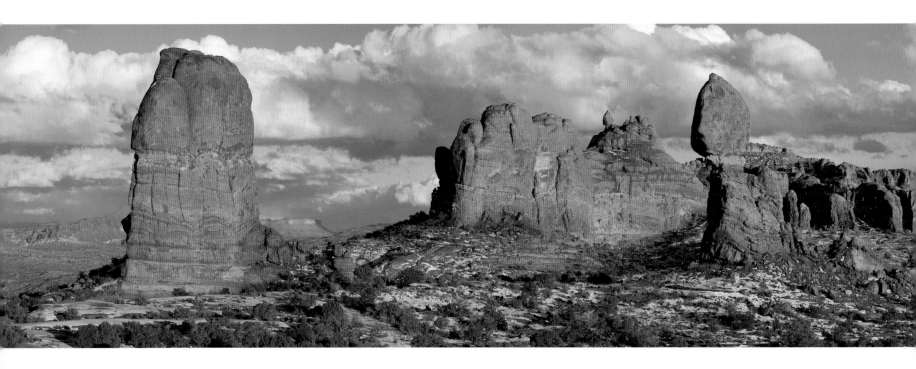

rock. There are times when I look at a scene unfolding and try to ignore the colour content to picture the view in black and white. This was not one of those moments, as this image was all about strong complementary colour, full on and saturated to suit by Mother Nature herself.

Even when the subject is not a landscape of red rock covered in snow, the light of Happy Hour at sunrise and sunset still delivers this warm/cool, highlight/shadow complementary colour relationship. It's one reason why we're instinctively drawn by the light at those times of day. I don't believe any of us deliberately search out complementary colours in the natural world, but when they do occur they usually have an irresistible appeal; think of a scarlet poppy amongst a sea of swaying lush green barley, or bright yellow sunflowers against the deep blue Provençal sky. Simple, bold compositions that make the most of these complementary colour relationships, often to the exclusion of all else, virtually always work. The colour becomes the subject.

Balanced Rock and the Windows Section with the La Sal Mountains beyond, Arches National Park, Utah, USA. Canon 5D Mk III, 12 vertical frames stitched together to make a panorama, 70–200mm lens at 105mm, 1/25 sec at f11, polarizing filter. It's a famously stunning scene, especially draped in fresh snow in the last daylight of a winter's afternoon. I've had this panorama printed up to 6.5m (21ft) wide; it's the way to look at such images. The impact here is only hinted at, but the complementary colour scheme of orange and blue is as clear as day.

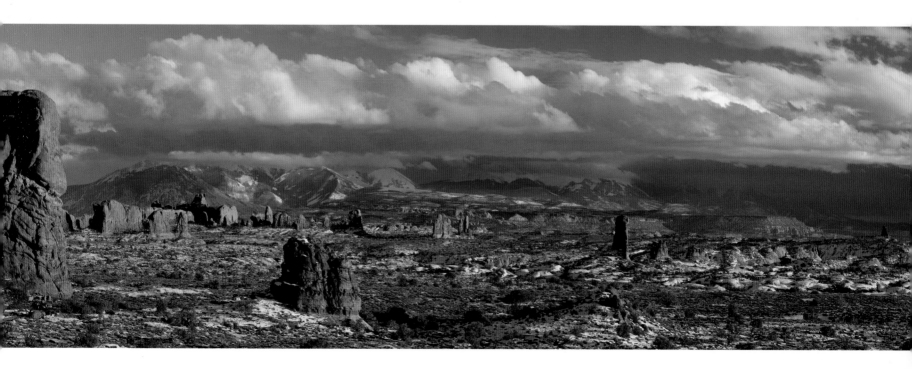

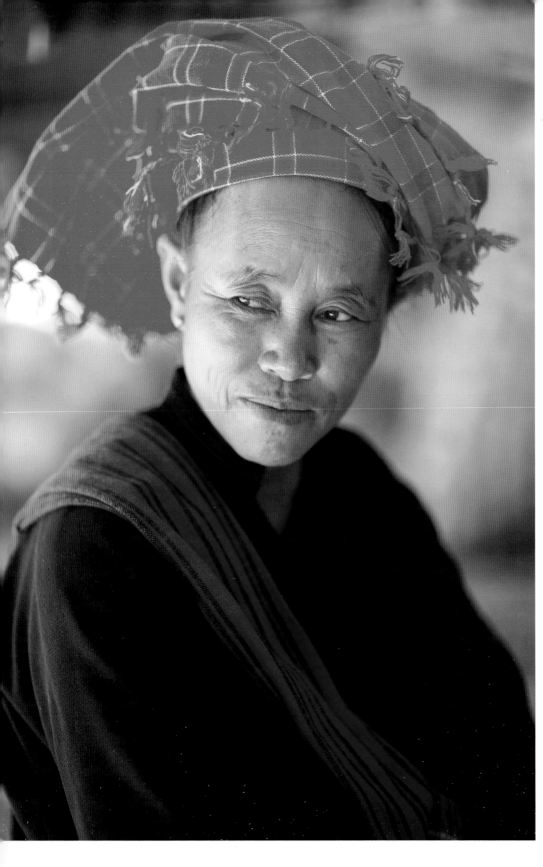

A lady in the market at Nyaungshwe, Inle Lake, Myanmar (Burma). Canon 1Dx, 85mm lens, 1/2000 sec at f1.4. The flaming red of her headdress couldn't be more vibrant; I've had to desaturate it a touch in post-production. With one so dominant colour it was just as well she was wearing black, but I guess she thought of that.

The considerations we've examined so far as we piece together an image are all interrelated: the idea leads to the location, which prompts decisions based on the composition, light, weather and now the role colour in the scene will play as our vision nears fruition. Often I'm trying to maximize the colour in an image, but whilst full throttle colour adds impact, sometimes a more restrained approach can be effective, as can colour of just one tone, or banishing all colour in black and white. But beyond these decisions it's always worth considering how the dominant colours in any scene relate to each other. OK, I may not have a choice in the matter – I usually have to go with what's on offer – but some pictures work purely because of their colour content, or lack of it.

Images containing every colour of the rainbow at full saturation have a certain technicolour impact. More often the multitudinous hues of a Smarties tube clash and fight one another for attention. There are times to express that effect, but usually a few colours will dominate a scene, and how those colours interrelate will have a profound effect on the impact of an image. It all keeps coming back to the colour wheel, so we had better get our heads around what that actually tells us.

The colour wheel is a key aid to understanding how colours relate to each other.

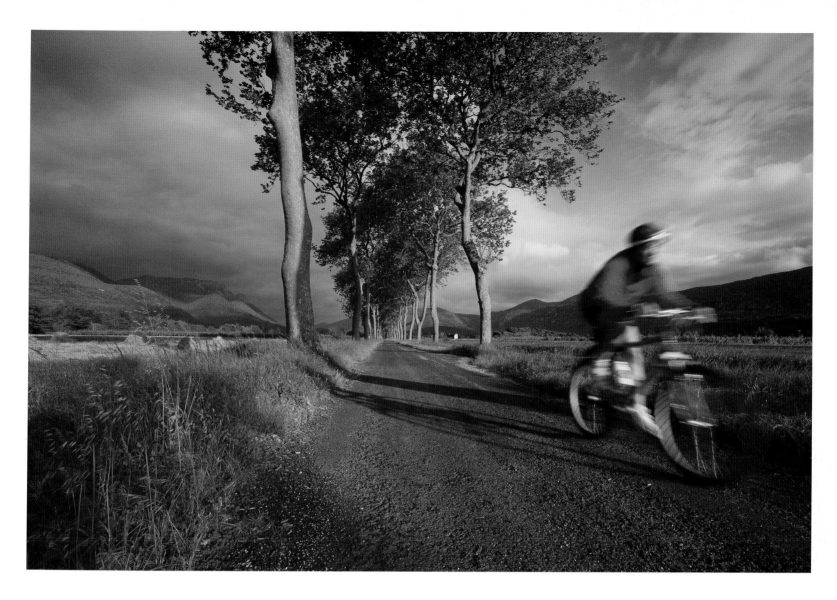

We know visible light is made up of the colours of the rainbow, ranging from violet at one end to red at the other. We also know that violet merges seamlessly into red – it just seems natural – so if we represent that spread of colour not as a linear chart but as a wheel, we can see how each colour merges naturally into its neighbour: violet into blue, blue into green, green into yellow, yellow into orange, orange into red, red into violet. Our eye tells us it's a natural progression around the wheel, but what's the point? Well, that wheel defines how colours relate to each other, and helps to explain why the scene overlooking Balanced Rock has such impact.

Our cameras can only see three colours: red, green and blue. The receptors of their sensors are arrayed to be sensitive to these three primary colours, but by combining these primaries in varying amounts any colour of the rainbow can be expressed. In between these three primary colours on the colour wheel are the secondaries that fill in the gaps: yellow, magenta (otherwise known as violet, or purple) and cyan (turquoise, a combination of blue and green). Clearly there are too many names for similar colours; instead of brown my sister calls the colour natural, and my car is an appealing arctic teal, but they can all be made with varying amounts of the primaries.

A cyclist – Mrs Wendy Noton to be precise – pedalling along an avenue of trees, Val du Fenouillet, Languedoc-Rousillon, France. Canon 1Ds Mk II, 17–40mm lens at 17mm, 1/40 sec at f13. This is deliberately a very colourful image, with all three primary colours present and correct. I requested that Wendy wore a red top so she would stand out against the blue sky. The clarity of the early morning light emphasizes the vibrant colours.

Actually, I should mention that there is a difference of opinion amongst artists wearing smocks and photographers with tripods on their shoulders about which colours are defined as the primaries. Our cousins with oily pallets regard red, blue and yellow as the primaries, but that's because they are mixing pigments, whilst we are working with wavelengths. You can rest assured that we are right and they are wrong; but we don't need to get pedantic, the colour wheel shows the same circular progression through the rainbow whether you're a pretentious artist tormented with self-doubt, or a photographer with muddy boots and an attitude.

The colours opposite each other on the colour wheel are termed as complementary – red/cyan, blue/yellow, green/magenta – whilst those alongside each other are termed as analogous. Complementary colours are known to emphasize each other and to add impact; thus the orange of the rock illuminated by the warm rays of the late sun appears more vibrant alongside the blue of the cool snowy shadows and sky. So if we want the colours in our image to have impact, complementary is the way to go. Yet we don't always want full throttle impact; sometimes more restrained subtlety and harmony is called for.

Japanese maple tree in autumn, Stourhead, Wiltshire, England. Canon 5D Mk III, 70–200mm lens at 85mm, 5 sec at f22, 0.9 ND filter. As the light faded on a short November day, I made this long exposure with the wind rustling the incredibly vibrant red leaves. The colour in this picture is almost too much – I'm still not sure about it – but no adjustment has taken place; it's as real as can be reproduced on a printed page. The impact of the red verging on pink of the maple is boosted by the backdrop of green. The artist's colour wheel defines red and green as complementary, whilst the photographer's RGB wheel does not. I'm not losing sleep over that; we know these colours are as near as damn it from opposite sides of the wheel, and the proof of that effect is evident here.

Country lane at dawn, near Charlton Horethorne, Somerset, England. Perched on the roof platform of my vehicle at dawn with mist lying over the landscape we call home, I was more concerned with not falling off than with the harmony of the scene. But looking at the image now it's clear that the dominant analogous colours of green and blue fit the subject and evoke tranquillity; the blue in the sky morphs into the pink of dawn on the right, another analogous relationship. Of course I didn't rise before the crack of dawn and head out unshaven and bleary eyed intent on finding a scene of analogous colour, but recognizing why a picture is working due to the colour content is all part of the game that sees our photography constantly evolving.

Whilst complementary colours lend impact, analogous colours as neighbours on the colour wheel bring harmony. Often in the natural world analogous colours exist alongside each other in many different hues; think of the varying tones ranging from yellow through orange to red that autumn brings to the leaves. Analogous colour schemes lack the contrast and vibrancy of complementary ones, but when harmonious empathy is required they are highly effective.

Strong colour content, whether spanning the rainbow or using complementary or analogous schemes is one approach, and deliberately restraining colour is another. We are surrounded by colour in our lives – apart from on a November day in Yeovil – so choosing to express minimal colour sometimes makes a powerful statement. The effective use of minimal colour relies on a scene with just a hint of a tinge to convey a message or mood, an approach that requires considerable perception and subtlety. Often again we are powerless but to go with what Mother Nature offers, and on an overcast day in Sutherland with precious little light and a heavy layer of cloud, muted colours are really the only option.

It has to be said that when I was judging a landscape photography competition recently, the preponderance of images featuring over saturated colours and blood red skies provoked a reaction that caused the few images using the subtle appeal of minimal colour to really stand out. Sometimes less is more, to the point where just one colour is all that is needed.

A penitent in the Semana Santa procession, Malaga, Andalucia, Spain. Canon 1Ds Mk III, 85mm lens, 1/640 sec at f1.2. She knew I was shooting her and I think she quite liked the attention. That's the great thing about fiestas and processions: they offer good opportunities for such candid studies and the participants are unlikely to object. The only colour in the picture other than black is her flesh tone, and yet the feel of this minimal colour image would be very different in black and white.

Images displaying a range of tones of just one colour can be very powerful. Monochromatic colour renders a picture with mood dependent on its tone, usually either cool or warm. I do love working in the cool blue light before dawn; in such conditions a monochromatic image is an almost given. The appeal of both minimal and monochromatic colour is quite different to black and white; there may not be a lot of colour present, but the impact of the restraint is tangible. Without just a trace of colour the feel of the image would be very different.

The issue of how vibrant we desire the colours in our pictures to be is a Hot Potato. We now have the option in post-production to boost colour at will using the vibrancy, clarity and saturation sliders. These controls really ought to come with a public health warning, as the temptation to overcook pictures to the point where the colours induce nausea, cold sweats and vomiting is clearly difficult to resist. It's easy to think after long hours hunched in front of the monitor working through a processing backlog that just a touch more vibrancy will enhance the picture just a touch more, but in reality the point where the reverse is true is very quickly reached. Gruesome, unbelievable colours are a product of our age; all too many strong images are ruined with over-the-top post-production and the oversaturation of colours. Subtlety consequently stands out in comparison. There is a glaring difference between the colours produced by lighting and subject matter, and those artificially boosted by over exuberance with the vibrancy slider.

Surrounded by such overly colourful images it's not surprising that black and white photography is experiencing a real renaissance. It's a medium that is in rude health, even amongst recent recruits to our craft who have never known the experience of watching an image appear in a developing tray under the safelights.

Market at Pyin Oo Lwin, Shan Highland, Myanmar (Burma). Canon 1Dx, 35mm lens, 1/80 sec at f1.4, ISO 800. I have all too many pictures of ladies selling vegetables from around the world, but markets are such bustling hives of colour, I can't resist them. Processing a picture like this, I have to be careful not to boost the colours unduly when tweaking the levels and tone curve; contrast and colour are inextricably linked. With such a technicolour subject, overcooking the post-production would quickly result in gruesome artificial colour.

Eiffel Tower and Champs de Mars in spring, Paris, France. Canon 1Ds Mk II converted for infrared, 17mm TS-E lens, 1/80 sec at f11. There is something about Paris that just shouts Black and White to me. I guess it's the associations with the classic French reportage photographers of the past: Cartier-Bresson, Doisneau, Lartigue, Brassai. These days, when we jump on Eurostar I'm think monochrome from the outset; it's fun to conceive a whole project that will run for years only in black and white. However Paris in the spring is a city in bloom; it's a subject difficult to portray in black and white, unless I'm shooting with a camera adapted to be receptive solely to infrared light as here. Then fresh vegetation records almost white against a sky that turns black.

Shooting in black and white digitally gives us every bit of flexibility and quality we desire, although the purists would argue the feel of black and white film and paper is impossible to replicate. That's a moot point, and somewhat akin to the old CD vs vinyl debate in the world of music, but however we choose to work the power of black and white is obvious. Whether it's because of a nostalgic appeal, or because colour often distracts, or because for some reason black and white seems synonymous with fine art, the bottom line is that when it's done well it looks fantastic.

So in a nutshell, what makes a black and white image work? Shape, tone, texture and form are the key ingredients. Personally I think the best black and white work is done when the photographer is thinking with his or her mono hat on from the outset. We have the ability to choose to convert subsequently at will, but the elements that make a picture work in black and white are so very different from in colour that the best images are those that have been conceived and composed with monochrome in mind, and a whole project executed in black and white has far more cohesion and impact than the odd random image converted in retrospect.

There is a time and a place for all of these approaches. They are all techniques to be kept in reserve in our creative arsenals, but again, having the vision to know when full, complementary, analogous, minimal, monochromatic or black and white colour is best going to express the idea lurking in our minds is just another skill to nurture and experiment with.

Moody evening sky over the Tugela Valley with the Drakensberg Mountains beyond, KwaZuluNatal, South Africa. Canon 1Ds Mk III, 14mm lens, 0.3 sec at f8. The original colour image shot in the cool twilight at the end of the day showed an angry sky full of deep blue tones. In retrospect I thought the rich colour detracted from the message of the brooding malevolence of a thunderstorm and thus chose to reprocess as a black and white image, which I think works well. Normally I'd choose to make such decisions before touching the camera, but every rule is made to be broken.

An abandoned crofter's cottage by a lochan, Sutherland, Scotland. Canon 1Ds Mk III, 24–70mm lens at 46mm, 4 min at f8, 0.6 ND grad and Big Stopper filters. With so little light and under such a thick layer of grey cloud, minimal colour was the only feasible approach. I do like the muted blues and browns though. Subtlety is the hardest of all looks to pull off.

Race horses being exercised on a misty morning at Venn Farm, Milborne Port, Somerset, England. Canon 1Ds Mk III, 24–70mm lens at 46mm, 1/50 sec at f5.6. By nature, the light bouncing around the atmosphere on a misty morning is a high colour temperature. I could choose to correct the resultant blue colour balance but it's not my style; I love the cool monochromatic light at that time of day. The merest hint of sunlight burning through the mist to reveal a trace of green is a subtle touch made by Mother Nature.

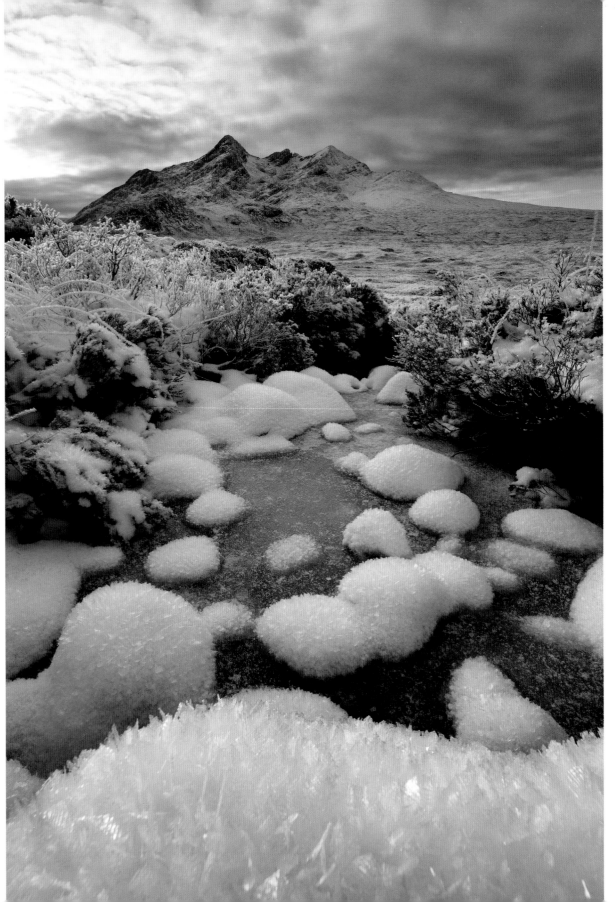

Glen Sligachan anad the Cuillins
in winter, Isle of Skye, Scotland.
Canon 1Ds Mk III, 17mm TS-E lens,
1/40 sec at f14. Restrained minimal
monochromatic colour at work.

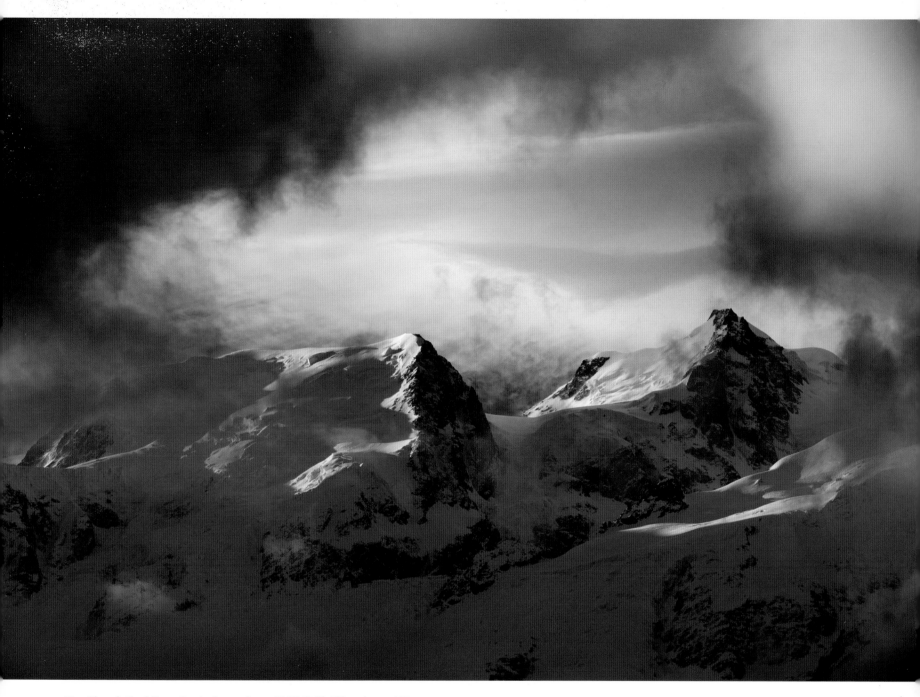

Mont Blanc du Tacul, Haute-Savoie, France. Canon 5D Mk III, 70–200mm lens at 105mm, 1/125 sec at f8. Just one colour – blue – was apparent as the clouds over Mont Blanc parted for a few minutes after days of rain and poor visibility, but what mood this evokes.

PHOTO ESSAY: BURMA

Burma – or is it Myanmar? – is a tantalizingly exotic destination. For now it remains an intriguingly welcoming and beautiful country that is becoming less and less detached from the rest of the world by the day. For a photographer it's a real treat, with a people so open to being photographed it's astonishing. Long may it remain so.

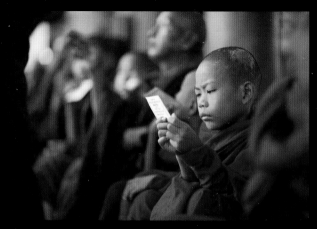

Monks at the Shwezigon Paya, Bagan. Canon 1Dx, 85mm lens, 1/800 sec at f1.2.

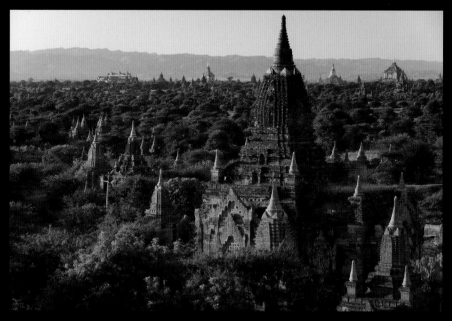

The Temples of Bagan. Canon 5D Mk III, 70–200mm lens at 140mm, 1/6 sec at f11.

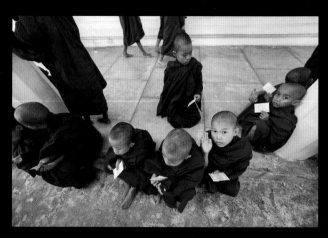

Monks at the Shwezigon Paya, Bagan. Canon 1Dx, 14mm lens, 1/50 sec at f5, ISO 400.

A woman etching laquerware, Bagan. Canon 1Dx, 85mm lens, 1/200 sec at f1.2, ISO 800.

Monks at the Shwezigon Paya, Bagan. Canon 1Dx, 70–200mm lens at 200mm, 1/200 sec at f7.1.

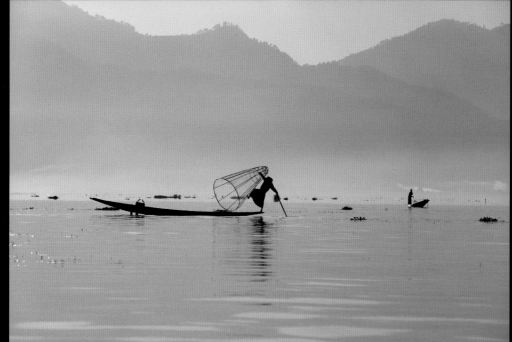

Fishermen at Inle Lake, Shan State. Canon 1Dx, 70–200mm lens at 200mm, 1/800 sec at f10.

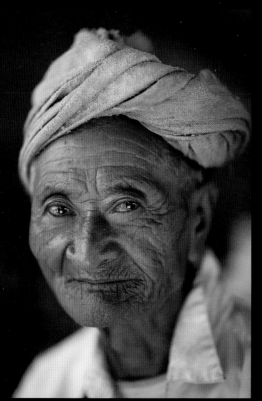

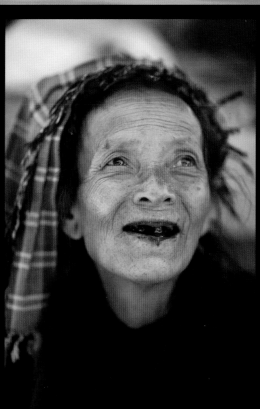

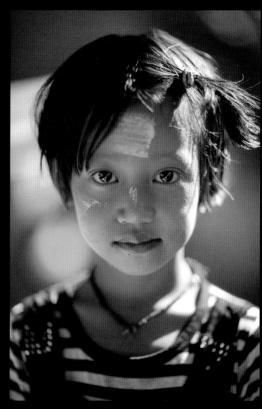

A man at Inle Lake, Shan State. Canon 1Dx, 85mm lens, 1/400 sec at f1.2, ISO 200.

A lady with teeth blackened by chewing beetle nuts in the market at Nyaungshwe, Inle Lake, Shan State. Canon 1Dx, 85mm lens, 1/2000 sec at f1.4, ISO 200.

A girl at Inle Lake, Shan State. Canon 1Dx, 85mm lens, 1/3200 sec at f1.2.

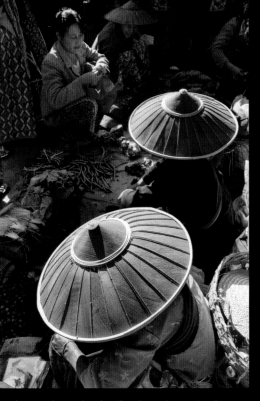

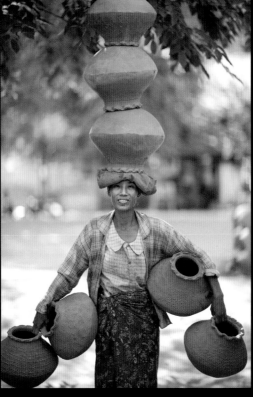

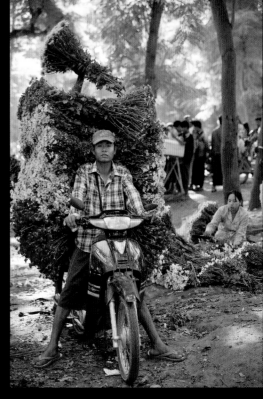

Market at Inthein, Inle Lake, Shan State. Canon 1Dx, 35mm lens, 1/125 sec at f8.

A lady carrying pottery, Mandalay. Canon 1Dx, 85mm lens, 1/600 sec at f1.2.

Flower market on a roadside, near Mandalay. Canon 1Dx, 24–70mm lens at 70mm, 1/320 sec at f2.8.

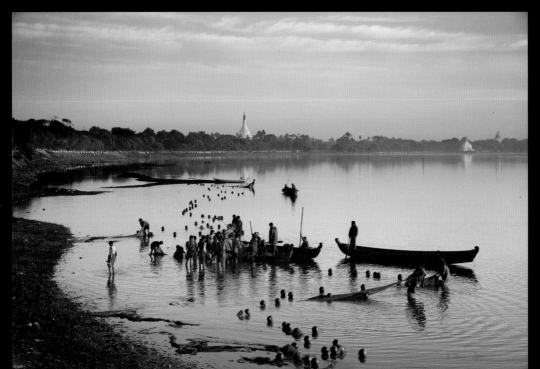

Fishermen on Taungthaman Lake, Amarapura. Canon 5D Mk III, 24–70mm lens at 59mm, 1/30 sec at f8.

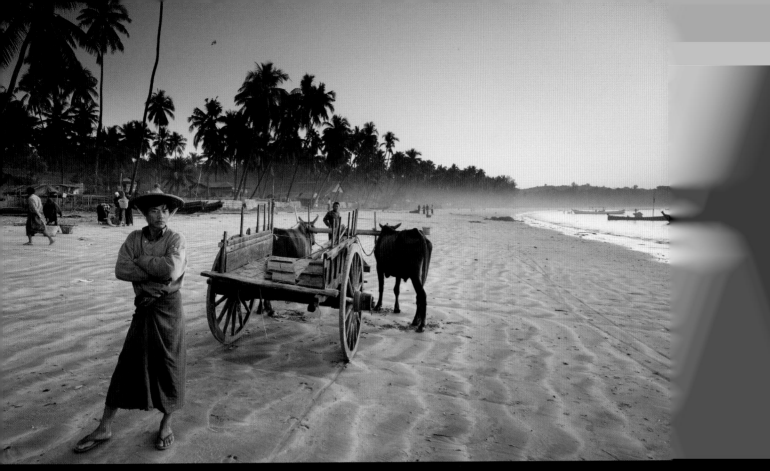

A monk with a tablet in Kandawgyi Gardens, Pyin Oo Lwin. Canon 1Dx, 24–70mm lens at 70mm, 1/800 sec at f3.5.

Soon U Ponya Shin Paya, Sagaing Hill, Mandalay. Canon 1Dx, 85mm lens, /125 sec at f16.

Chapter 7

The Plan

I am starting to feel a touch guilty. Some of you may have purchased this book with the prospect of a holiday approaching and the opportunity to indulge your enthusiasm for photography in mind. As may now be apparent, the pursuit of our craft requires commitment and devotion; it also imposes a timetable on a trip that is at complete odds to what most call a holiday. Friends, family and partners accompanying you will need to have the patience of saints. Companionable dinners, lie-ins, pleasant strolls, lazy days; forget it. The routines of scouting and shooting mean arising in the dead of night, waiting for long hours, missed breakfasts, frustrating days of location searching and evening vigils by the tripod. The demands of photography will require a plan, and such plans will tend to dominate the timetable of your so-called holiday if you are a true slave to your creativity. If this book has filled you with inspiration to get out behind the lens exposing, quite frankly I fear for your relationships. Photographers' partners are a long-suffering species, as Wendy can vouch.

Durdle Door at dawn, Jurassic Coast, Dorset, England. Canon 1Ds Mk III, 24mm TS-E lens, 30 sec at f11, 0.9 ND grad and 0.9 ND filters. Hitchcock contrived to appear as a walk on part in all his films, and I in similar fashion have decided Durdle Door should appear in each of my books. I know the world is not exactly short of images of this iconic coastal arch, but it's a place on our home patch that means a lot to us, and I will never tire of shooting it in all sorts of lighting situations and seasons. This was the first time I'd considered shooting the Door backlit against the pre-dawn twilight sky, which inevitably required arriving in darkness after another outrageously early start. In fact, yomping along the coastal path by the light of my torch is, once the brutality of the early morning alarm has worn off, one of the best bits of doing what I do – I love it. I feel as if I'm doing something special and am on my way to experience a unique encounter with Mother Nature. When I look back over all the dawn and dusk patrols so far and think of the vistas beholden, I feel a very wealthy soul. That's the joy of photography.

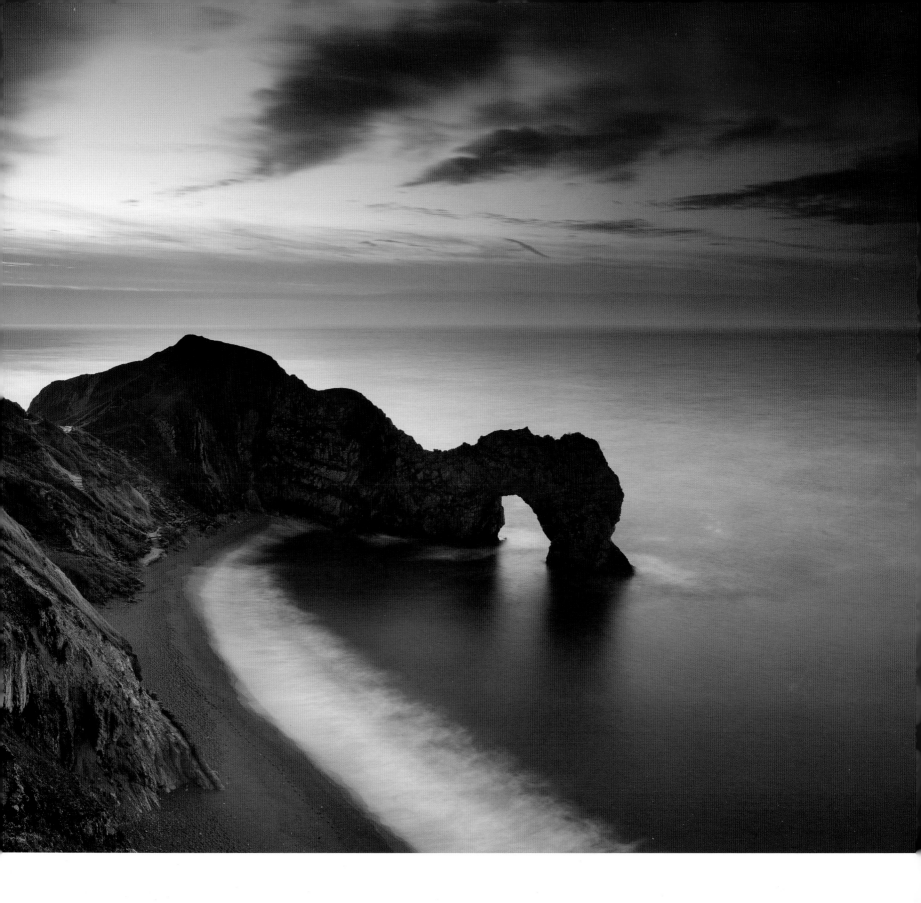

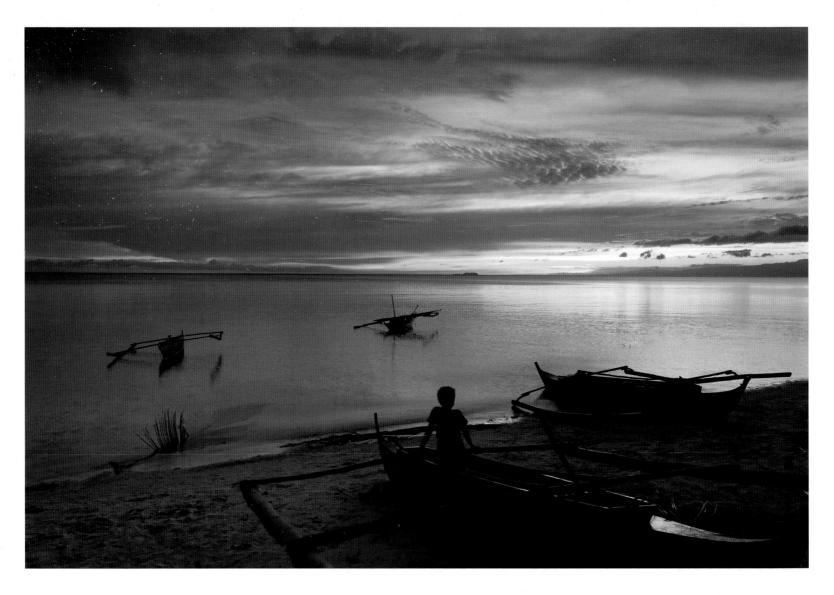

Boats and a boy on San Juan Beach at dusk, Siquijor, the Visayas, Philippines. Canon 1Ds Mk III, 24mm lens, 0.5 sec at f11, 0.9 ND grad filter. Not all shoots involve arduous hikes and freezing conditions. The beauty of basing ourselves in a hut on the beach here in tropical paradise was that I could explore the visual potential on our doorstep for several days running. I could say this local lad was pondering his family's future in an uncertain world of dwindling fish stocks, rising sea levels and climate change, but knowing the resilient optimism of youth, he was probably just wondering what was for dinner.

Still, it'll be worth it – although your partner may not agree. So now it's finally time to make the picture, what's the plan? What, where, how; the nitty-gritty of being in the right place at the right time now comes into play. With the idea and location bagged and due consideration given to the light, weather and creative options, the challenge now is an exercise in logistics to ensure we are in position suitably equipped for the Moment. The plan may be as simple as: drive to the location late afternoon, shoot and get home for dinner. The trouble is, what we're trying to do usually requires a bit more commitment; unique images are not often made in locations with convenient car parks alongside. Of course there's no reason why great pictures can't be made from the roadside, but most locations are a touch trickier to access, and if the desired light for a particular shoot is the twilight before dawn or after dusk, a hike in the dark becomes a certainty. So our first consideration is transport: how are we going to get there and how long will it take?

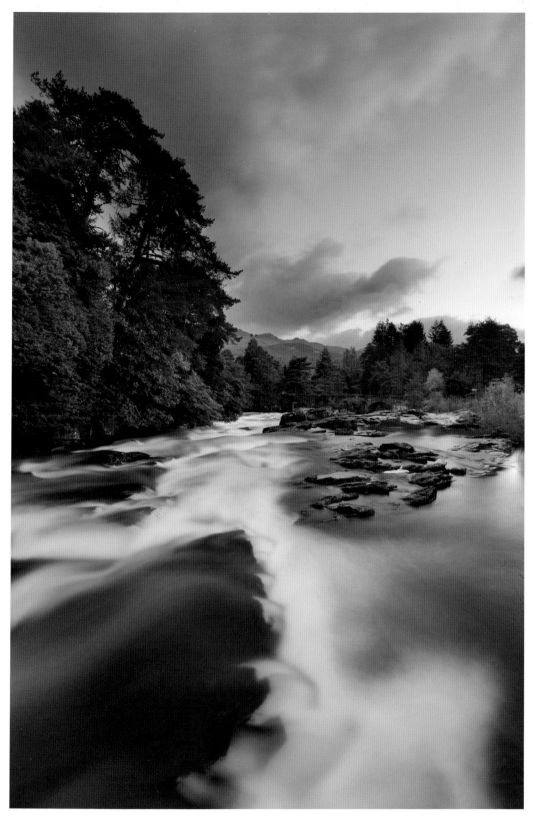

Falls of Dochart, Killin, Perthshire, Scotland. Canon 1Ds Mk III, 17mm TS-E lens, 20 sec at f16. I like to arrive early on location, but in this case I took it just a touch too far; I had to wait for at least an hour in the cold darkness before the first glimmer of light appeared in the autumn sky. Yet better that than being rushed and missing the moment, and those waiting hours over the years have usually been spent experimenting with exposures in unusual light; all part of the learning process that never stops. Here I spent the best part of four hours totally engrossed as the scene evolved from pitch black to bright sunlight. I only realized how chilled and hungry I was when I stepped back from the tripod after the last exposure. Never has a Full Highland Breakfast tasted so good.

I always like to arrive early. There's nothing worse than rushing to get into position and setting up as the light tantalizes. Besides, standing watching the light on the landscape evolve from starry skied darkness through the evocative misty moods of dawn to daylight is one of the fundamental joys of this game; it never fails to stir the soul. Of course the whole process is repeated in reverse at dusk, but for me there's something special about watching the world awaken, which brings me to a truth unpalatable to some: early rises are part and parcel of what we do. How early? The answer is as early as necessary, and that will depend on how long the days are and how long the journey in is likely to take. On a recent trip to Patagonia I was arising at 1.30am; you see what I mean about holidays and partners? If you are not an early morning person then maybe it's better to stick to portrait photography.

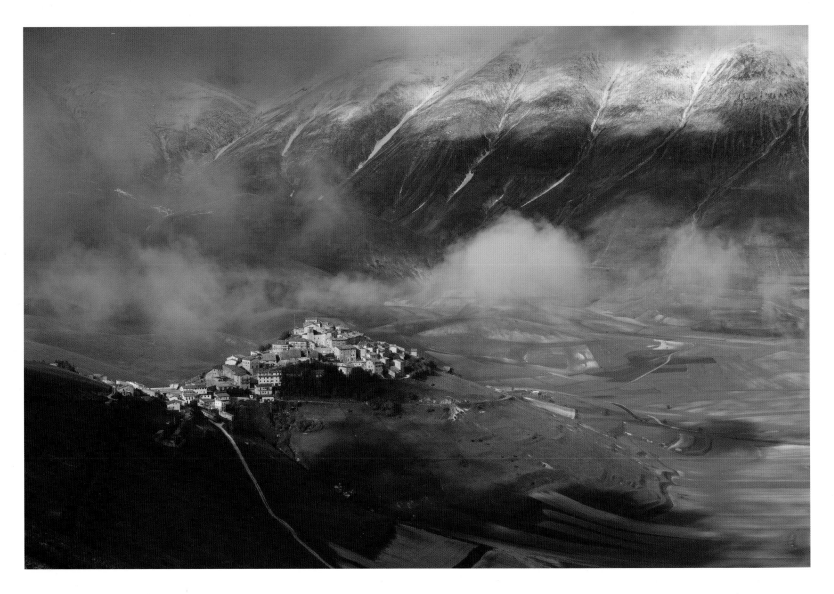

Castelluccio and the Piano Grande, Monti Sibillini National Park, Umbria, Italy. Canon 1Ds Mk III, 70–200mm lens at 70mm, 1/640 sec at f5.6. There are times when having a vehicle capable of reaching places that are inaccessible to most saloons is an advantage. I do not advocate off-road driving across pristine wilderness, but where a rough mountain track used by the locals exists, a 4x4 opens up opportunities. Sure, I could have hiked up from Castelluccio and would do so if necessary, but I'll use the tools for the job when I can, be it a boat, train, rickshaw or my Land Rover.

Clearly, when regularly rising in the wee small hours, the whole schedule of the days has to be shifted accordingly. On a long trip, keeping such hours day in day out requires adopting the unusual routines so familiar to nurses on shifts and seamen on watch. The toughest bit is catching up on sleep in the day; without fail some handyman starts up a power tool right by our tent or the chambermaid wants to clean the room just as we're having an afternoon kip.

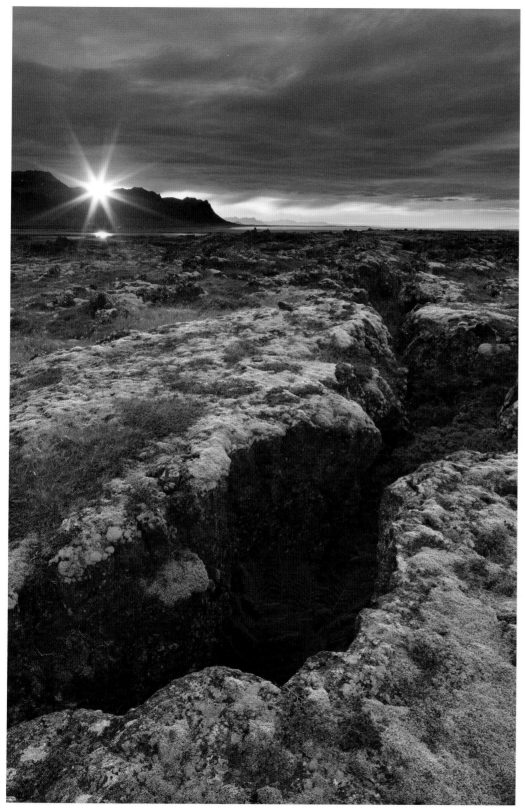

Sunrise in amongst the lava fields on the coast at Budir, Snaefellsness Peninsula, western Iceland. Canon 1Ds Mk III, 24mm TS-E lens, 1/4 sec at f16, 0.9 ND grad filter. Dawn in the Icelandic summer means horribly early starts, if sleep is an option at all. Here I was shooting until close to midnight and was up again for first light at 3am; keeping such hours over the course of a week or more takes its toll. On landscape shoots such as this I wouldn't be without my tilt-and-shift lenses.

The transport itself is the next consideration. We've used every mode imaginable to reach the location in our time: cars, planes, trains, boats, bikes, donkeys and feet. I'm all for making life as easy as possible though; why face an hour's drive when it may be possible to stay within shouting distance? Being able to spill out of the sleeping bag or B & B straight on to the location is an indescribable treat, particularly when the days are long.

In any case, when doing the location search I will time the journey to allow leeway for getting there. Most locations require a walk in of some degree, so either arriving or departing in near darkness is highly likely. It's why the ubiquitous head torch is one of the handiest gadgets in my bag. I would never be without it, not just in the wilds, but also when stumbling around an unfamiliar hotel room in a jet-lagged fugue trying to find the light switch. It also comes in handy for reading menus in dim restaurants, much to the cringing embarrassment of Wendy; I told you she was long-suffering.

Glen Sligachan anad the Cuillins, Isle of Skye, Scotland. Prior knowledge of this location from several backpacking jaunts convinced me of the visual potential long ago. We've camped on the site nearby many a time, usually in atrocious weather. Maybe I'm getting soft, but on this occasion I opted to stay in the hotel just yards from this spot, which enabled me to shoot the Glen in the early evening light before heading back for dinner. I'll use whatever accommodation is most convenient for a location, be it a tent, hotel or rented cottage. I used to lug two camera systems about with me on landscape shoots, a panoramic film camera as used here and a 35mm system; my bag consequently grew far too cumbersome. Now using a full frame DSLR system I have all the flexibility I could wish for and a more portable load, although the fully laden bag still seems to weigh a ton going uphill.

Other considerations on equipment are just as crucial, particularly regarding clothing. It's an inescapable fact that the best locations are often the most exposed, windy, frigid vantage points. Being cold on a shoot should only ever happen once, but getting the layers right takes thought and planning. The challenge of being there may involve a sweaty yomp up a hill followed by hours of immobile waiting in the sub-zero wind; dressing for those contradictory challenges requires a well-considered outdoor clothing system comprising base, thermal and protective layers, with additional layers to be donned or jettisoned as required. Even in summer on lofty cliffs before dawn clothing needs to be considered. If we are miserable, shivering and uncomfortable we can't do the job, and the pictures will suffer. In hot environments the challenges are different, but water is a prerequisite wherever we are shooting.

And so to the actual photographic equipment: what to take? I have far more lenses and bodies than I can ever carry at once, so I always make decisions based on what I'm shooting. For a landscape shoot after a

detailed recce I should be able to decide on the focal length I need and in theory could go with just one lens and a body, but to do so would be tempting fate. My whole approach for landscape work is meticulous and I'll usually have a precise idea of the shot I'm after, but few plans ever survive the first contact with reality, and not being able to respond to unforeseen opportunities with the appropriate lens as Mother Nature reveals her multitudinous moods would be a big mistake. The idea is the starting point for the plan, but many is the time that I've veered off on a tangent to explore other creative options that unfold after I've nailed the desired image. I may appear to be contradicting myself here, as I've already preached the wisdom in these pages of not faffing about and having faith in our ideas. Yet that's not to say the idea may just be the starting point for a train of thought that ends up producing an image radically different from the original concept. The original idea may just be the germ that allows creativity to flow, but the plan is the foundation that makes it all possible. Being there is half the battle.

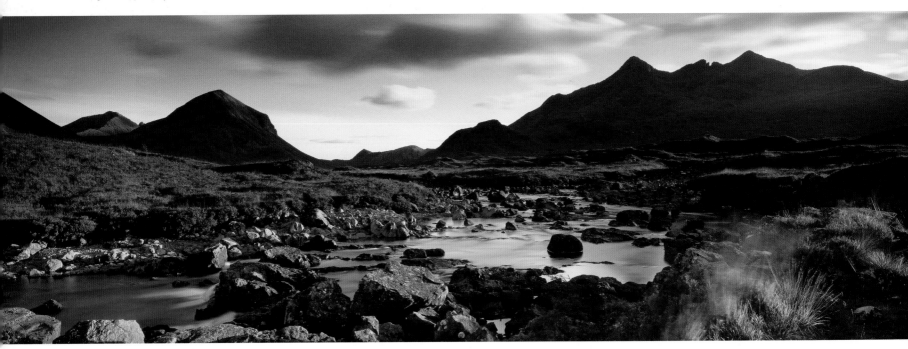

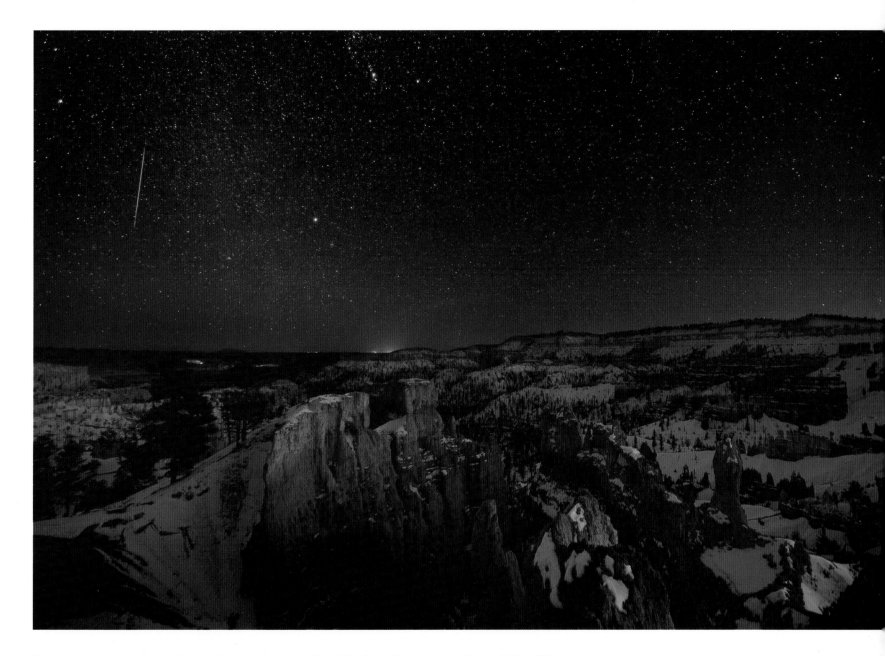

Shooting star in the night sky over the Amphitheatre, Bryce Canyon, Utah, USA. Canon 1Dx, 14mm lens, 20 sec at f4, ISO 12800. Making a picture like this involves careful planning, not least as the basic tasks of framing and focusing are difficult in the pitch black. The composition needs to be finalized when there's still light to see. On such shoots a head torch is an absolute necessity, as is appropriate clothing. Mid-winter in Utah at an altitude of 2,400m (8000ft) in the middle of the night I wore multiple layers of goose down to insulate, although inevitably the fingers still suffered; they just don't make cameras to be used with gloves on. With my torch doused I just stood watching the sky in awe as I exposed, and then a shooting star streaked through my frame – magic.

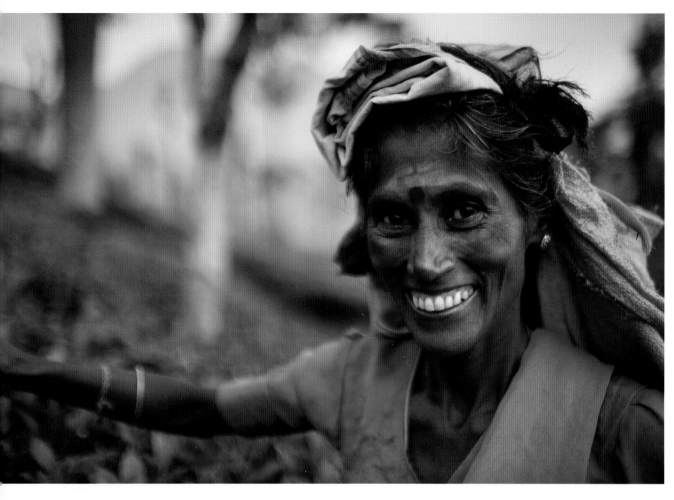

A tea plucker in the hills above Ella, Central Highlands, Sri Lanka. Canon 5D Mk II, 35mm lens, 1/5000 sec at f1.4. This was one of those chance encounters that could never be predicted. I was on my way back from an early shoot that hadn't really come together, when there in the lush fields of tea was this charming, beaming lady just waiting for me to walk past. It pays to be flexible with your plans to enable such opportunities to unfold. The very process of heading out to enticing locations with an objective in mind means the likelihood of such lucky encounters increases, even if the original concept hasn't worked. On most shoots in Sri Lanka I packed my fast 35mm lens with these sorts of eventualities in mind.

So the desirability of flexibility is a given, which means having the lens options to suit. Decisions on what to carry will always be a trade-off between portability and functionality. Carrying too much is usually a mistake. After all, it's only possible to use one camera and lens at a time, and if the walk in becomes a load bearing slog the enjoyment of the experience will be lost; at the same time, a burden that ends up restricting mobility is counterproductive. Generally speaking, for a typical landscape shoot I'll carry one body and lenses ranging from the 14mm super wide prime to the 17mm and 24mm tilt-and-shifts with 24–70mm and 70–200mm zooms, but that does vary depending on the idea and how arduous the approach is. Sometimes something longer is needed, in which case I'll pack the 100–400mm zoom, but generally there aren't many situations where the combination of a body and just two lenses – the 24–70mm and 70–200mm – won't suffice. If the light's good enough, these two workhorse optics can cope with most eventualities. Being there for the Moment is far more important than the equipment that is deployed.

Often going light has distinct advantages, particularly when working in crowded or busy environments, and having a plan is just as crucial for a spontaneous shoot involving unpredictable people, such as that of a Burmese market. The actual shots may not be preconceived but the way of working will be, and in such bustling surroundings my favoured set up is a small bag, one body and just two fast glass primes: the 35mm f1.4 and the 85mm f1.2. Changing lenses crouched over a gargantuan camera bag amongst the heaving throngs is not a feasible option. Normally I try to make the most of fleeting encounters as they unfold with the lens to hand; the moment will be lost by the time I've fussed around changing glass, and a tripod in such a setting would just be a millstone around my neck. Being quick, spontaneous and responsive is vital, but an idea for how I'm going to tackle the shoot and a recce of the setting is still valuable preparation. Whatever the shoot, we always need a plan with precise timings and objectives; after all the sunrise waits for no one, and the Decisive Moment is rarely repeated.

180-degree panorama of the Pont des Arts with the Institut de France and Left Bank of the Seine, the Île de la Cité (left) and Eiffel Tower in the distance (right), Paris, France. Canon 5D Mk II, 24–70mm lens at 42mm, 1/20 sec at f8, ISO 200, 0.6 ND grad filter. I had the idea in mind for this shot well before boarding the Eurostar. Piecing the shoot together required an unusually complex plan that involved models in the form of Wendy and our friends. On the recce the previous day I was horrified to see the garish green rubbish bags Paris City Council had placed at regular intervals all along the famous Pont des Arts. With Heinz, Tanya and Wendy placed strategically to hide the nearest offending eyesores, I got on with the job of making the panorama. Just as I was shooting, a man looking like an extra from a film about the Maquis walked across the bridge as if to order. My Mrs sporting a beret and looking suitably Parisian chic added to the atmosphere, but I'm not sure about Heinz; it looks as if he's about to have a pee in one of the bins!

Journal Entry: Filipino Island Hopping

DAY 2

On Alona beach, possibly the worst busker in the world is serenading the dusk diners feeding on grilled seafood under the palm trees. His rendition of Clapton's *Wonderful Tonight* is anything but wonderful and people are paying our minstrel to move on; it's time for us to head somewhere a little less popular. I've had my first productive shoot of the trip at the distinctive Chocolate Hills here on Bohol, and tomorrow we set sail for the island we can see on the skyline to the south: Siquijor.

DAY 3

We approached a boatman on the beach, pointed to the island to the south and said 'take us there.' Three thousand pesos and two hours later we're wading ashore, camera bags held precariously above our heads, on to a gem of a Pacific tropical island. It's what island hopping in the Visayas is all about.

DAY 6

It is becoming increasingly difficult in this crowded world to find tropical islands untouched by rampant development, so maybe I shouldn't be letting on that in the Philippines they're ten a penny. Deserted crescents of white sand, overhanging palm trees, beach bungalows, smiley fishermen, verdant landscapes, waving children, lush forests, geothermal pools and waterfalls – we're just about coping.

Actually, I'm feeling guilty; these trips are supposed to be challenging adventures requiring all our experience, wit and resolve. But I do have to deal with some serious challenges here on Siquijor: we've no cash, my fingers are red raw, and there's sand in my camera bag.

Long, earnest discussions with fellow travellers ensue: there's a rumour going around that the only ATM on the island is dispensing cash this morning. A mad dash across Siquijor on our mighty Honda 100s follows. Will my card be accepted? It's a lottery. We might be peeling prawns to pay our way, if my fingers can take any more crustacean abuse.

DAY 7

Yet another spectacular evening light display arcs twilight over the Visayas. Earlier I shot a portrait with the 17mm tilt-and-shift, which was a first; now I'm working quickly, as dusk in the tropics is a short-lived affair. The sun drops over Negros, our next destination; in the afterglow of orange and blue, women wade in the placid waters looking for shells, molluscs, and maybe even prawns to torment my red raw fingers. I'm totally absorbed, revelling in the light. Do you know, I think I'm enjoying my photography more than ever.

Just yards from where I'm shooting a crisis is developing. With just minutes of Happy Hour left Wendy has ordered her Pina Colada, but there's a power cut. Will she get served in time? It's as much stress as we've had to deal with since…actually, since our last run to the ATM.

DAY 9

We've voyaged over the water to Negros. Whose idea was it to come to Dumaguette? Mine. Ah well, it doesn't always pan out. After the best part of a week in a bungalow under the palms, the appeal of our sterile room with all the ambience of a hospital ward is limited. I really like the Philippines, but they don't have the culinary heritage of other Asian destinations; the food is getting a little predictable. I'm eyeing the Swiss Chalet restaurant on the front, but resist. Would a Swiss/Filipino schnitzel be wise?

DAY 10

I'm out by the roadside in the south of Negros experimenting with panning shots of the overloaded tricycles and jeepneys that are such a part of Filipino life. How many Filipinos can you get on a tricycle? I've counted 15. Everyone waves as they pass. Inevitably a few local children materialize out of nowhere, curious as to what I'm doing. One introduces himself as Mike Angelo. He'll go far.

DAY 11

We ride to Pulang Bato Falls up the slopes of the volcano. Inland Negros is beautiful with red rocks stained by the water that is high in iron content. The contrast with the lush green vegetation is striking. It's Saturday, so I have to choose my moment as picnicking Filipinos keep wandering into shot. One particularly boisterous group of women are frolicking under the cascade. I decide to make the shot with them in, wondering if it's a hen party.

Back at base we're in Kleine Deutscheland; we're the only non-Germans. No problem; it looks like I will score a schnitzel after all.

DAY 12

We awake to the sounds that have become the norm: cockerels, the surf, and the wind in the palms. Tonight we'll be in congested Manilla. We've only scratched the surface of the Philippines, not surprising considering there are over 7,000 islands to choose from. It's another place we'll just have to come back to.

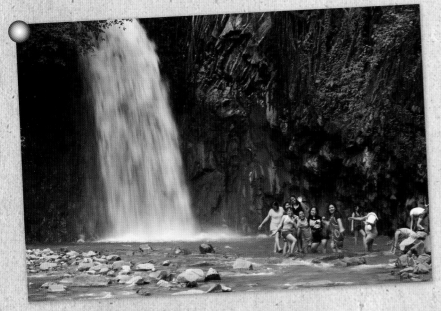

The Moment

Looking up I could see stars. It was also still with no wind and cool in the darkness. Yesterday we'd had rain; these were the exact conditions needed for localized mist to be draped over the Purbecks. Plan A was rapidly replaced by Plan B: Corfe Castle. We arrived at the foot of the Norman ruins in darkness, with the looming presence of the castle above only dimly visible, and trudged up the hill to the west by the lights of our torches. As we climbed, my excitement grew as the scene in the half-light below revealed itself; this was looking good. Off to the south-east, out to sea, a bank of thick fog hovered low threatening to obscure our view, but for now as the first dim twilight seeped through the sky the stark shattered towers of the castle stood out against the wisps of mist draped around it. I set up hurriedly, composed and waited briefly for the right combination of mist, ruins and hills beyond, conscious of the fact that the fog could close in at any time. That's the thing about mist; it's unpredictable stuff.

The lights from the village below lit up the mist at the base of the mound with an orange glow as if fires still raged from a Roundhead bombardment. A trace of mist crept in behind the castle whilst the hill behind was fleetingly visible; that was my Decisive Moment and I exposed in the cool blue light. It was still so dark that a 30 second exposure was necessary even at an aperture of f5.6 with the ISO upped to 400. With the white balance set resolutely to daylight the rich blue of the scene was revealed as I reviewed the RAW image on the monitor. A minute later the mist rolled in obscuring the view. We hung around in the damp fog for another couple of hours as day broke – as you do – hoping for another chance, but it became increasingly clear as the thick fog settled that those few minutes just after we arrived had been the Decisive Moment.

Corfe Castle in the mist at dawn, Dorset, England. Canon 5D Mk III, 70–200mm lens at 105mm, 30 sec at f5.6, ISO 400. In near darkness the scene of the early mist wrapped around the stark towers of the castle that was so badly battered by the Roundheads in the English Civil War was ethereal. Conscious of the fact that the mist was threatening to close in on the view at any moment, I upped the ISO to 400 to allow a more manageable exposure time of 30 seconds and hit the shutter release. Sure enough, a minute later the view was obscured and that was my Moment gone, never to be repeated; every misty dawn is different. I've often thought this scene is far more evocative with the castle as a shattered ruin than if it still stood undamaged. Built by William the Conqueror in the wake of the Norman invasion, held as a Royalist stronghold, besieged by the Parliamentarians; a millennia or thereabouts of English history captured in one fleeting moment.

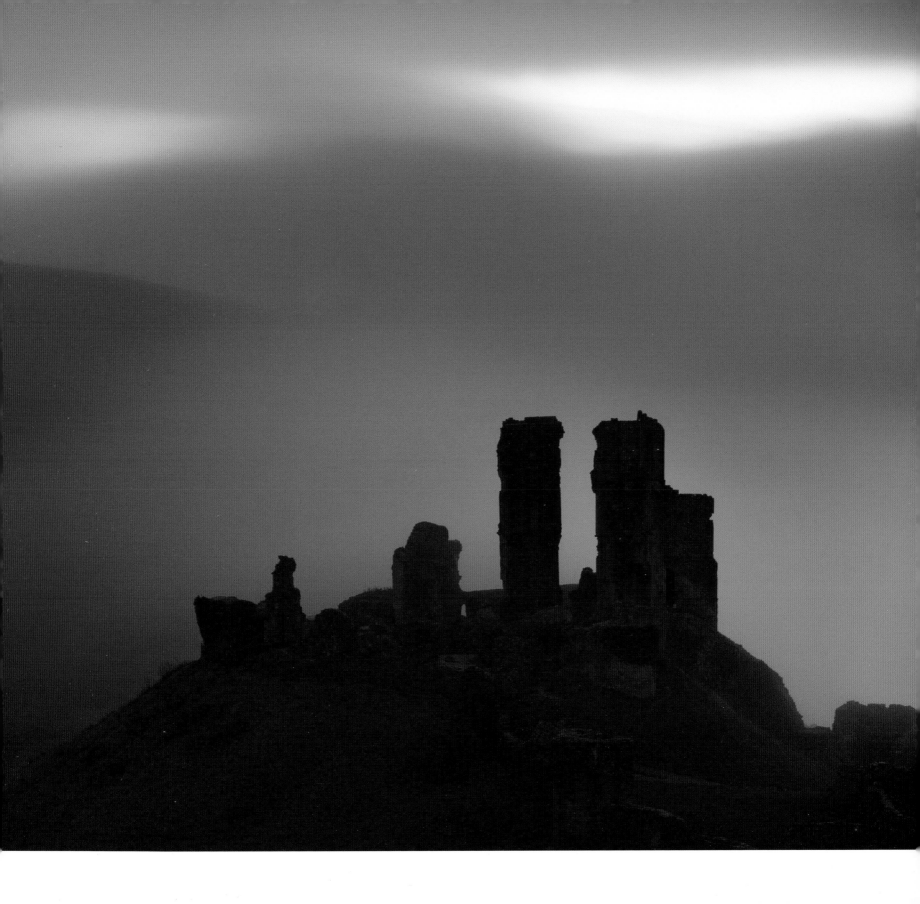

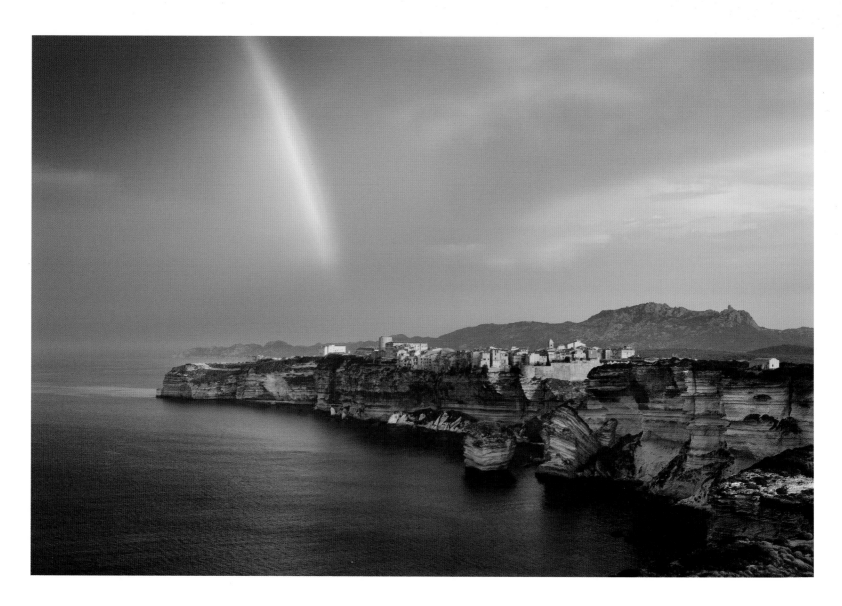

Rainbow over Bonifacio, Corsica, France. Canon 1Ds Mk III, 24–70mm lens at 59mm, 1/8 sec at f11, polarizing filter. I could never have predicted that a rainbow would appear that morning; nothing heralded the slight shower that suddenly came out of nowhere to douse us on the cliff top. The thing is, I know if I put myself in the right place at the right time enough good things will happen eventually. I'd had the light I desired that morning and made the picture I'd planned, but this unforeseen Moment lasting just seconds was the icing on the cake.

Everything this book has been about so far is all about preparing for such moments; being there ready doesn't happen by accident. Now the final piece in the jigsaw waiting to click into place to complete the process of converting our vision into reality is the challenge of recognizing the Moment as it's about to happen. As a workshop guest once said to me, 'I know there's a Decisive Moment for every shot, it's just I can't recognize when it is.' He is not alone; often it's only apparent in retrospect, which is of course way too late.

It was the famous French photographer Henri Cartier-Bresson who coined the term to describe his approach to his finely observed reportage. He reasoned that there is just one fleeting Decisive Moment in time when all the elements in a picture combine perfectly to convey a message. Few would argue with his concept when applied to his perceptive images of Parisian street life, but I believe strongly it's a truism that applies to every picture we make. The Decisive Moment may last for a thousandth of a second, one second or, more rarely, ten minutes, but

it's a fact that there is a moment when it all comes together just a little bit better than the moments before or after – whether we're shooting a landscape, a portrait or a street scene. Only when shooting a still life in the suffocating confines of a studio where the lighting can be controlled to order does it not apply, and even there the photographer condemned to a life shooting plastic products and plates of food whilst pining for the Great Wide Open will know when it all comes together just so.

Most Decisive Moments can be predicted. When setting up a landscape shoot I will arrive early, but the process of predicting the light on the scene that will work best will take place well before that on the recce. The anticipated moment may well be when the first direct rays from the rising sun paint the scene, or just before the sun dips over the hill to the west, or when the shadow across the foreground is finally banished, or when that last light of the day lingers in the twilight sky. It's up to us to have thought all this through well beforehand and to be ready, picture composed, camera on the tripod, filters attached, exposure determined and finger on the remote release button. All that just doesn't happen by chance.

A house on the campo near Los Molinos, Periana, Andalucia, Spain. Canon 1Ds Mk III, 24–70mm lens at 27mm, 1/8 sec at f11, polarizing filter. The last light before the sun disappeared over the hill to the west was my Decisive Moment. I was ready and waiting, and the moment was entirely predictable; it's not always so.

The Roman Baths at dawn, Bath, Somerset, England. Canon 1Ds Mk III, 17mm TS-E lens, 4 sec at f11. I felt very privileged to be granted solitary access to the Roman Baths at dawn. This game of photography takes me to some interesting places that drip with historical atmosphere. I really revel in being alone, at the best part of the day, seeing such scenes in a way that very few others do. With the lights on around the baths I tried to imagine Romans slipping out of their togas and into the warm waters 2000 years previously. I'd done my recce the previous day, I knew the exact composition I wanted, and my Decisive Moment came as predicted when the exposure from the warm gas lights matched the levels of the cool ambient light outside. Don't you just love it when it all works as planned?

There are moments that are easy to identify, such as the fleeting opportunity at Corfe Castle, and others as the light just keeps changing and evolving when it's difficult to be sure what's working best then and there. Many a time I've been ready and waiting as the clouds part and lovely light paints the scene as hoped for. I expose, but the light just keeps getting better, so I keep working the shoot until the game is clearly over. I'll usually have a hunch when the Decisive Moment took place, but sometimes it's not apparent until I'm looking at the results later in Lightroom. Immediately after the shoot there may be a few similar options that are difficult to

choose between, but I can guarantee with the benefit of detachment from the raw experience of the shoot that the Decisive Moment will be apparent a month or so later. I always work with the assumption that the Decisive Moment will be fleeting and unrepeatable. If Mother Nature delivers a second chance then I'll gladly take it, knowing full well that one shot will be better than the other. When such prolonged shoots occur, I'll start the edit at the point where the light was at its best and work backwards, ignoring the also-rans. I really don't need loads of similars that aren't quite as good as The One from the Decisive Moment.

Loch Morlich and the Cairngorm Mountains, Cairngorms National Park, Scotland. Canon 1Ds Mk III, 24–70mm lens at 50mm, 4 min at f11, 0.6 ND grad and Big Stopper filters. Some Decisive Moments last a fraction of a second, others minutes. Here I deliberately prolonged the exposure using filters to record movement in the clouds and the water, but the Moment was the few minutes when dappled late afternoon sunlight played on the mountains in the distance.

It's usually the light that determines when is the Decisive Moment for a landscape image, but when photographing people all sorts of other intangibles come into play. Lighting yes, but composition, facial expression, hand movements, body language, eye contact and background detail all play a part too. Relating to the subject, getting the technique of focus and exposure right, and capturing the Decisive Moment gives the photographer a lot to consider in a very short time. Most people I shoot on my travels become self-conscious very quickly. The opportunity to make a spontaneous, relaxed portrait is gone before I know it; I may manage just a handful of frames, and overstaying my welcome never works.

A penitent in the Semana Santa procession, Malaga, Andalucia, Spain. Canon 1Ds Mk III, 85mm lens, 1/400 sec at f1.2. People do strange things in the name of religion, such as dressing up and parading through the streets at Easter. The eyes of this one penitent caught my attention, but as usual with these kinds of shots the out of focus background is just as important as the sharp foreground. The Moment came when the blurry shapes of the penitents beyond were just so, a fleeting moment barely registered before the shutter was released.

For that reason I will always get as ready as I can be before making contact with my victim; once permission has been granted I'll have just seconds usually before expressions become wooden and eyes glaze over. That means having my camera settings of exposure mode and compensation, focus point, ISO, aperture and shutter speed all pre-set and ready to go, with the intended composition considered and background detail or distractions accounted for. With every travel portrait shoot there will be one moment when the subject looks into my lens or a fleeting expression passes; that is the Decisive Moment. It can be so easily missed, and we're all haunted by the memories of shots that got away, but capturing that moment is a triumph to make the soul sing.

The ability to review what we've just shot is handy, but when shooting the people we encounter on our travels it's also a huge advantage to be able to show them the results. It helps to involve them in what we're trying to do and serves to break the ice. Often I'll do pictures as a precursor to show the subject before going for the shot I actually want, deliberately paving the way for the Decisive Moment. The monitor on the back of the camera can be dangerously seductive though; many a time on workshops have I noticed guests with their back to the subject scrolling through the pictures they've just shot whilst the build-up to the Decisive Moment is still playing out. Shoot first, look at the results later; these moments are so precious.

A novice monk at the Shwezigon Paya, Bagan, Myanmar (Burma). Canon 1Dx, 85mm lens, 1/320 sec at f1.2, ISO 400. These kinds of opportunities unfold so quickly; capturing the Moment relies on being ready with exposure, focus, composition and background all taken care of. This novice's fleeting eye contact with the camera was the Decisive Moment, gone in the blink of an eye. The way I work in such situations is in complete contrast to how a landscape shoot unfolds; it's a refreshing change, and makes capturing such moments doubly satisfying.

A monk crossing U Bein Bridge at dawn, near Mandalay, Myanmar (Burma). Canon 5D Mk III, 17mm TS-E lens, 1/60 sec at f6.3, ISO 400. This location the evening before was crawling with tourists and pleasure boats. The next dawn saw the rickety bridge somewhat quieter and I was able to set up and wait for a suitably Burmese passer-by to walk through my frame. The Decisive Moment came when this monk strolled by just as the sun was rising. This image was rigidly preconceived and constructed, but I had no idea if I'd be lucky with the human element. More often than not in Asia, setting up and waiting to see what transpires nets an image of interest.

Ella Gap at dawn from Little Adam's Peak, Southern Highlands, Sri Lanka. Canon 1Ds Mk III, 35mm lens, 0.3 sec at f11, 0.6 ND grad filter. I was dubious that this shot was working until a waft of mist crept up the valley from the other side and started spilling over the ridge. So often I do all I can, but the final ingredient that will make the shot relies on a random intervention from Mother Nature.

With so many factors contributing to what makes the moment Decisive, it's tempting to think that just blasting away to cover all eventualities is a sound cost-free insurance policy. However it just doesn't work; capturing the Decisive Moment requires concentrated observation and anticipation, no matter how fast our camera's drive or how capacious the memory card. That shoot from the hip mentality is a frame of mind totally at odds with the perceptive observation needed to capture the Decisive Moment. I for one am shooting fewer frames now than I did in the film era. That's mainly because there is no longer a need to bracket exposures, but also because I am far better at predicting and recognizing the Decisive Moment. Filling memory cards with mediocrity just condemns the shutter-happy photographer to hours of tribulation and drudgery spent wading through the less than inspiring results, whereas editing a tight shoot building up to a discernible Decisive Moment that nets the desired stunning image is a satisfying joy. It all comes back to the importance of quality over quantity, every time.

The whole process of creating a winning image that is a product of our unique vision has now played out. Following the creative path from the Idea to the Moment is, when it happens for the first time, a Eureka as well as a Decisive Moment. Life as a photographer will never be the same again, as the power of inspiration, pre-visualization and planning is realized. Those yet to see the light may scoff; those that have made the breakthrough will know exactly what I mean. Much of the pleasure of our craft is in the chase; particularly in being there and observing uplifting scenes and events that many never will. But the added satisfaction of looking at a print on the wall, replaying the experience of its creation, and knowing it's the product of your unique vision is what the joy of photography is all about.

Turenne, Limousin, France. Canon 1Ds Mk III, 70–200mm lens at 140mm, 1/4 sec at f8, polarizing filter. After the storm, with the heavy cumulus still filling the sky, the light was as good as it gets, glowing with a warm luminescence on the castle walls. Turenne is officially one of most beautiful villages in France, along with 148 others. How they decide defies me, as the country seems full of them; I'm hereby volunteering for the job of scouting for new ones. Tripping over villes such as this is what our rambles through rural France are all about. Although the nation's fleeting opening times frustrate, and it's a mystery how anyone earns a living, we are complete Francophiles; I even adore les escargots. As usual, we set off south with a loose plan, knowing it would be changed at will. We were originally heading further south, but never actually made it past the Dordogne Valley. Early summer was unseasonably wet, but the reward was misty mornings and evenings such as this. I would willingly wait weeks for light like this, but in the incomparably beautiful Limousin I didn't have to. And as for côte de boeuf du Limousin, well, it goes beautifully with a starter of snails in garlic.

Night sky over Lago Roca, Patagonia, Argentina. Canon 6D, 14mm lens, 20 sec at f4, ISO 12800. You can imagine my relief on arrival at 3am. I had told them all that the Milky Way would be bright in the sky over Lago Roca at this time of year and hour of night. All my research on the movement of heavenly bodies confirmed that, but research is one thing; I had no way of knowing just how bright the night sky would actually be on our chosen night. As we climbed out of the car and doused all lights we gazed in awe – I'd got it right. All I had to do now was make the shot, but when I saw the cloud drifting in from over Chile, I thought the game was over. We'd just started experimenting with the illuminated tent idea and it had taken a while to get the balance of the light levels right. Generally speaking, completely clear skies are a must for starry night shoots. I'd travelled a long way for this shoot, had a sizeable crew in support, an expectant client, and the pressure was on to nail the shot there and then. We might not have had the luxury of another clear night. The window of opportunity with the Milky Way in the sky to the south-west would last only about an hour before the twilight would start spreading through the heavens from the east, masking the impact of the stars. The cloud stared to obscure the Milky Way but I carried on shooting, still revelling in the moment. As I saw the monitor on the camera back shining with the result I knew we were on to a winner; the Milky Way was glowing through the thin cloud, and the shape of the formation provided a strong diagonal lead-in line to the tent. I realized the shot was actually stronger with the cloud than without.

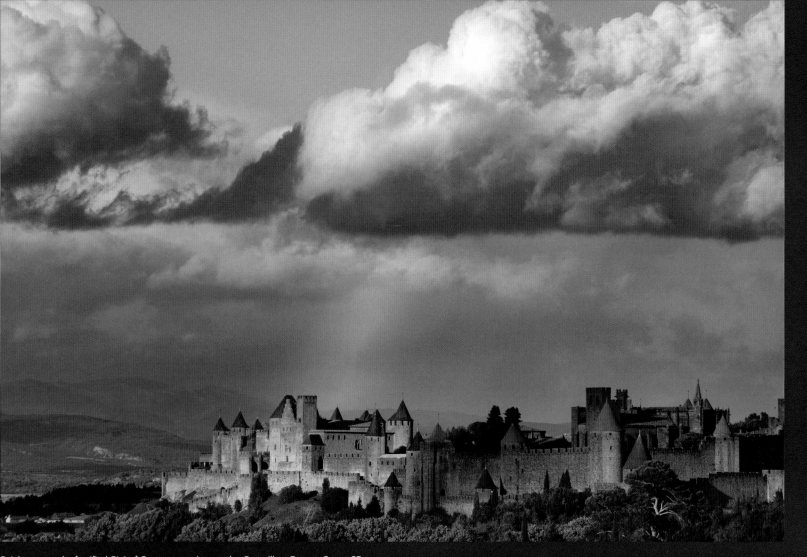

Rainbow over the fortified Cité of Carcassonne, Languedoc-Roussillon, France. Canon 5D Mk II, 100–400mm lens at 200mm, 1/60 sec at f8. As we waited for the light on this classic view we had a tailgate picnic on the go; it's the way to work, especially in France. It had been raining all day, but I suspected it could come good as the sun dipped. A rainbow over the Cité was a moment to be savoured, but I was so busy ensuring that I had the shot in the can, it's only in retrospect that the magic is evident. Carcassonne is one of those places that I think looks a lot better from afar; inside the ramparts it's a tourist trap – a pot of gold for the restaurateurs and shopkeepers – but not the real France. I've worked this location several times in different light, but now having made this rainbow image it's time to move on; I don't think I can better it.

Detail of the gloves and robes of penitents in the Semana Santa procession, Malaga, Andalucia, Spain. Canon 1Ds Mk III, 85mm lens, 1/400 sec at f1.4. Sometimes it's the small details that can say as much as the big picture. The Semana Santa processions in Andalucía are a bustling, heaving riot of colour, religious fervour and photographic opportunities that can pass before they are even registered. Hands can be as expressive as faces, as was the case here: I saw the white gloved hand clutching the rose against the black robe, dropped to my knees, focused, dialled in -2/3 exposure compensation to allow for the dark content, and exposed – all in a blink of time far shorter than that took to read. Then my victim had moved on and I was hunting for the next chance. Such fleeting opportunities can never be planned like a landscape shoot, but thought on how I'm going to approach a shoot and preparation in the form of being ready with the right camera settings, lens and so on, all plays a part.

Rothiemurchus Forest and the Cairngorm National Park, Scotland. Canon 1Ds Mk III, 1/8 sec at f16. The Cairngorms are not the easiest mountains to photograph. They may be amongst the highest in Britain, but essentially the region is one high plateau, which from afar makes them somewhat underwhelming if you expect peaks to look like the Matterhorn. But spend a bit of time here and the region is bound to get under your skin, helped by the warming amber produce of nearby Speyside, of course. Personally I can't wait to return. What drew me to this location were the red branches of the trees; it's rare to find such colour in a winter landscape. I was setting up my tripod, wary of the spongy, boggy ground, as several deer passed creating an evocative scene I was mortified to miss. I lectured myself to just enjoy the setting, the peace, the atmosphere and the calming solitary experience of being there, doing what I do. I started working the location as the light just got better and better. Hours passed, totally engrossed.

A jogger on the towpath of the Canal du Midi, near Castelnaudary, Languedoc-Rousillon, France. Canon 5D Mk II, 24–70mm lens at 70mm, 1/6 sec at f11. I was set up on the towpath, trying to make the most of this evocative misty morning when a jogger hove into view. For me, the tiny figure rounding the bend at the Decisive Moment was the final je ne sais quoi that lifted the image. The repetition of pattern of the trees receding into the mist was the compositional anchor. The mist also gives the colours a muted, restrained quality. The various tones of green predominate, which the rustic brown of the few leaves on the towpath only emphasize. The lighting, colour and composition all combine to make a subtle, harmonious image. They are now in the process of felling many of the trees lining the Canal du Midi due to a fungus; it's a tragedy.

Market at Can Tho, Mekong Delta, Vietnam. Canon 5D Mk II, 16–35mm lens at 16mm, 1 sec at f16, ISO 50, 0.9 ND filter. If I were to set up my tripod virtually under the noses of the stallholders at our local Sherborne Farmer's Market and proceed to shoot long exposures of them sorting their carrots, I might get a few looks at least; suspicious quizzing of my intentions, more likely. But there in the Mekong Delta the conically hatted ladies at Can Tho market didn't bat an eyelid; in fact, they barely registered my intimate proximity. It's one of the things I love about being in Asia; I feel emboldened to do things I'd never contemplate back home. For me these places are all about the bustle, and the way to express that is with longer exposures to convey motion, hence the tripod. Getting stuck in, up close and personal as part of the action, is always the way to make pictures with bold compositions. Hanging back reticently never works.

Curemonte, Limousin, France. Canon 1Ds Mk III, 100–400mm lens at 260mm, 1/6 sec at f16.
We'd been here several evenings before shooting this view in the evening light, but I drove
away dissatisfied. I knew I'd made a pleasant picture of another quaint hilltop village, but that
was about as far as it went. It was a good location – of that I was sure – and good locations
are always worth really flogging to get the most out. That means repeated visits until Mother
Nature serves up something special. The evening before I sensed the conditions that would
create morning mist, so my plan was settled. I arrived before dawn and stood on my hilltop
peering into the void. I knew Curemonte was below, but would it make an appearance? For
maybe a minute the towers were visible surrounded by the swirling mist before it closed in
again. I know I have a mist obsession, but I can't fight it.

Sri Pada (Adam's Peak) from a tea plantation on Lake Maskeliya, Central Highlands, Sri Lanka. Canon 1Ds Mk III, 14 vertical frames stitched together to make a panorama, 35mm lens, 1/6 sec at f11, 0.9 ND grad filter. To bag a location as strong as this one within 24 hours of arriving in the country was a real coup, even if the price to pay was being devoured by leeches. Local knowledge certainly helped. The landscape of hills covered in the lush, velvety green of tea plantations is the major draw of Sri Lanka's hill country, while including the Holy Peak of Sri Pada as well made for me what was the defining image of the country. As we drove towards the spot for the second time following the previous day's initial recce, the heavy rain clouds looked threatening and ominous. They remained so for the shoot, but the sense of drama in the sky and the low contrast, cool muted light suited the panoramic approach well. I made several attempts at this panorama; the light changing as I rotated the camera for my overlapping frames made things tricky. It's a good way of chewing up the memory. The colours in this scene are predominantly blue and green, analogous hues from the same side of the colour wheel, thus lending the picture harmony. That was how I felt that night: at one with the world. Nailing a strong shot early in a trip always helps.

Two cottages on the shore at Stoer, with the peaks of Suilven, Cul More, Cul Beag and Stac Polaidh beyond, Assynt, Sutherland, Scotland. Canon 1Ds Mk III, 70–200mm lens at 78mm, 45 sec at f11, Big Stopper filter. I drove south towards Kylesku through the lunar landscape of Sutherland. Despite the sombre light I was getting the buzz of being back in Scotland. I headed out on the narrow road to the Point of Stoer lighthouse, but stopped when I caught the view looking south, an epic sweep of coast with lonely cottages and the distinctive mountains of Assynt beyond. A few minutes later I was trying without much success to make a picture, sinking up to the top of my wellies in the squelchy bog. The combination of the stiff wind and spongy ground meant there was no hope of making a sharp picture with a long lens. I tried shielding the camera with my body but it wasn't working; I upped sticks and headed uphill in search of firmer ground. In amongst some rocks the tripod legs were well rooted, but the wind was worse. Well, I reasoned, I wasn't going to get the waves without the wind, and no one ever said this game was easy. It's a muted subdued image, but so typical of the west coast of Scotland, and so much moodier than a clear blue sky.

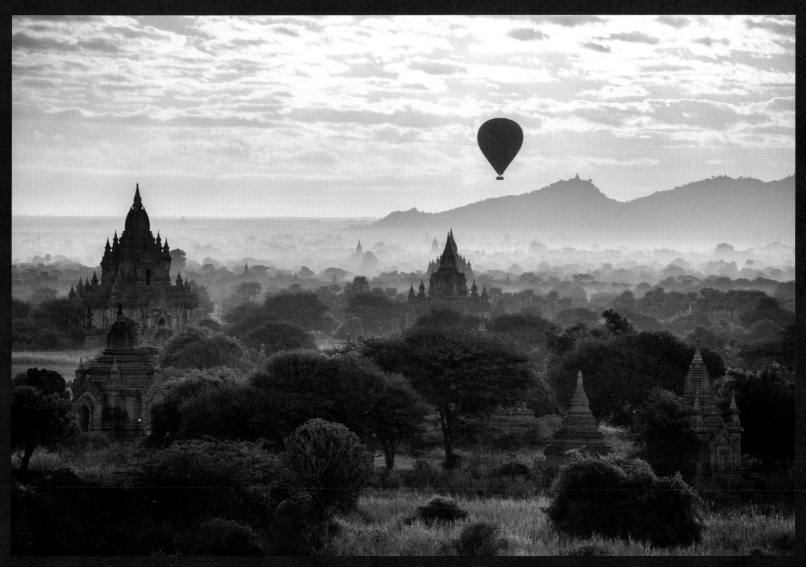

Balloons over the Temples of Bagan at dawn, Myanmar (Burma). Canon 5D Mk III, 70–200mm lens at 200mm, 1/250 sec at f5.6. After a day of temple hopping we headed back grubby, dusty, footsore and knackered, but content; we'd had a full day, with a lot of promising images shot. The next day we'd be up on the top of our chosen temple again to watch the sun rise over the plain, with the spires of multitudinous pagodas protruding. After Angkor I wondered if I really could do more Buddhist temples justice, but Bagan is one of those sights that has to be seen to be believed. Like Machu Picchu and the Taj Mahal the reality was beguiling, no matter how many pictures we'd seen before. Dinner of red pork curry and coconut rice preceded an 8.45pm bedtime; party revellers will find Burma a disappointment, but for us dawn patrollers it was just the natural way of things. The next morning at 5am we were crawling up a narrow claustrophobic staircase inside a pagoda by the light of our head torches to experience the sight of balloons drifting over the plain. I did a series of shots, but there was one where I knew the balloon was in just the right place in the sky.

Poppy in a field, near Norcia, Umbria, Italy. Canon 1Ds Mk III, 70–200mm lens at 170mm, 1/250 sec at f2.8. One poppy in a sea of barley; nothing could be simpler. Without fail the best pictures are always the simplest. The impact of the image hinges on the fact that the only thing sharp and in focus in the frame is the solitary poppy. Of course it wasn't solitary, the field was full of them, but using a long lens enabled me to isolate my chosen specimen with accurate focusing, careful composition, and minimal depth of field. Shooting through the barley to pick out the poppy with more of its kind out of focus beyond made the picture. Positioning the poppy on the top right intersection of thirds just seemed the natural thing to do. When the power of selective focus and the rule of thirds combine, a pleasing composition is likely. The early Umbrian sun backlighting the scene turned the fresh barley into a field of gold. Many have questioned if this picture has seen major work in the dark recesses of post-production, but it's about as straight a shot as there is.

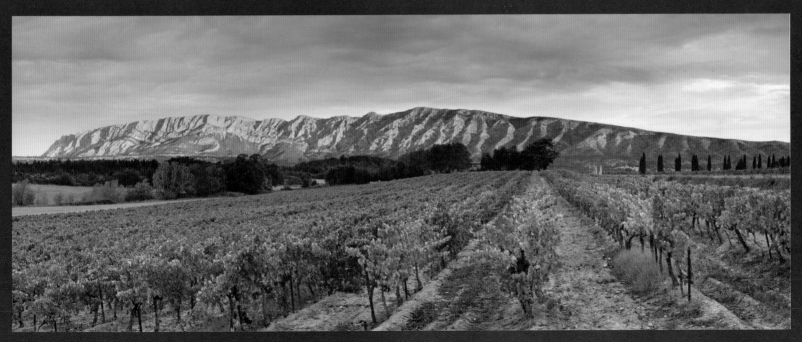

A vineyard near Puyloubier with the Montagne Sainte Victoire at dawn, Provence, France. Canon 5D Mk III, 10 vertical frames stitched together to make a panorama, 24–70mm lens at 70mm, 3.2 sec at f16, 0.6 ND grad filter. When seeing this shot, one guest on our Provence workshop asked why I hadn't taken those black things on the nearest vine out in Photoshop. Weren't they distracting? I didn't think so, especially as they happened to be grapes. It's sort of what these vineyards are all about, isn't it? Apart from wine production, they are also very

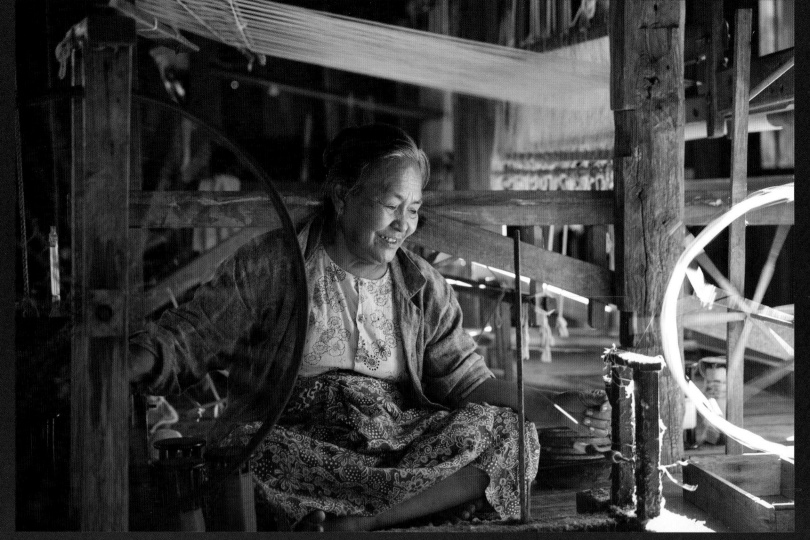

A woman weaving at In Phaw Khone, Inle Lake, Myanmar (Burma). Canon 1Dx, 24–70mm lens at 70mm, 1/125 sec at f2.8, ISO 800. I tagged along on one of Wendy's missions; maybe it would result in an interesting encounter. So far in Burma I just seemed to keep falling into promising situations; it couldn't go on, could it? Our first day cruising the lake saw us stopping at a weaving workshop built on stilts above the water, a subject right up Wendy's street. Mine too, it soon turned out, as the charming lady who couldn't stop beaming into my lens seemed to epitomize a woman happy in her work. As she squatted cross-legged on the floor weaving her lotus and silk (so I'm reliably informed) the light on her face was exquisite. In the setting of her timber workshop, it made for an arresting image of a woman at work. Apparently she's been weaving for 50 years. I hope I'm as content in my work as she seemed to be after five decades; more trips like this Burma adventure will help.

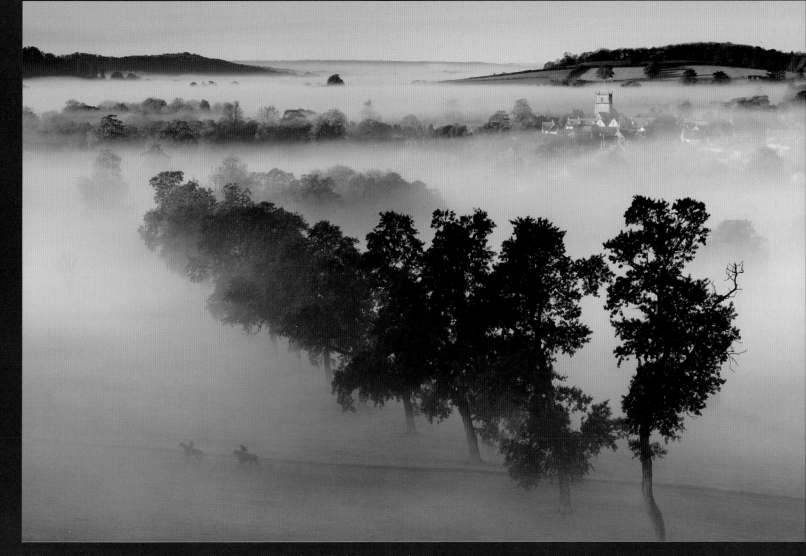

Misty autumn morning, Milborne Port, on the Dorset/Somerset border, England. Canon 1Ds Mk III, 70–200mm lens at 85mm, 1/10 sec at f11. I could hear and feel them long before I saw them; heavy breathing, the rumble of hooves and a distinct shaking of the ground signalled their approach. I tried to imagine what it must have been like as a humble infantryman at Waterloo, facing the massed charge of the French cavalry; intimidating is not the word. They burst out of the mist, thundering up the hill towards me, nostrils flared. A few jockeys cast me quick glances as they passed, surprised to see a figure lurking by a tripod on the bank above the exercise track before disappearing back into the fog. I could hear these jockeys chattering as they slowed to a trot, circling around to do it all again. I reverted from Napoleonic musing to wondering when mist becomes fog. Down below lay a line of trees, the cinder track and the village – our village. In a few minutes the horse and riders would hopefully appear below circling back to the start and that would be my Decisive Moment, but there was one big problem: I couldn't see a thing. The wispy mist that had enticingly lain over the landscape before dawn had now morphed into a thick blanket of impenetrable fog. That's the thing about mist, it does tend to waft and fluctuate; it's unpredictable stuff. Decades of misty morning vigils had taught me to be patient. My moment came.

Pont Saint-Bénezet at dusk, Avignon, Provence, France. Canon 5D Mk III, 24–70mm lens at 45mm, 1.3 sec at f11. It seemed a futile waste of time as we drove towards Avignon through sheets of rain as heavy as I've seen. On the banks of the Rhone, it seemed a glimmer of late light might just penetrate, but no, this was as much as we were going to get. However something about the weak light had a curious appeal, especially when combined with the threatening sky hanging over the Palais des Papes and the cool blue colour temperature. There are so many variables to light that I never stop being surprised; it always pays to experiment. On our way back in the car I started pontificating on the papal schism of the fourteenth century that had resulted in two rival Popes, one based in Rome and the other here in Avignon, and my passengers nodded off. I wonder why?

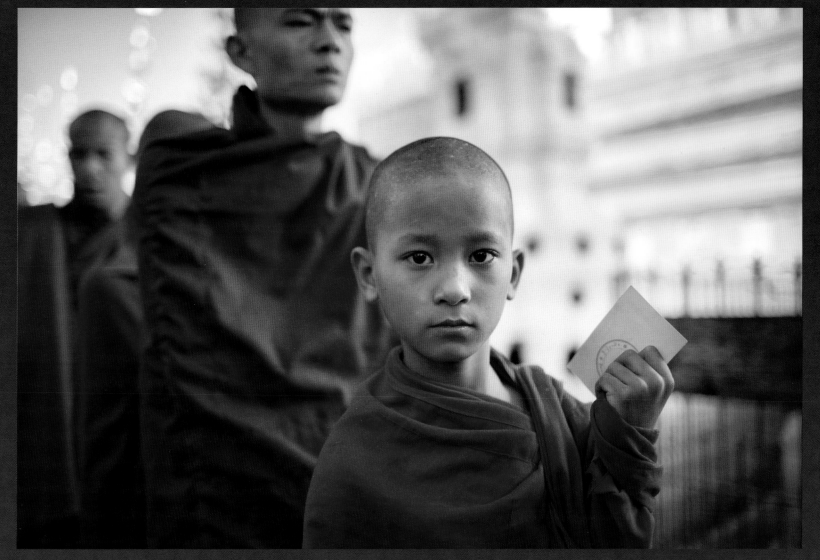

A novice monk at the Shwezigon Paya, Bagan, Myanmar (Burma). Canon 1Dx, 35mm lens, 1/2000 sec at f1.4. Htay, our guide for the day, turned out to be a keen photographer. As we drove towards the Full Moon Festival he seemed more inclined to quiz me about my equipment than to fill us in on what we were heading for. On arrival he grabbed his camera and was off, pursuing his own photographic agenda. Oh well, I hate being led by the hand anyway. I bolted a fast glass on to my recently acquired 1Dx and got stuck in; pictures were to be had everywhere I looked. The fabulous colours of the rows of monks against the gold pagoda with blue sky above made for almost too many visual stimulants. I forced myself to settle down, concentrate, and make carefully perceived and crafted images. The temptation to grab as many pictures as possible needed to be resisted fast. But also I was very conscious that such occasions don't come along often, so I really needed to make the most of it. A frantic 90 minutes followed, but what fun. I know I should stop shooting so many monks, but it keeps me out of trouble.

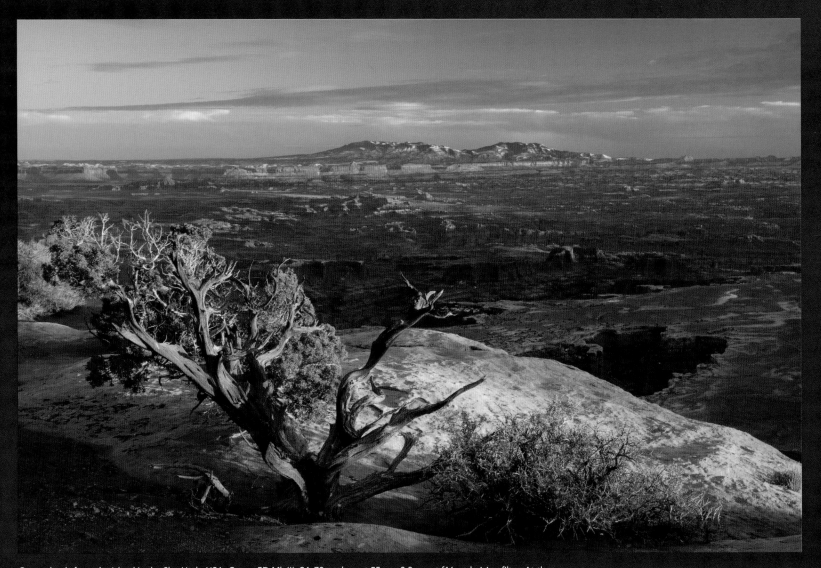

Canyonlands from the Island in the Sky, Utah, USA. Canon 5D Mk III, 24–70mm lens at 55mm, 0.8 sec at f16, polarizing filter. At the Island in the Sky the afternoon was sliding into the evening. A juniper tree on the edge of the precipice had caught my attention on the recce, and I was working out how to incorporate it into my frame as foreground interest. Going wide would accentuate the impact of the tree's gnarled shape, but the canyon beyond would appear not as the gaping chasm it is, but as a few distant bumps only marginally more impressive than the Mendips. These are the classic considerations of perspective I always go through when composing a picture. It's a case of deciding just what weight to give to the foreground vs the background. I could have exposed options at both extremes of my 24–70mm lens' range, but when the light was at its best just before it disappeared over the western rim I needed to be making the most of it, not faffing about moving backwards and forwards, composing and recomposing. I like to be decisive about the composition and perspective, choose the appropriate focal length, then wait for the Decisive Moment. A wide view accentuated the foreground at the expense of the background, whilst a narrow view emphasized the scale of the distant buttes. In between lay the middle ground of the standard lens' angle of view. The 50-degree(ish) angle of view is commonly acknowledged to replicate the perspective of the human eye, and when all is said and done it's a choice that has a lot going for it. That natural balance between the foreground and background was just what I needed for this shot.

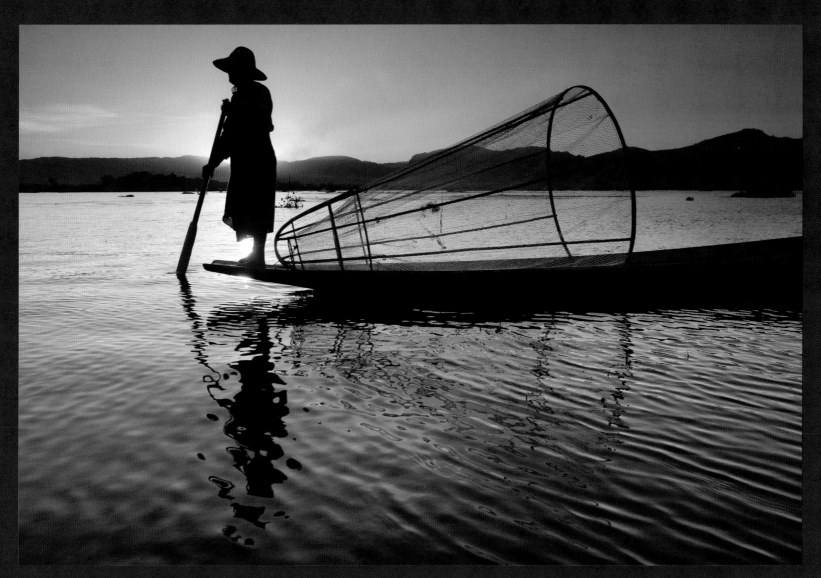

A fisherman on Inle Lake, Myanmar (Burma). Canon 1Dx, 24–70mm lens at 30mm, 1/80 sec at f7.1, 0.6 ND grad filter. I had a vision of a picture I wanted to make, as well as time to make it happen. Coming back across the lake in late afternoon we came across a likely looking fisherman. Sanda, our guide, asked if it was OK to just drift in his proximity as we waited for the sun to set and the fisherman came alongside, thinking it all hilarious; he was on his way home but was happy to wait. The water was flat and calm with perfect reflections, and we chatted amiably as we drifted, an encounter that sums up what travel is all about. Just as the sun was about to disappear, I asked him to paddle past, standing in the bows in the curious way they do on Inle Lake, backlit by the setting sun. He made several passes as my high speed drive chattered; I concentrated on the simple shapes and composition, then the sun was gone. We finished with a handshake from boat to boat, and I came away with a warm feeling: Burma in a nutshell.

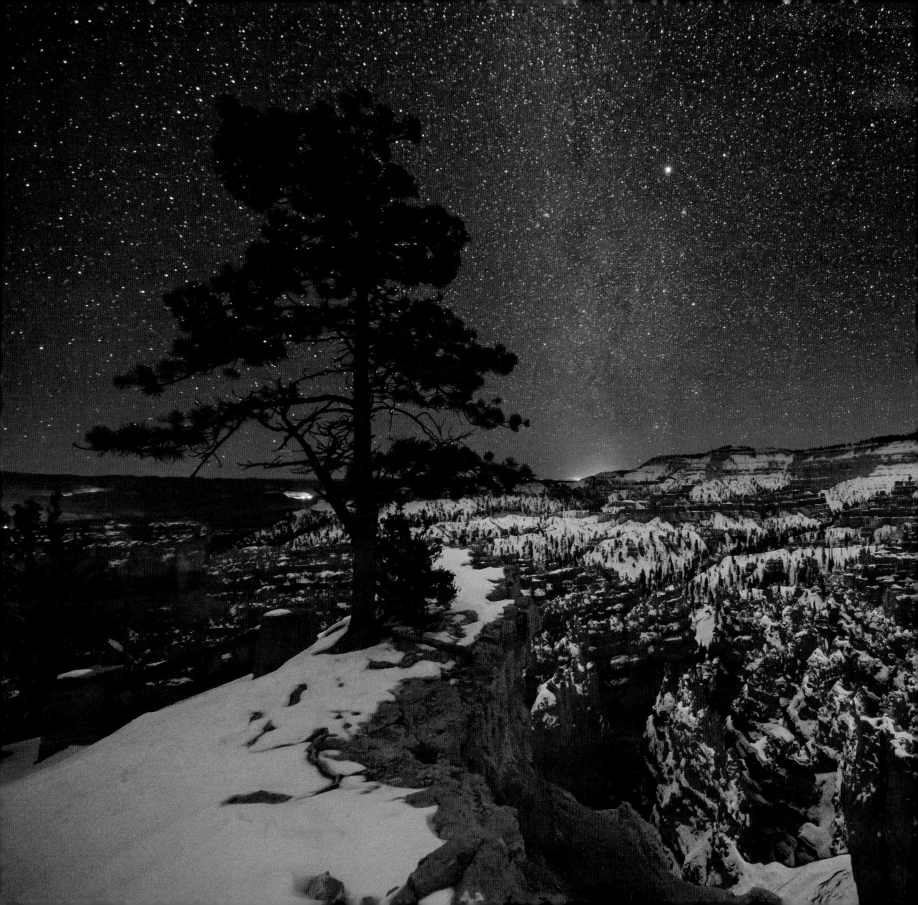

Bryce Amphitheatre at night, Bryce Canyon, Utah, USA. Canon 1Dx, 14mm lens, 20 sec at f4, ISO 12800. I arrive in the pitch black, trudging through the snow into the tunnel of my head torch's illumination. I know the exact point where I need to set up, but framing the composition is tricky; I can't see a thing. Trying to photograph a landscape I can't even see seems strange, but slowly my eyes adjust and the night sky above is revealed. I walk into the shot, leave my torch on the ground, stumble back to the camera in the darkness, and focus on the pinprick of light. Next, composing involves shining the torch on to the left, lower and right margins of the frame whilst adjusting the geared tripod head – tricky on my own. I'm wearing full winter kit – base layers, insulated over trousers, fleece, gilet, down jacket, Goretex shell, sleeves, hairy hat and head torch – but as usual the big problem is my fingers; whatever I do I keep needing to remove my gloves to alter the ISO settings. There's slight light pollution emanating from a power station some 20 miles or so away, but I'm confident that the idea is working. The experience of standing under the twinkling stars in such a big landscape alone at night is special – very special. Would I be stood here if it weren't for the stimulus of photography? It's these moments that make photography such a joy.

Summary

On the last day of the Burma trip we're walking through the streets of Yangon in the hours before dawn, heading for where – photographically at least – it all started a month before: the imposing temple complex of Shwedagon, which dominates all around. I have an idea based on what I learnt from my first shoot here. It's not an idea stunning in its scope or complexity, but that doesn't matter; it's all I need. I'm going to set up at the south-east corner, using the strong patterns of the marble paving as lines leading towards the bold shapes of the golden spires, and just hope that someone interesting walks through my frame. The first light from the rising sun will be glowing on the gold leaf from over my right shoulder. I know the location, I've considered the light and the composition, and the weather is favourable. So what about the colour? The gold of the temple should really stand out against blue sky and the cool marble; if I'm lucky, a passing monk may add a splash of scarlet. The plan is no feat of complex logistics either – it doesn't need to be: simply walk to the temple, set up and wait as long as it takes. Keeping things simple always works. What is important is that I have a vision of what I'm aiming for this morning.

We reach the steps leading up to Shwedagon and remove our shoes. One of my abiding memories of Burma will be the pile of sandals at the entrance to every pagoda. We've still not acclimatized to walking barefoot on hard concrete, but have revelled in another aspect of this trip: a month without fiddling with mobile phones. I wish there were more places in the world so unconnected. It's bound to change; indeed Internet connectivity is already far more widely available than we had expected. Yes, we've had hassles in the cash-only economy with our less than pristine dollar notes being rejected, as well as sometimes chaotic airports, but the vistas, people, culture, food and ambience of Burma have been intoxicating. As I'm extending the legs of my tripod, I'm reflecting on the last month that is sadly coming to an end. I'm looking forwards to not brushing my teeth with bottled water but will be sorry to leave, and I know I have a strong set of images to show for it all. If the shoot this morning works it will be a bonus, but I'm philosophical; I'll do all I can, but I know that sometimes it all comes together, sometimes it doesn't.

We're early, sunrise isn't for another 30 minutes, but I set up anyway with the camera on the tripod all squared off and level with the aid of the spirit level. The composition is very precise, so any ugly converging verticals will stand out like a sore thumb. Hence the choice of the 17mm tilt-and-shift lens, this time fitted with an ingenious jury-rigged system for allowing filters to be attached despite the bulbous front element utilizing an adapted lens cap. I wait by the tripod, my station in life; Wendy comes and goes. In the evening this temple is busy with worshippers and a fair few tourists, but this morning there are few about – for now. As the first rays just start to glisten on the highest tips of the pagoda, the daily life of the complex starts to pick up. A few crows are circling in the thermals above as the sun warms. My moment will be when those rays have crept down to the base of the spires.

An hour after setting up, I'm still waiting. The light now is perfect, but to make this idea work I need some human element, a chance intervention. I could ask a monk to pose in just the right place in the frame, but I think it would look a bit contrived. I've shot several groups of monks walking through my frame but they've not been in the right place, and I'm aware that maybe I've done enough monks for now. I'm starting to become resigned to this shoot not really working, but I'll give it time.

From behind I spot a pink clad nun approaching. Monks are ten a penny here, but I've yet to make a worthwhile shot of a nun. I had suggested to Wendy that she don pink and shave her head, but her devotion to the cause was temporarily lacking; maybe, just maybe, this is my opportunity. My finger is on the button of the release as the nun passes and walks into my frame just where I want her. She's carrying an umbrella too – even better. I expose a few frames as the moment unfolds and instinctively I know before even checking that it's worked. Warm satisfaction glows, but as I scroll back through the frames the glowing ignites to roaring flames. The best frame where the nun is in just the right spot has an extra, unforeseen contribution: above the gold spires, bold in the blue sky, hovers the distinctive shape of a circling crow. Oh joy! Talk about a Decisive Moment. What a way to finish this Burmese adventure.

I cannot think of a picture that better sums up the way I work and all we've been talking about in this book. I know some will suspect I've pulled in elements from different frames to combine in post-production, but I know it's one simple shot that defines the concept of the Decisive Moment, and that's all that matters. All the work that made this picture happen started with the simple idea. The prior knowledge of the location gleaned from a previous shoot had made me really consider how powerful a compositional element the patterns in the marble combined with the gold spires could be. The composition relied on the precise positioning of those dominant lines in relation to the frame. The time when the lighting on the temple would be just right was predicted, and the weather considered. Rain the previous day had

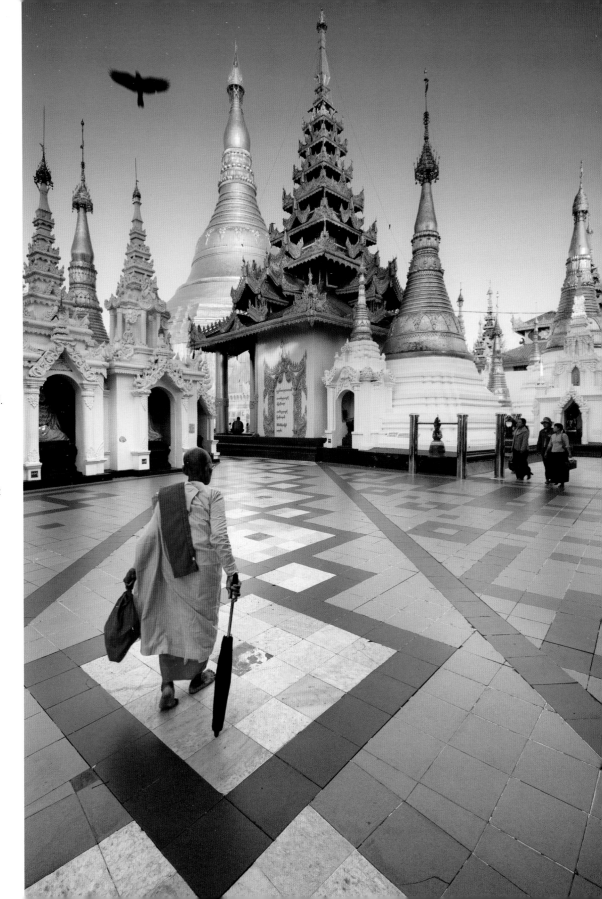

A nun at Shwedagon Pagoda, Yangon, Myanmar (Burma). Canon 5D Mk III, 17mm TS-E lens, 1/100 sec at f8, ISO 200, 0.9 ND grad filter.

washed the skies over Yangon of haze; a few clouds would have been my preferred choice, nevertheless the light was clear and crisp. The colours in the frame were a key component: complementary blue and gold. This was always meant to be a full colour image, and the added component of a pink clad nun standing out against the cool tones of the marble was the unforeseen bonus. The plan saw me set up by the tripod suitably equipped and ready when the Moment came. Ultimately the success of the shot relied on the unscripted appearance of the nun, coupled with the bird that flew overhead at the same time.

I hit the shutter just at the right moment, but I know I got lucky that morning. The best images that really stand out nearly always have that random, lucky element to lift the whole, be it a shaft of light, a rainbow, a passing nun or a soaring bird. But those moments can never be captured if we photographers aren't there, expecting the unexpected, ready for the Moment. The more I put myself into these situations the luckier I get. These are the moments when preparation and chance combine, when the power of imagination and inspiration are combined with pre-visualization and prediction, when the vision comes to fruition.

Hardware

As the central theme of this book is the vision, the actual hardware I use is inevitably barely considered. Cameras and lenses are merely tools, and the photographer only rudimentarily equipped but with that vision will always produce superior pictures to the fully kitted out equipment freak with all the gear but no idea. Nevertheless, the tools for the job are important, and I do take great satisfaction from knowing how they work and how to get the very best from them. The modern digital single lens reflex camera (DSLR) is an incredibly flexible tool capable of producing images of superb quality in even the most extreme environments. I revel in that flexibility and control; it helps me to make pictures in challenging situations that I couldn't have dreamt of tackling just ten years ago.

Photo: Wendy Noton

For decades I was wedded to the large panoramic film format. I still love to produce panoramas: they're just fun, and a natural shape for a landscape picture. Now though I work entirely digitally with just one camera system: Canon's full frame EOS format in its varying guises. When I converted to digital capture in 2004 the catalyst for change was the release of the Canon 1Ds Mk II, the first DSLR to better the quality available from film. I've always thought that full frame sensors are a must for my work. Yes, I could opt for larger sensors still in the form of medium or large format backs, but I've always considered the inherent loss of flexibility and portability a price not worth paying. In a nutshell, the choice of lenses is just too limiting, and the ponderous cameras have none of the advantages of speed and versatility I need on a boat in Burma or under the night sky in Patagonia. The flexibility of a DSLR system backed up with the full array of specialist lenses, from fisheye to super telephoto, allows me to express my vision – it's as simple as that. The quality

that a camera such as the 5D Mk III is capable of producing is amazing; when needed, I can print to exhibition standard at a size well over 1m (3ft) wide.

My bodies have come and gone. The 1Ds Mk II was retired when the 1Ds Mk III came along, and then brought back for an infrared conversion. The 5D Mk II entered the armoury, and now I'm using the 1Dx and the 5D Mk III. The 1Dx is my favoured tool when working with people, or in low light.

I have many more lenses than I can carry at one time, but they all have their uses; every item I own has to earn its keep. At the wide-angle end I have the 14mm f2.8 L super wide, a 15mm fisheye, the 16–35mm f2.8 II L zoom with 17mm and 24mm TS-E lenses. The latter tilt-and-shift optics are tools that I wouldn't be without for my landscape work. My 24–70mm f2.8 II L mid-range zoom is a workhorse lens that I rarely venture forth without. The same can be said for the 70–200mm f2.8 II L, although when working in tight crowded environments shooting people I'll usually opt

for my lightweight set up with just two primes. You can't beat fast glass and there's none faster than the superb 85mm f1.2 L; coupled with the 35mm f1.4 L they make a great team, especially when used on the 1Dx. I can now walk into the dingiest Sri Lankan sweatshop knowing I can make pictures, no matter how dark. When I need the compressed perspective of a lens longer than 200mm I reach for my 100–400mm, a conveniently portable zoom for its focal range. Occasionally I beg, steal or borrow a 500mm f4 L, a superb telephoto that is a joy to use on a monopod, but it's not a lens to go backpacking with.

Over the years I have worked with the people at Canon regularly, but that relationship intensified in 2012 when they asked me to join their Ambassador program as an official Canon Explorer. I'm hoping that this role will enable me to give the feedback necessary to help guide future camera and lens development in the direction us photographers in the field with muddy boots really need.

The filters I always have with me are a set of neutral density graduates: a 0.9 ND grad hard, a 0.9 ND grad soft, plus a 0.6 ND grad hard (my most used filter). Also, to slow exposures down I use straight NDs: a 0.6, 0.9 and the Big Stopper (approximately 10x). Finally, polarizing filters are also indispensable.

My memory cards are all Lexar; I used to use 4GB CFs, then 8GB, and now I have 32GB cards and fast USB 3 readers. Doubtless by the time you read this, such memory capacity will look dated. I always back up as soon as I can after a shoot to my laptop, but sometimes when far from civilization I have to just rely on the cards. I've not yet lost a digital image – touch wood!

With the ability to shoot at what were previously considered to be sky-high ISOs using cameras such as the 1Dx, the times I need flash now are very rare. In fact there's not one single image in this book that was lit using flash, but occasionally the

Photo: Wendy Noton

Photo: Jon Gooding

option of splashing a touch of fill in light just where I need it is handy. In these cases I use the Canon 580EX II of which I have two; used in tandem, remote from the camera, surprisingly complex lighting effects can be achieved.

The tripod is one of the most important pieces of equipment a landscape photographer needs. It's no good having the best cameras and lenses if the support for them isn't there. I have numerous tripods, but my favoured set up currently features Giotto's carbon fibre legs with a Manfrotto geared head.

All the gear goes into Lowepro photo rucksacks of varying sizes, depending on what I need for a particular shoot and how I'm travelling. Just as important are the ancillaries: head torch, Swiss Army knife (not least for the corkscrew!), Land Rover Discovery, water bottle, shades, phone, and so on. It's a lot to carry, but ultimately it's all secondary to the really important equipment that costs nothing: my eyes.

Acknowledgements

One way or another I rely on many talented people's expertise and commitment to keep our photographic bandwagon on the road, and the production of this book is no exception. As usual our Office Manager Sharyn Meeks has been the rock of dependable stability who ensures our ship remains afloat while we are wafting around in Burma or Sri Lanka. Matt Hunt is the man who keeps us technically ticking over, and this book just wouldn't have happened without Editor Freya Dangerfield's input. At D&C Hannah Kelly has been a pleasure to work with from the moment the original idea for this book was discussed, and designer Jodie Lystor has again delivered the goods. Last but not least my Wendy is the person who deserves a long service medal; the lot of a photographer's partner is not an easy one. Without her I just couldn't do what I do.

About the author

Photo: Wendy Noton

David is one of the world's most renowned landscape and travel photographers, and runs his own highly successful freelance photography company based near Sherborne, Dorset. His passion for photography, travel and the world's most beautiful locations are the defining influences that have shaped his life, work and creative approach to photography.

David was born in Bedfordshire, England in 1957, but spent much of his youth travelling with his family between the UK, California and Canada; he took his first photographs on a Kodak Instamatic he was given for his 13th birthday. After leaving school David joined the Merchant Navy in search of further travels and adventures; it was whilst sailing the seven seas that his interest in photography grew.

After a few years at sea, David decided to pursue his passion and returned to study photography in Gloucester, England in 1982; he has been captivated by the subject ever since. After graduating in 1985 he began to work as a freelance photographer specializing in landscape and other travel subjects, which has taken him and his wife Wendy to almost every part of the globe over the last 25 years.

David is now established and recognized as one of the world's leading landscape and travel photographers. His images are published all over the globe – both as fine art photography and commercially and David has won international awards for his work.

David is the author of two previous books, *Waiting for the Light* and *Full Frame;* the former was launched at an accompanying exhibition at the Oxo Gallery in London that attracted over 27,000 visitors. He has also made two ground breaking films on photography *Chasing the Light* and *Full Frame,* writes regularly about travel and photography for a range of photography magazines and websites and publishes his own innovative monthly *Chasing the Light* eZine. David and his team stage regular *Chasing the Light* Road Shows and run workshops across the UK and abroad.

Index

A DAVID & CHARLES BOOK
© F&W Media International, Ltd 2013

David & Charles is an imprint of F&W Media International, Ltd
Brunel House, Forde Close, Newton Abbot, TQ12 4PU, UK

F&W Media International, Ltd is a subsidiary of F+W Media, Inc
10151 Carver Road, Suite #200, Blue Ash, OH 45242, USA

Text and Photography © David Noton 2013 except page 10, the work of art
depicted in this image and the reproduction thereof are in the public domain
worldwide. The reproduction is part of a collection of reproductions compiled by
The Yorck Project. The compilation copyright is held by Zenodot Verlagsgesellschaft
mbH and licensed under the GNU Free Documentation License.

Layout and Designs © F&W Media International, Ltd 2013
First published in the UK and USA in 2013

David Noton has asserted his right to be identified as author of this work in
accordance with the Copyright, Designs and Patents Act, 1988.

All rights reserved. No part of this publication may be reproduced in any form or
by any means, electronic or mechanical, by photocopying, recording or otherwise,
without prior permission in writing from the publisher.

A catalogue record for this book is available from the British Library.

ISBN-13: 978-1-4463-0296-5 hardback
ISBN-10: 1-4463-0296-2 hardback

ISBN-13: 978-1-4463-0297-2 paperback
ISBN-10: 1-4463-0297-0 paperback

Printed in China by RR Donnelley for:
F&W Media International, Ltd
Brunel House, Forde Close, Newton Abbot, TQ12 4PU, UK

10 9 8 7 6 5 4 3 2 1

Publisher: Ali Myer
Desk Editor: Hannah Kelly
Project Editor: Bethany Dymond
Proofreader: Freya Dangerfield
Art Editor: Jodie Lystor
Production Manager: Beverley Richardson

F+W Media publishes high quality books on a wide range of subjects.
For more great book ideas visit: www.stitchcraftcreate.co.uk